An Introduction to
Drawing

An Introduction to Drawing

An Artist's Guide to Skills & Techniques

Robin Hazlewood

NORTH LIGHT BOOKS

For
Nellie, "Did" and Zoë
from the past to the future.

Acknowledgements
I would like to thank Pauline Hazlewood for her support and advice and Harriet Gilbert for her help and encouragement especially in proofreading and suggestions for the text of the book.

First Published in 2004 by Arcturus Publishing Limited

Distributed to the trade and art markets in
North America by North Light Books
an imprint of F & W Publications, Inc.
4700 East Galbraith Road
Cincinnati, OH 45236
(800) 289-0963

ISBN 1-58180-488-1

Cover Design: Alex Ingr
Text Design: Elizabeth Healey

Printed and bound in China

Contents

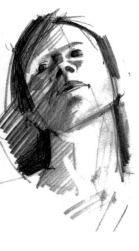

PREFACE 6

INTRODUCTION 8

DRAWING OBJECTS 17

TONE AND FORM 34

FIGURES 49

PERSPECTIVE 66

FORESHORTENING 88

COMPOSITION 98

LANDSCAPE 114

SKETCHING 132

PORTRAITS 152

USING PHOTOGRAPHS 178

TOOLS AND MATERIALS 194

INDEX 208

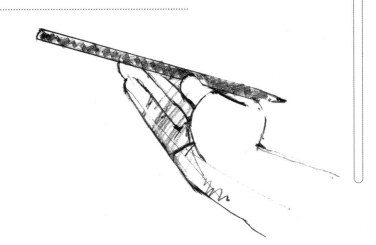

Preface

The aim of this book is to show you that learning to draw the visual world is not about some mysterious talent or innate facility but rather about looking at objects in a different way from that in which you normally do. It is also about application, motivation and practice. If your desire to draw is strong enough, you will be able to.

When I first started to "look" in the way in which I am asking you to do, I thought it was cheating because it seemed too much like copying. I had been told that drawing was about using my imagination rather than seeing in a different way. It was only when I started to look at the work of great painters that I realized that seeing was what really mattered, and unless you saw what was there in reality you had nothing on which to feed your imagination. In the end, imagination is more about how you remember what you have seen than conjuring up something out of nothing.

Beginning to see in a manner that can be translated to paper can give you a new way of looking at the world – seeing its shapes and forms perhaps for the first time. This can not only feed your imagination but also give you a view of the world that is unique to you.

Although not all the exercises in this book are easy, they are within everyone's grasp if they are prepared to put in the time. Like most things, drawing becomes easier the more you do it. I have not attempted to show you all the ways of drawing that exist – such as imaginative, illustrative, technical, and so on – as I believe that what is important in the beginning is to have confidence and belief in yourself. One of the best ways of gaining this confidence is by being able to represent the visual world in two dimensions by drawing it.

Drawing is a wonderful experience; seeing objects gradually appear on the paper can be magical. Once this magic has started to work you will want to take things further. Then it not only becomes a process of getting better but also a road towards getting to know more about yourself.

OPPOSITE

Even a complicated still life will become surprisingly straightforward once you have learnt how to look at it.

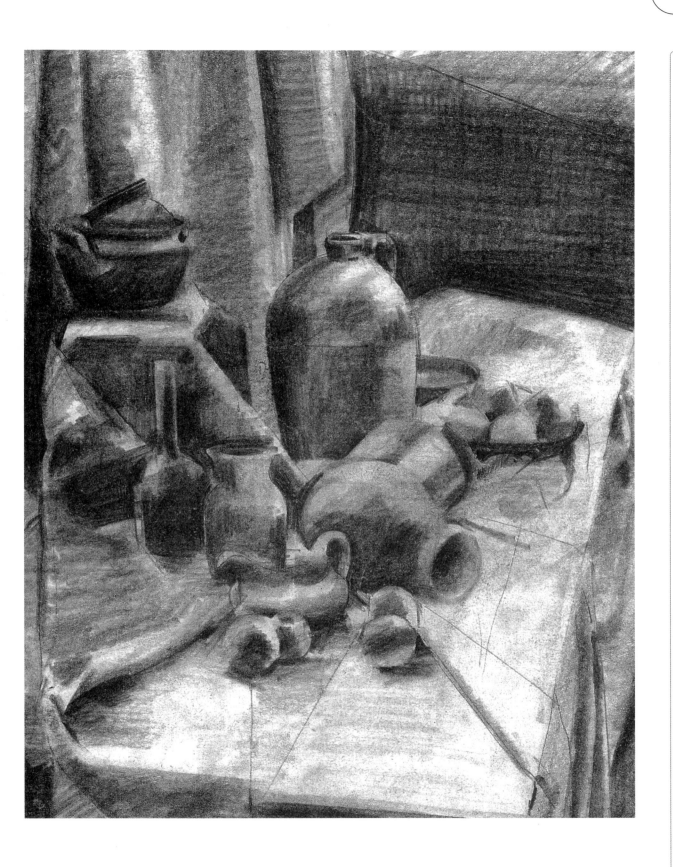

SECTION 1

Introduction

We all draw. From very early on we make marks, whether with instruments such as pencils and pens or just our fingers. Most people think that learning to draw is difficult and requires a certain type of inherent talent, but in fact it is much more about learning to see in a different way than it is about any particular facility of the hand.

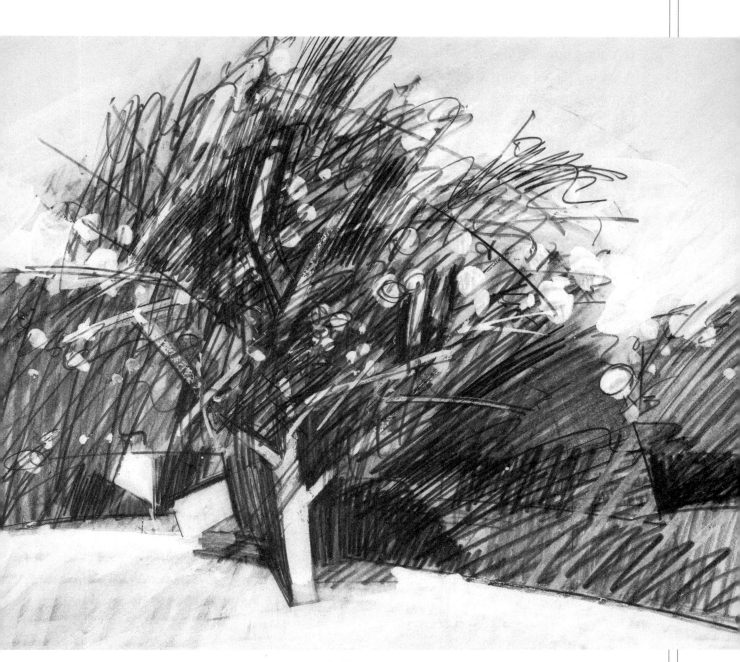

ABOVE

In this study of a pear tree in a French garden,
notice how the marks made by the pencil are used to
indicate the quality of movement of the branches.

Writing was at one time thought to be a skill that only a few people could possess. Today most people write without any thought of it being difficult.

Unlike playing an instrument such as the piano or violin, drawing does not require us to train our hands in a new way. Learning to write has already done that for us, therefore anyone who can write their name should be able to draw.

So why, I hear you say, can we not all draw? The answer is that we have learned to use our eyes in a way that helps us move about the world – to get our food, to fight or flee – not to see the world from one static point of view. This has meant that we create concepts of what the world is like three-dimensionally, rather than seeing it in a static two-dimensional way.

For instance, when we walk into a room we do not see the enormous variety of visual shapes, patterns and colours – made by tables, chairs and so on – that constantly change as we walk about. We use the visual information that comes to us to create, from these fleeting shapes and colours, a three-dimensional room containing solid tables and chairs with spaces between.

When you look at an object such as a table, a chair or a jug from one point of view, there is always visual confusion between what you see and what you know the object to be like as a three-dimensional whole. It is this confusion you need to overcome in order to be able to draw. This will involve you concentrating more upon what you can actually see than on what your brain tells you about a familiar object.

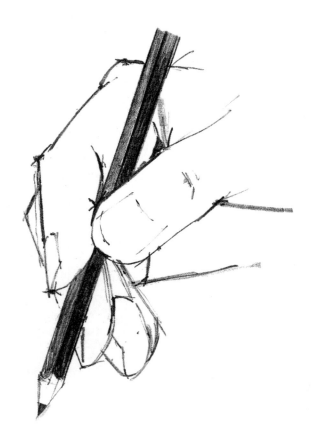

Getting started

You will first need something to draw with and a surface to draw upon.

There are many different types of pencil, ranging from very hard ones such as 6H to very soft ones such as 8B. We will go into this in more detail later, but for now, a B is a good basic grade for drawing.

Use a piece of cartridge paper, either in a sketch book or attached to a board. A good size of paper to begin with is A3. Equip yourself also with a pencil sharpener and an eraser, and you will be ready to start.

Basic elements

The basic elements of all line drawings are straight and curved lines. It is how you judge whether a line or curve is in the right relationship with another that is the essence of making a good drawing.

The following are a few drawing exercises that will develop your ability to successfully make these sometimes fine judgements of proportion and relationship.

HORIZONTALS AND VERTICALS

First, draw freehand three approximate squares. These can be any size you feel comfortable with. Then, using only your eyes as a guide, divide the first square horizontally in half (Step 1). Do the same in the next square and then divide each of the halves in half (Step 2). In the third square, divide each area again in half (Step 3).

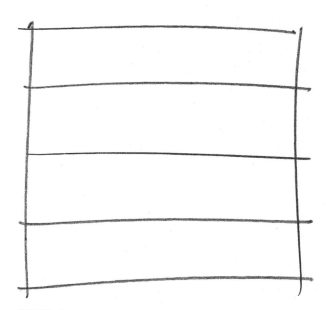

STEP 2

Divide the square in half horizontally then divide the two halves into quarters.

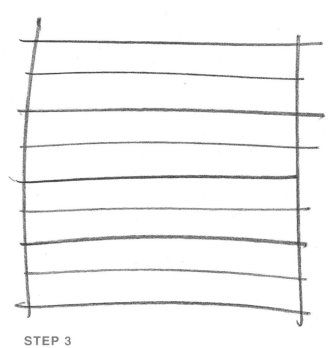

STEP 3

Divide the square in half horizontally, then divide the two halves into quarters and the quarters into eighths.

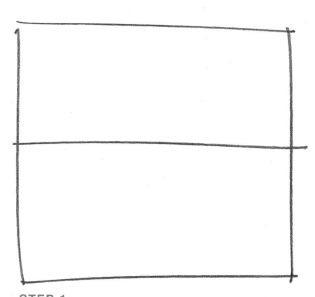

STEP 1

Divide the square in half horizontally.

This process of halving is important, since it makes it easier to judge equal proportions rather than trying to divide the square in four or eight equal parts from the beginning.

When you have finished, check how well you have done. How parallel are the lines? How equal are the spaces apart? If you feel you can do better, have another try.

VERTICALS

Having done horizontal lines, draw another three freehand squares and try vertical ones (see Steps 4, 5, 6).

STEP 5

Take the square to Step 2, then divide vertically into quarters.

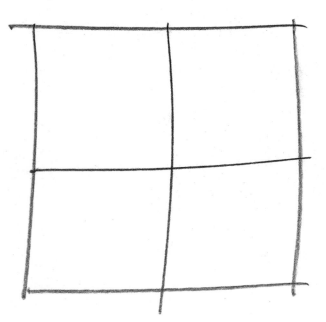

STEP 4

Repeat Step 1 on the previous page, then divide the square in half vertically.

STEP 6

Take the sixth square to Step 3, then divide vertically into eighths.

DIAGONALS

Now let's move from horizontal and vertical lines to lines at various angles. Again, draw three freehand approximate squares.

In the first square, draw a diagonal line from one corner to the other (Step 1). Then do the same in the second square and divide the two remaining spaces in half (Step 2). Repeat in the third square and again divide the remaining spaces in half (Step 3).

You will see how important it is to be able to judge proportions correctly when you start to draw objects, especially buildings.

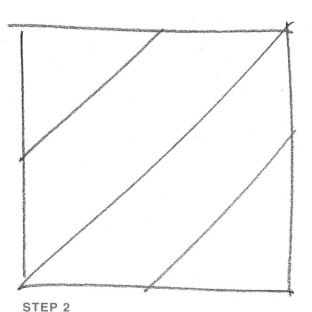

STEP 2

Repeat Step 1, then divide the two halves with diagonal lines.

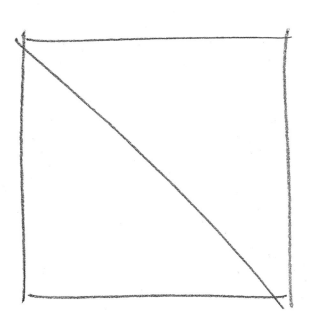

STEP 1

Draw a diagonal line halving the square.

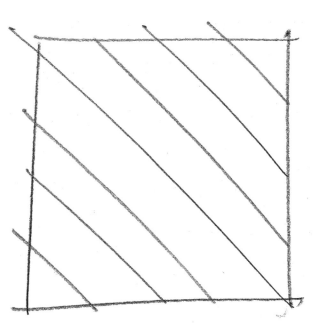

STEP 3

In the third square, repeat Steps 1 and 2 then divide the quarters in half again.

ANGLES

Now draw three further freehand squares. In the first of these, draw a diagonal again (Step 1). Repeat in the next square and divide each half of the square in half, this time starting your lines from the bottom of the diagonal line (Step 2). Then do the same again in the next square and divide the angles in half once more (Step 3).

Again, when you have finished, check how well you have done. How equal are the angles? How parallel are the lines?

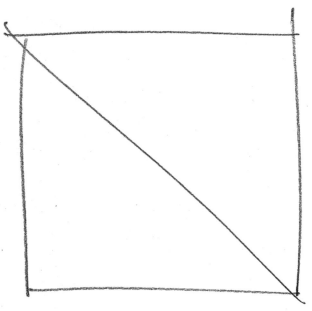

STEP 1

Divide the square in half with a diagonal line.

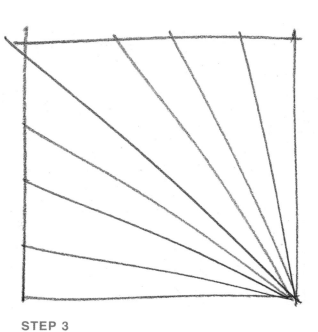

STEP 3

Take the third square to Step 2, then divide all the angles in half again.

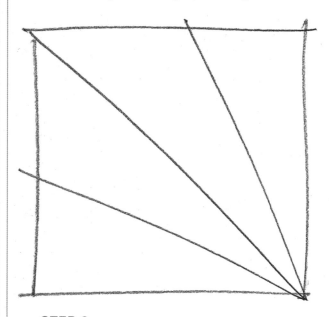

STEP 2

Repeat Step 1, then divide the two angles in half, creating four equal angles.

CURVES AND CIRCLES

Now have a go at a few curves. Draw three squares but this time use a ruler, as this will help you in drawing your freehand curves. Divide your first square into quarters horizontally and vertically then, in the first quarter, draw a curve as if it were the start of a circle in the whole square (Step 1). Repeat the process again in the second square but this time put another curve into the second quarter (Step 2). Then repeat in the third square and complete the circle (Step 3). If you find this difficult at first, try

it again. You may find the curve easier to draw if you turn the sheet of paper round.

You are not expected to do this perfectly straight away, but when you feel you can make reasonable visual judgements you are well on the way to drawing with confidence.

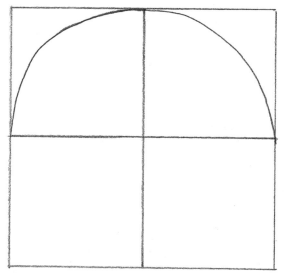

STEP 2

Repeat Step 1, then continue to draw the circle in the second quarter, making a freehand semi-circle.

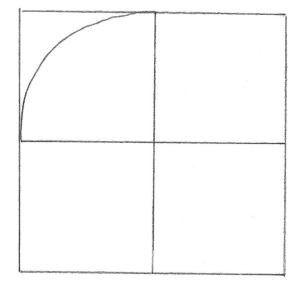

STEP 1

Quarter the square with one vertical and one horizontal line, then draw a freehand curve in the first quarter of the square.

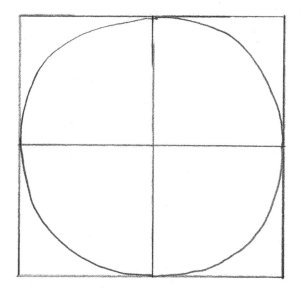

STEP 3

Repeat Steps 1 and 2, then complete the circle in the last two quarters.

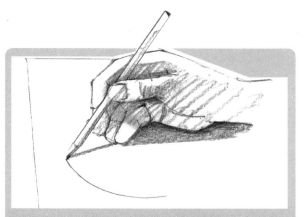

TIP

When you are drawing curves and circles, you will find it helpful to steady your hand by resting the heel of it on the paper and drawing the curve by moving your wrist and hand in an arc.

One of the most common shapes in the visual world is the ellipse – a squashed circle. Ellipses are difficult to draw, so now let's have a go at one of these.

Draw three more squares with a ruler. Divide the first one in half horizontally and vertically, then in half again horizontally. Draw a freehand ellipse in the centre of the square, building it up one section at a time as you did with the circle (Step 1). Now have another go in your next square, putting an ellipse in each half (Step 2). Now divide your final square with further horizontal lines and put four ellipses in the square (Step 3).

If you're not satisfied with your attempts at these exercises try them again as they will stand you in good stead for what follows.

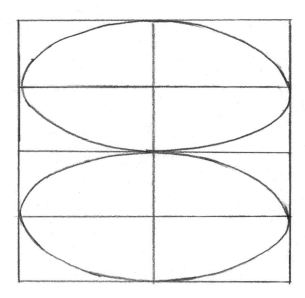

STEP 2

Start as you did in Step 1, but this time draw an ellipse in both halves of the square.

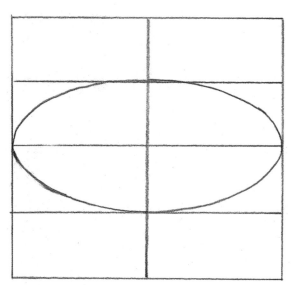

STEP 1

Divide the square horizontally into four quarters, then divide it in half vertically. Draw a freehand ellipse in the central four segments, following the method you used to draw a circle.

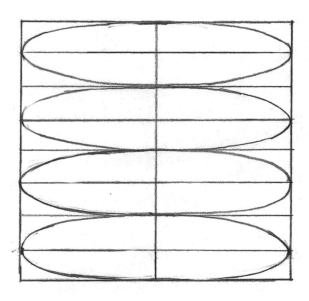

STEP 3

Follow Step 1 but add additional horizontal lines, dividing the square into eighths. Draw four ellipses in the four quarters.

SECTION 2

Drawing Objects

A three-dimensional object will appear to be a different shape every time you change the position from which you look at it. Consequently, you have a concept of its shape gained from how it looks from a number of perspectives. When drawing it, the task is to reproduce how it looks from a single viewpoint.

First, set up a simple object in front of you. This could be a jug, a piece of fruit or a bottle. Put it against a simple background such as a plain wall. Take your sketch book or board and paper and your B pencil, eraser and sharpener. Make sure you are sitting comfortably and can easily see both the object you wish to draw and the paper you are drawing on without too much twisting of the head. This is important because you need all your attention on the drawing and the object.

Seat yourself in a comfortable position in front of the object you wish to draw, making sure that you can easily see it without having to turn your head.

WHAT SIZE SHOULD IT BE?

The first thing you need to decide is what size your drawing is going to be. You may want to make it very small in the centre of the page, so large that it takes up the whole page, or indeed any size in between those two extremes.

One of the most common difficulties for novices is keeping objects and their component parts to a unified size over the whole drawing, so it is vital to have some sort of system that will help you to be consistent in this respect. The systematic approach to keeping objects in scale that I am going to teach you in this book is known as "sight-sized measured drawing".

CHOOSING A SIZE

Whatever the size of your paper, you can choose whether to draw the object quite small in relation to the available space or taking up the whole sheet.

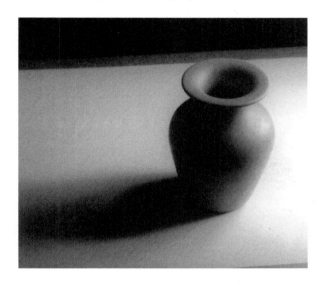

LEFT

Here the vase is shown with a generous amount of space surrounding it.

RIGHT

The vase now fills the page.

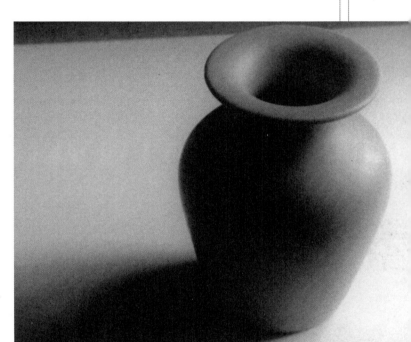

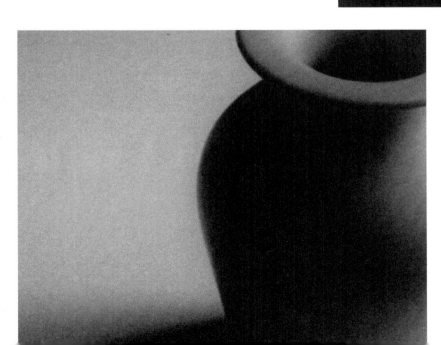

LEFT

The vase is half off the paper, leaving just an abstract detail of the whole object.

Sight-sized measured drawing

Sight-sized measured drawing means that the drawing is the same size as an object appears to you if you measure it against your pencil with your outstretched hand.

If objects are at some distance from you, they might be smaller in your drawing than you want. In this case you can double the measurements and make the drawing twice sight-sized by laying your pencil with the sight-size measurement twice on your paper. A word of caution: it is easy to forget the double measurement. If some measurements are double and others single, the result will be a drawing with the wrong relationships.

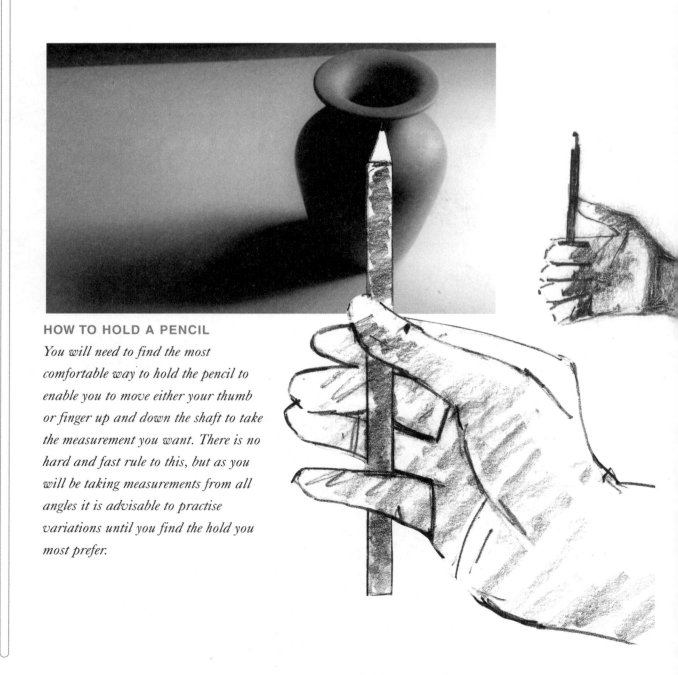

HOW TO HOLD A PENCIL
You will need to find the most comfortable way to hold the pencil to enable you to move either your thumb or finger up and down the shaft to take the measurement you want. There is no hard and fast rule to this, but as you will be taking measurements from all angles it is advisable to practise variations until you find the hold you most prefer.

MEASURING TECHNIQUE

First put your hand out with your arm straight – and keep it straight. When you are taking a measurement it is vital to take it from one fixed point or your measurements will not be consistent and your drawing will not be in proportion.

To prove this to yourself, look at the object and, with your arm outstretched, measure with your thumb and forefinger the size it appears to you at that distance. Then move your hand closer to your body,

keeping your thumb and forefinger in the same position. The size of the object gradually diminishes as your fingers come closer to your eyes.

Fix your gaze on one spot near what you want to be the centre of your drawing, such as the top of a jug, and make a mark on your paper to indicate this point. Now hold your arm outstretched and your pencil perpendicular to the floor. Keeping the top of the pencil on the point you first selected, measure the length of the object by moving

TIP

Keep switching your gaze between the object and the drawing to check for accuracy

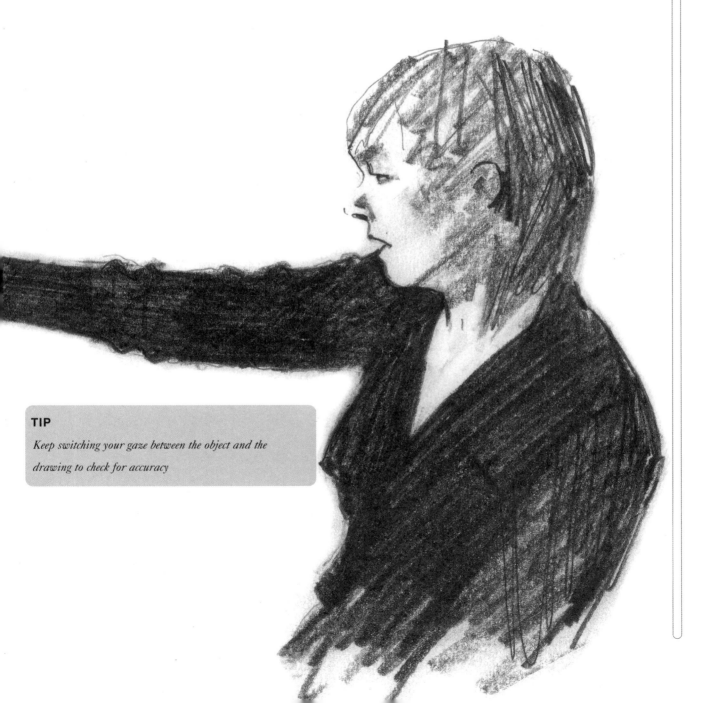

your finger or thumb along the pencil until it reaches the bottom of the object. Now move your pencil to the paper, putting the end of the pencil on the mark you have already made on the paper. Make a second mark where your finger or thumb is. The space between the two marks will be the sight-sized length of the object.

Just as important as accurate measuring is getting the angles right. Hold your pencil in line with the angle of the object you want to check, then move your pencil down to your paper and check whether your drawn line agrees with the angle your pencil is at.

Gradually build up the picture, taking measurements from different parts of the object. It is important not to rush; I cannot emphasize this too much. It is also important not to guess. You need to remember that you are trying to see in a different kind of way from the way you normally would. You are learning to see two-dimensional shapes.

SIGHT-SIZED MEASURED DRAWING
Brown vase

STEP 1
The more measurements you take to plot the shape, the less guesswork will be needed when you join your marks together.

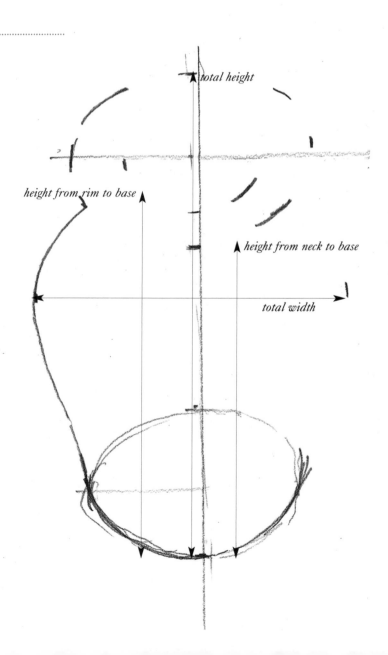

total height

height from rim to base

height from neck to base

total width

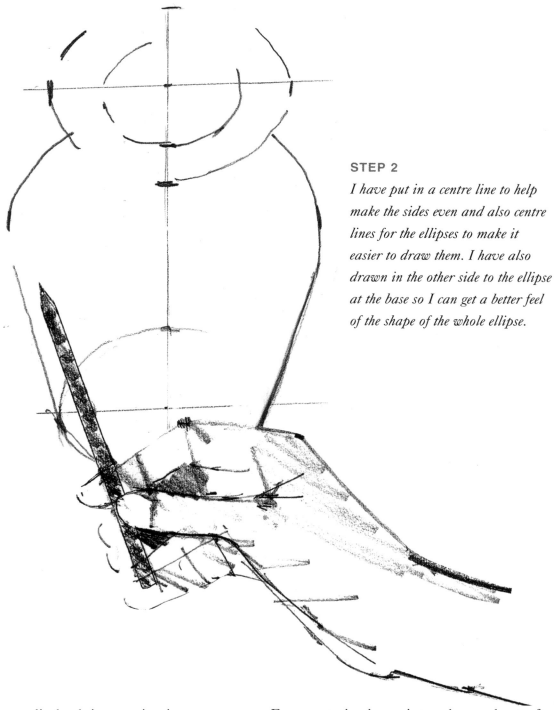

STEP 2

I have put in a centre line to help make the sides even and also centre lines for the ellipses to make it easier to draw them. I have also drawn in the other side to the ellipse at the base so I can get a better feel of the shape of the whole ellipse.

It is easy to slip back into seeing in a conceptual way, but the nature of the objects you are drawing is of secondary importance at this stage; what is important is seeing their shapes and reproducing them.

Even spaces between objects have two-dimensional shapes. Known as negative spaces, these should not be seen as less important than the shapes of the objects.

From a static viewpoint and on a sheet of paper they are all interrelated. If both the shapes of the objects and the shapes in between are in the right relationship to each other, the whole picture will have the right relationship.

At this stage do not worry about the tone – the lights and darks of the object. Just try to get the basic shapes right.

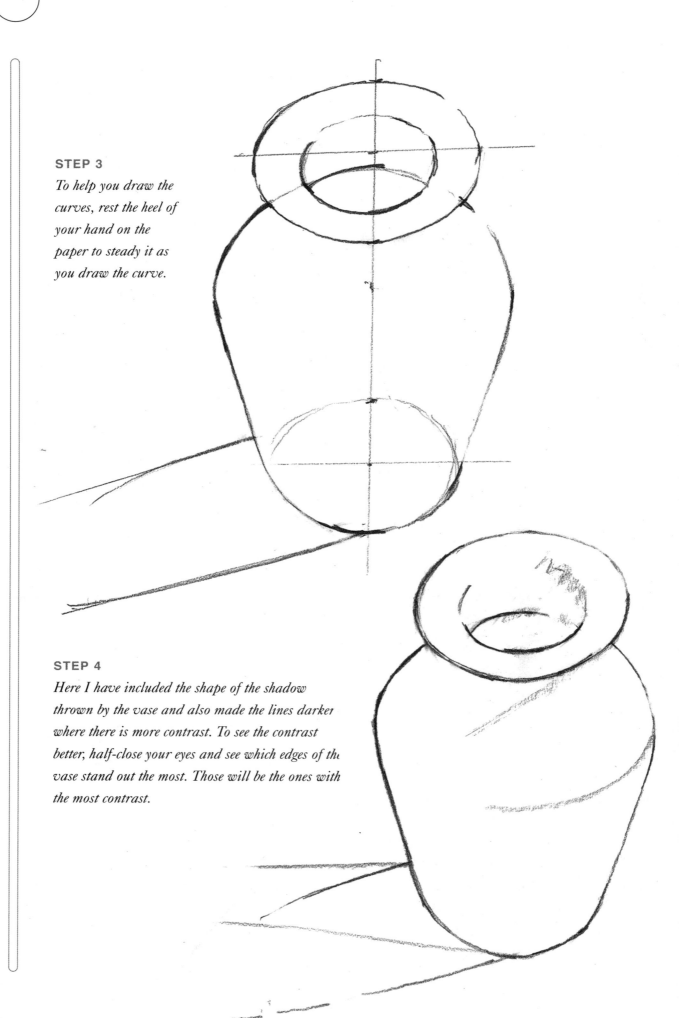

STEP 3

To help you draw the curves, rest the heel of your hand on the paper to steady it as you draw the curve.

STEP 4

Here I have included the shape of the shadow thrown by the vase and also made the lines darker where there is more contrast. To see the contrast better, half-close your eyes and see which edges of the vase stand out the most. Those will be the ones with the most contrast.

Exercise: Group of Objects

Next let's try drawing a number of objects. I suggest you use fruit such as apples, pears, bananas, oranges – whatever you have in the house. Do not have more than six or seven objects to start with. Place them against a plain background.

Once again, before you start make sure you are comfortable and that you can see the objects and your drawing without too much turning of your head.

When drawing a group of objects it is best to plot the whole picture out rather than starting with one object and then moving on to the next. This is because it is very easy to get the whole picture out of proportion if you go from one object to the next.

EXERCISE 1:

Summer fruits

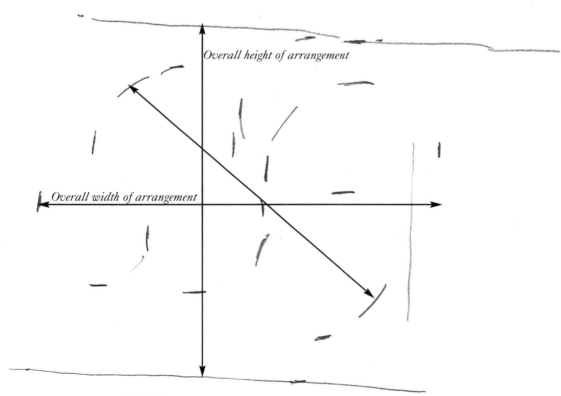

STEP 1

Measure and plot the overall size of the group of objects. Check angles by moving the edge of your pencil in line with the angle of the object and then move it down to your paper.

Start by measuring the overall width of the group of objects and the overall height. Then, using the same method of measuring with your pencil as before, plot the individual objects in relation to one another within the overall picture.

To start with, look for the basic shapes of each object. Do not worry about making them look three-dimensional. The important thing at this stage is to get the shapes and their proportion in relation to the other objects right first.

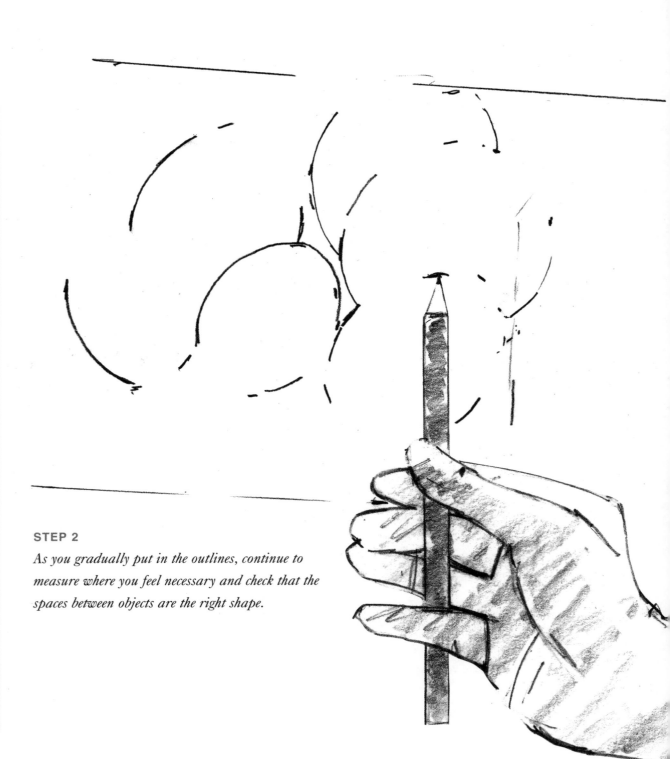

STEP 2

As you gradually put in the outlines, continue to measure where you feel necessary and check that the spaces between objects are the right shape.

STEP 3

Once you have completed the basic shapes, erase unnecessary construction lines. Look at those lines that have the strongest contrast and make those darker.

STEP 4

I have used a ruler here to indicate the edges of the card the fruit was on. Rulers should be used sparingly as most lines in nature are not straight.

LINE AND SHAPE

The line you draw around an object – the outline – is used to describe the shape of the object and to separate it from other objects in the drawing. However, if you look carefully, you will note that objects do not have lines round them; what actually shows their difference from other objects is their colour and tone (light and dark). If you look very carefully there may even be places where the colours and tones between two objects are so close they blend into each other.

So when we are drawing the outlines of objects we are drawing their basic shapes. We are not at this stage trying to draw their form (volume). If, however, we look hard at the objects in front of us and try to make the darkness and lightness of the line round the objects relate to different contrasts between the objects and the background, the drawing will take on volume on its own account.

While we are still looking at line and shape, let us now take something a little more complex such as a flower.

Set up a simple group of leaves or flowers against a plain background. Keeping to the same method of drawing, first decide whether you want to draw part or the whole of the group of flowers.

USING A VIEWFINDER

Using a simple "viewfinder" will help you to decide what you want to draw. Cut a simple square or oblong in a stiff piece of paper or card. Do not make the hole too large – 5 × 5 cm (2 × 2 in) or 5 × 2.5 cm (2 × 1 in) is enough. Then move this viewfinder forwards, backwards and around the objects until you have the area of flowers or leaves you want to draw. If you do not have a viewfinder available, you can always use your hands to make a simple viewfinder.

stem has a clearly defined edge

tones merge into each other

LEFT

When looking at an object as complex as a group of flowers, notice how some groups of flower heads merge because they are the same tone and colour whereas others are quite distinct. Begin by drawing each merged groups as a single shape.

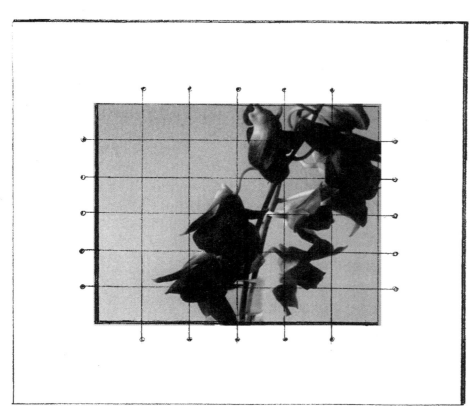

A strung cardboard viewfinder can help you see proportions and shapes better.

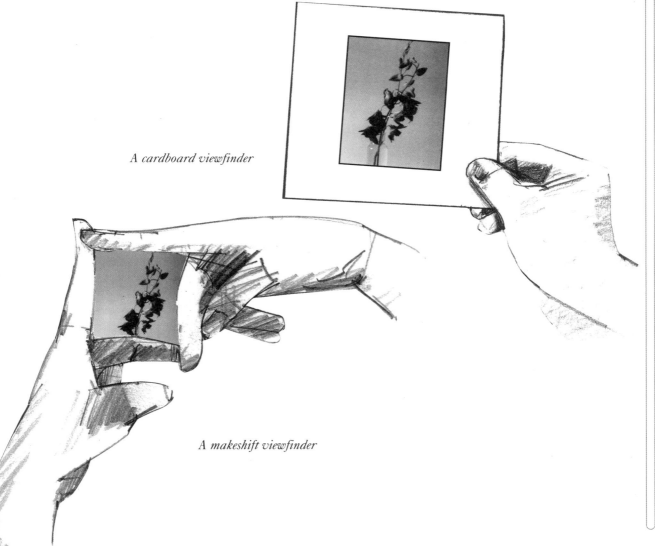

A cardboard viewfinder

A makeshift viewfinder

EXERCISE 2:
Orchids

STEP 1

Look for the overall size of the picture first and then the major shapes within this. Plot the basic outline of the objects, giving as much consideration to the shapes created by the spaces between them.

Width of orchid spray

Width of vase

> ### DON'T FORGET TO...
>
> ✏ *Check the angles by holding your pencil in line with the angle of the object then moving your pencil down to your paper to see whether your drawn line agrees with the angle that your pencil is at.*

STEP 2

The major larger shapes are gradually appearing. When drawing anything irregular it is important to get the right angles of the lines as well as their measurements.

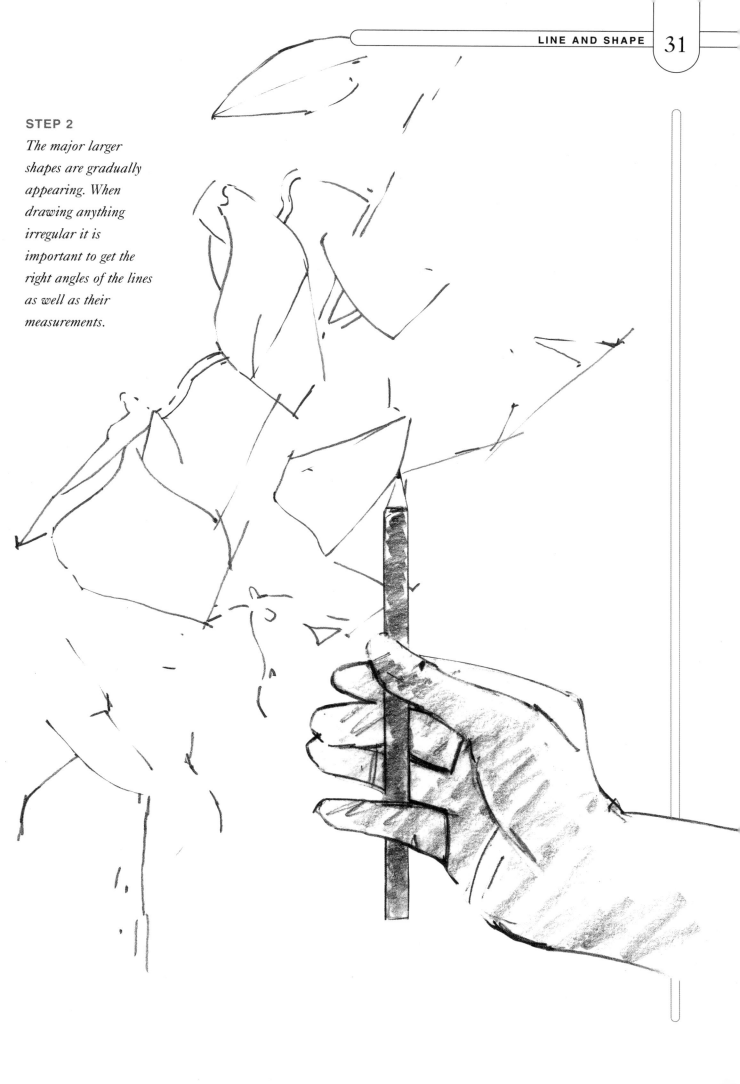

STEP 3

This final line drawing has the basic shapes but will need tone to give it a more three-dimensional appearance.

TIP

Remember to check the shapes between objects as well as the shapes of the objects themselves.

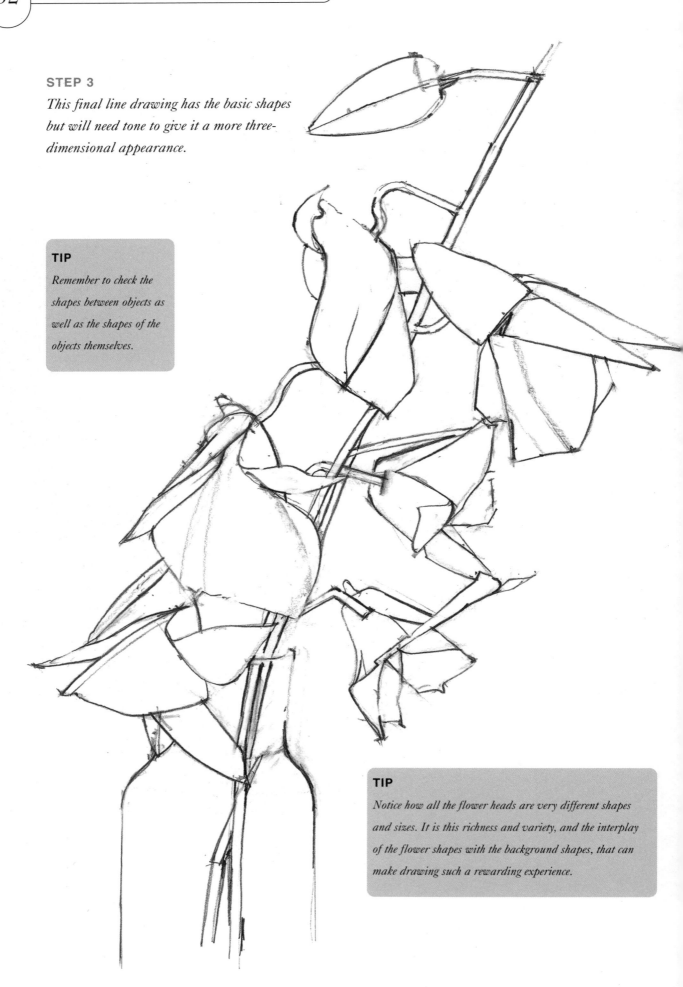

TIP

Notice how all the flower heads are very different shapes and sizes. It is this richness and variety, and the interplay of the flower shapes with the background shapes, that can make drawing such a rewarding experience.

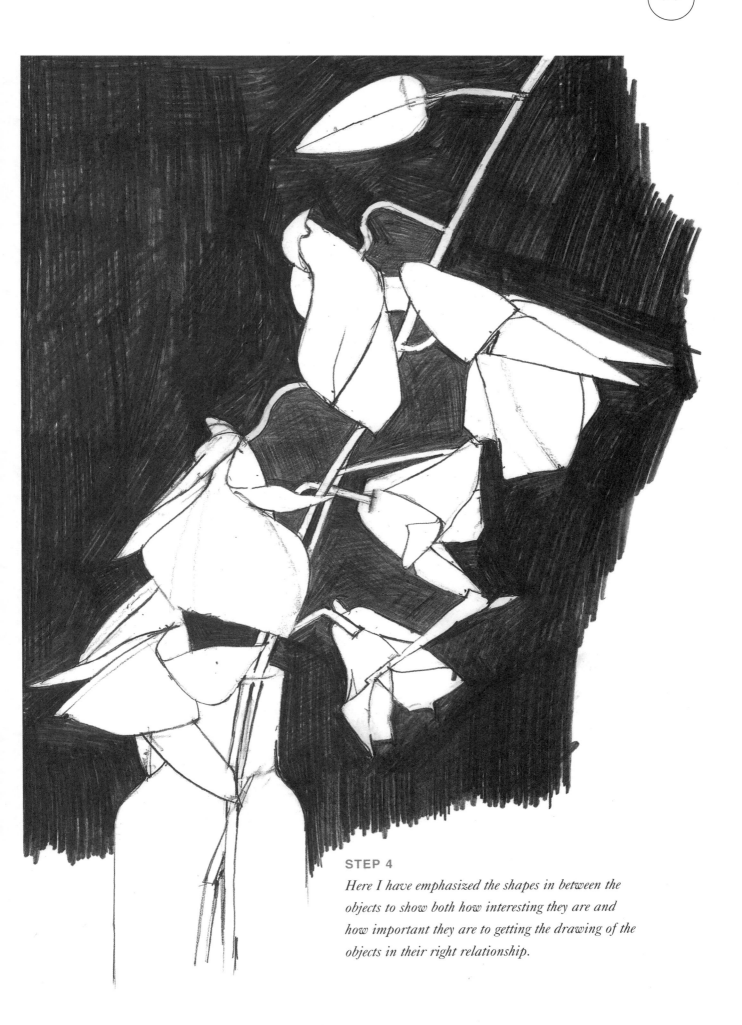

STEP 4

Here I have emphasized the shapes in between the objects to show both how interesting they are and how important they are to getting the drawing of the objects in their right relationship.

SECTION 3

Tone and Form

Creating a three-dimensional appearance on a two-dimensional surface is achieved by giving the appearance of volume. This is done by making use of the lights and darks that result from light falling upon objects. In between the lightest and darkest areas there will be a range of midtones. Observing tones and shading them in on your paper will make your objects look convincingly solid.

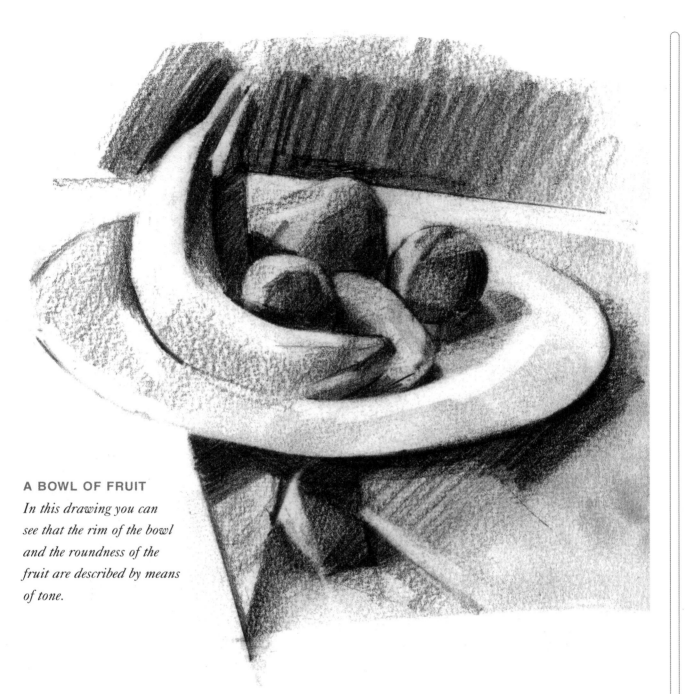

A BOWL OF FRUIT
*In this drawing you can
see that the rim of the bowl
and the roundness of the
fruit are described by means
of tone.*

Tone is used to give a shape (denoted by the outline of an object, and apparently flat) the appearance of having three dimensions (form or volume). For instance, a circle is a flat round shape whereas a sphere is a three-dimensional round form.

We are able to see objects because of the light reflected from them, whether this is derived from the sun or some artificial light source. The direction from which the light is coming determines what parts of the objects are light and what parts are dark, and also where the shadows cast by the objects fall.

When you are looking at a painting or even a photograph, make a habit of noticing

which direction the light is coming from. In many instances, especially in the case of interiors, it may be coming from more than one source (artificial or natural) and direction.

If there is only one light source, its identification is relatively simple. However, the matter becomes more complicated when there are several light sources striking the composition at different angles.

Using shading to create form requires you to look carefully at the relative light and darks on the object and its background and to note the darkest and lightest areas and the modulations in between. You will also need to practise varying the tones of the pencil marks on the paper so that you are able to create a variety of tones. The simple exercises shown here will help you in this respect.

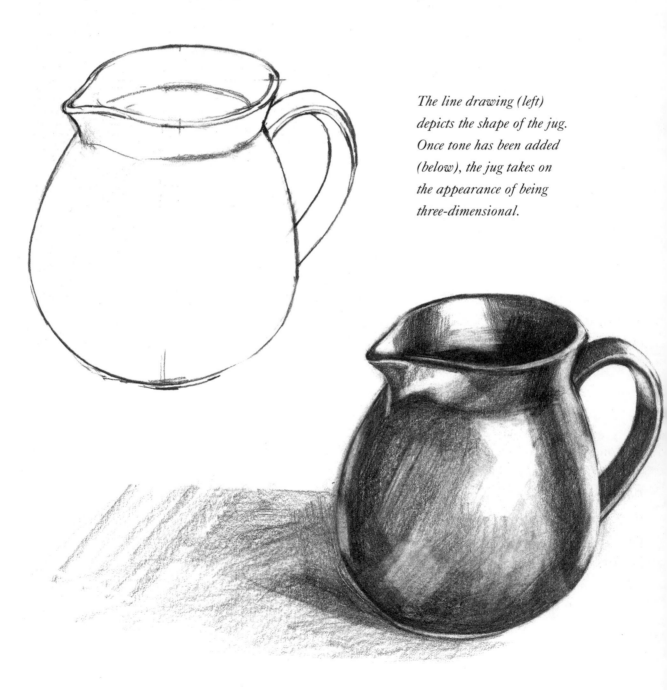

The line drawing (left) depicts the shape of the jug. Once tone has been added (below), the jug takes on the appearance of being three-dimensional.

EXERCISE 1: SHADING

First, draw six squares in a column. Using your B pencil, shade the last square in as dark as you can.

Then, leaving the first square blank, shade the remaining four squares from light to dark, trying to make four even steps in the gradation of tone (*Fig. 1*).

Next, using the same overall rectangular shape, try shading from one end to the other without the guidance of squares, graduating the tone as you go (*Fig 2*). You may find this difficult at first, but with a bit of practice you will soon get the hang of it.

TIP

When you are putting in the shading, especially if you are graduating the tone over a large area, it is helpful to sharpen your pencil to a long point and use the side of the lead rather than the point to put in the tone.

Fig.1

Fig.2

6

5

4

3

2

1

EXERCISE 2: SPHERES

Next, draw three circles, using a round object such a glass or a cup as a guide.

In the first circle, assume the light is coming from above and to the left. Shade the circle, making the area that gets the least light the darkest and the area on which the light falls the lightest. Gradually shade the area in between, moving gradually from the dark to the light.

The circle should now look as if it has volume – like a sphere or a ball. Thus you have moved from the circle having the appearance of a flat shape to its having volume or form.

Repeat this, with the light coming from a different direction.

With the third circle, assume the light is coming from two sources at opposite directions to each other.

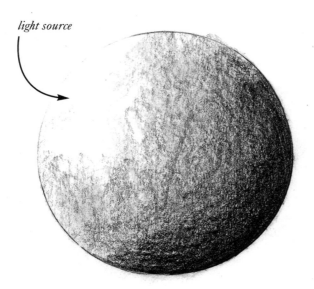

light source

The light is coming from above and to the left of the sphere, so the darkest area is at the bottom right.

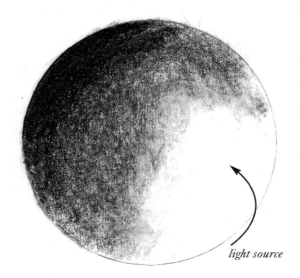

light source

The light is coming up from the right of the sphere, so the darkest area is at the top left.

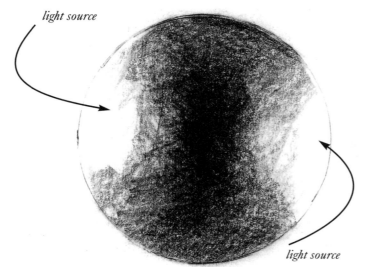

light source

light source

Here there are two light sources – one on the right and the other on the left. The darkest area is in the middle, furthest away from each source of light.

A SMALL VASE

Now take a simple vase or jug. As before, put it against a plain background.

Start as you would a line drawing – measuring and plotting the general shape of the object – then half-close your eyes and see where the lightest and darkest areas are.

In the example, I have used the vase on which I worked in the line-drawing

exercise, as the first stages are the same as shown there.

First, put in the midtones of the picture, Then look for the really darkest bits in the picture and make them as dark as your pencil will allow.

EXERCISE 3
Shading a vase

STEP 1

After you have measured and plotted in the basic shape of the vase, as you did in the exercise on line drawing, look at the object and its areas of light and dark – half-closing your eyes will make it easier to see tone rather than colour. Note where the light is coming from. Begin by putting in a midtone and leave the lighter areas blank for the moment.

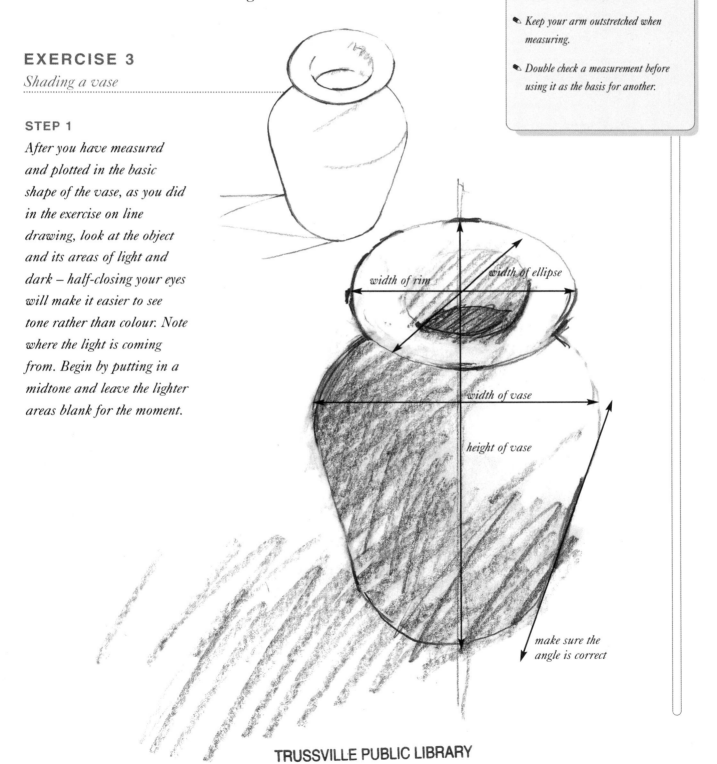

width of rim

width of ellipse

width of vase

height of vase

make sure the angle is correct

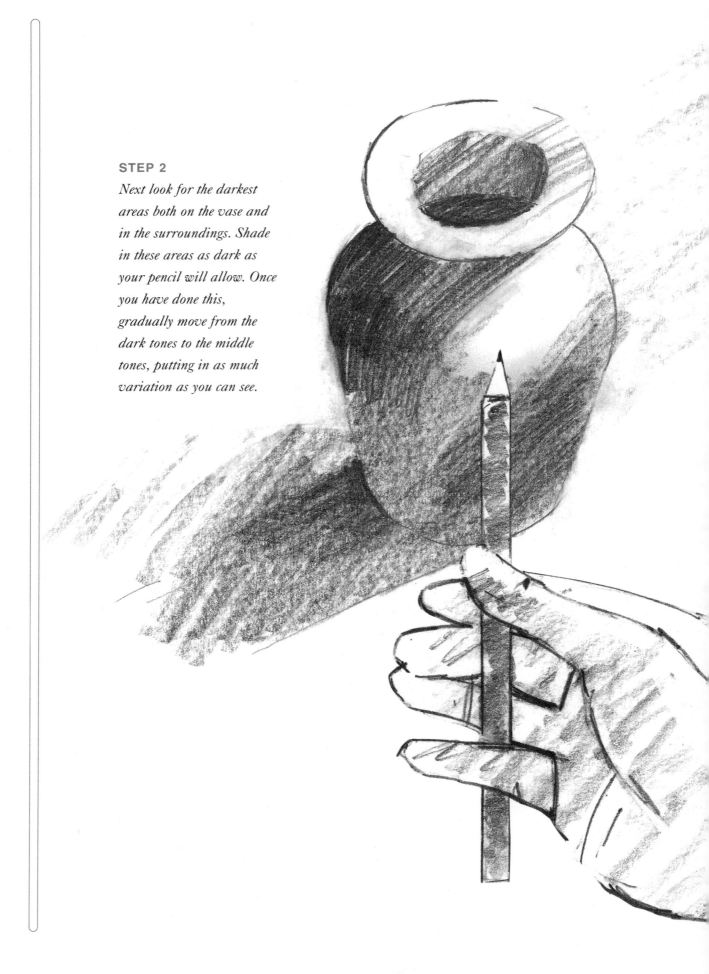

STEP 2

Next look for the darkest areas both on the vase and in the surroundings. Shade in these areas as dark as your pencil will allow. Once you have done this, gradually move from the dark tones to the middle tones, putting in as much variation as you can see.

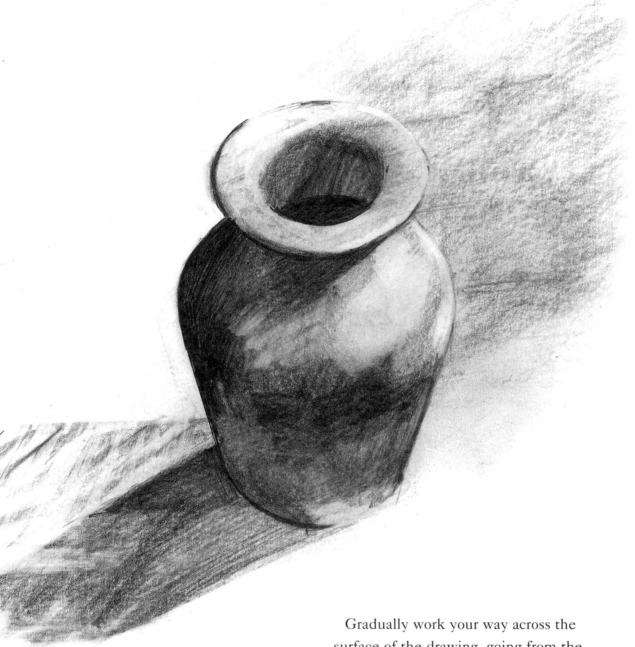

STEP 3

The closer you look at the tones, the wider the range you will start to see. You will also realize that in nature forms are not defined by lines.

Gradually work your way across the surface of the drawing, going from the darkest to the lightest tones. If you find you have made an area darker than it should be, just use your eraser to correct your mistake.

Do not hurry this process. The more you study the variation of tones, the more aware of them you will become.

When you have finished with your jug or vase, try another rounded object such as a lemon or an orange to get a bit more practice before you move on to something a little more ambitious: a group of objects.

GROUPS OF OBJECTS

Now we are going to look at using a group of five or six objects in a composition. Fruit is always a good subject for early work with groups as it does not have the problems regarding ellipses that jugs or bottles will present you with.

Again, start by plotting the overall size of the whole group and move from the larger areas to the smaller. Remember to keep your arm straight when measuring.

In my example, I have used the group of fruit I started in the line-drawing exercise as the first stages are the same.

EXERCISE 4

Shading a group of fruit

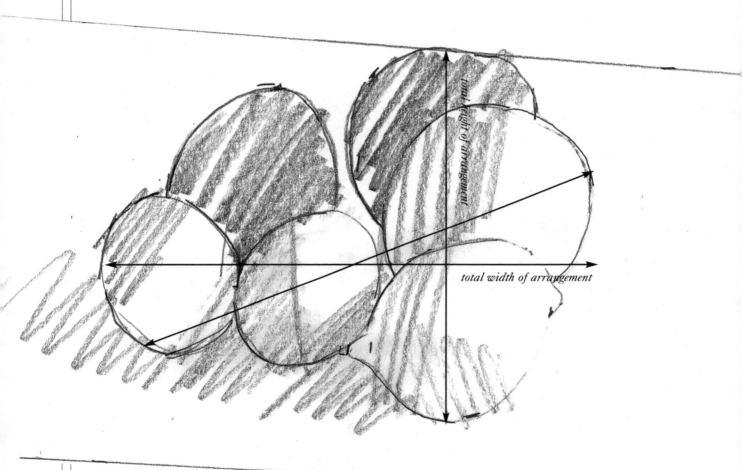

total height of arrangement

total width of arrangement

STEP 1

The middle tones have to take account of the different colours of the objects as well as the light falling on them.

As with the single objects, look for the darker areas of the drawing and put in the general midtone. Then look for the darkest tones and make those as dark as your pencil will allow. Now, gradually work over the whole drawing from the darkest areas to the midtone and then from the midtone to the lightest areas.

Remember that the more you look at the differences in tone of the different objects and their background the more you will be training yourself to see. It is this seeing that makes the drawing.

The next step is to take something a little more complex such as a variety of objects – bottles, fruit, jugs or anything else that you like the shapes of.

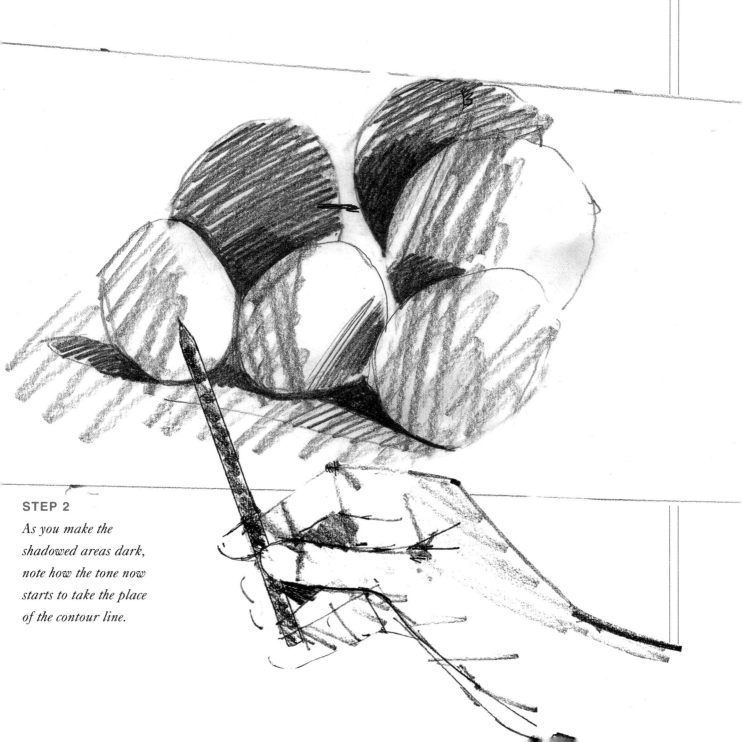

STEP 2

As you make the shadowed areas dark, note how the tone now starts to take the place of the contour line.

TIP

Keep in mind the direction the light is coming from.

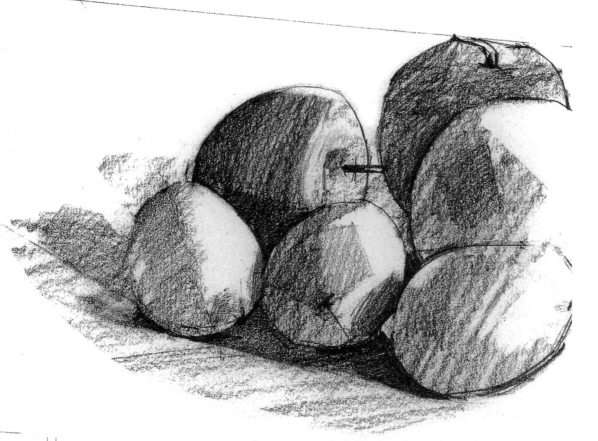

STEP 3

As you introduce more subtle tones you can use your eraser to help define the shape of the lighter areas.

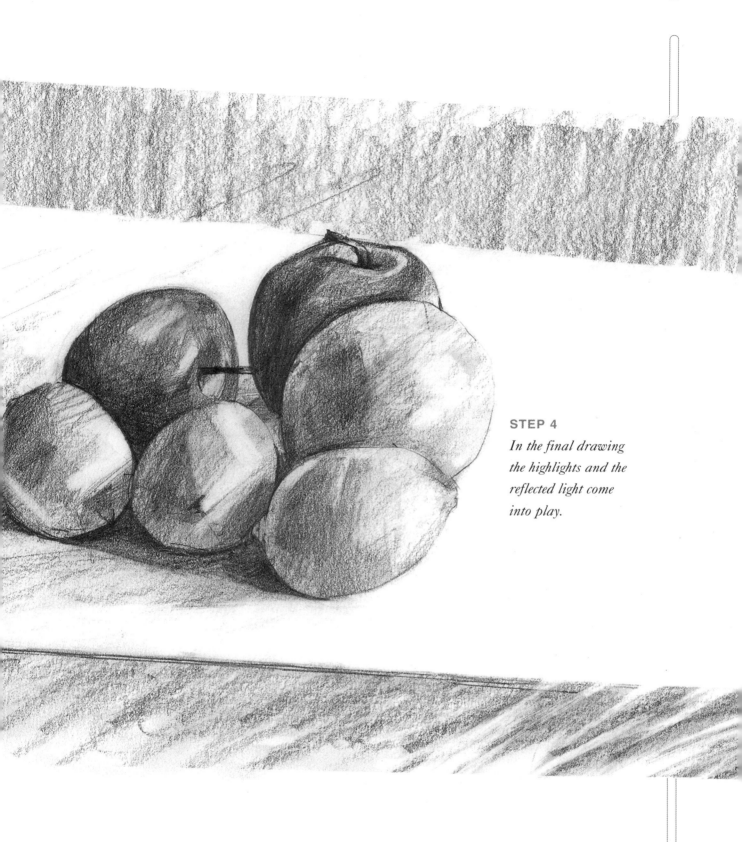

STEP 4

In the final drawing the highlights and the reflected light come into play.

EXERCISE 5
Drawing a variety of objects

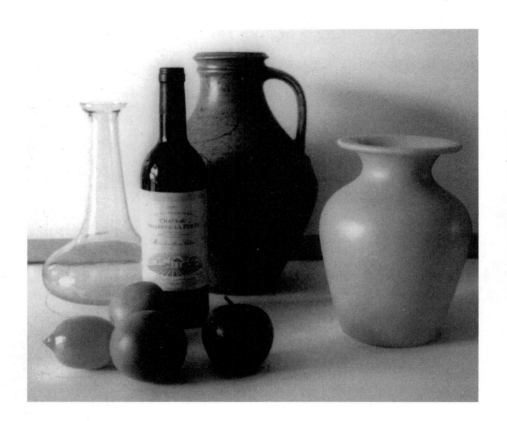

TIP
In case you can't finish your drawing in one sitting, mark the position of the objects with light pencil marks or tape. If they are moved it will make it easy to put them back in the right place.

STEP 1

This drawing of the basic shapes has gone through the same preliminary stages of measuring and plotting that has been described before.

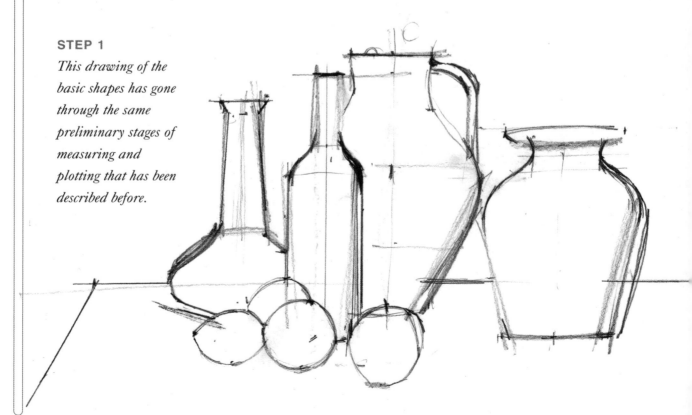

STEP 2

Once you have the basic shapes you can move to putting in tone. It is helpful to half-close your eyes so you can see the lightest and darkest areas more clearly. Even at this stage you should continue to measure and plot the size and relationship of the objects and the shapes in between.

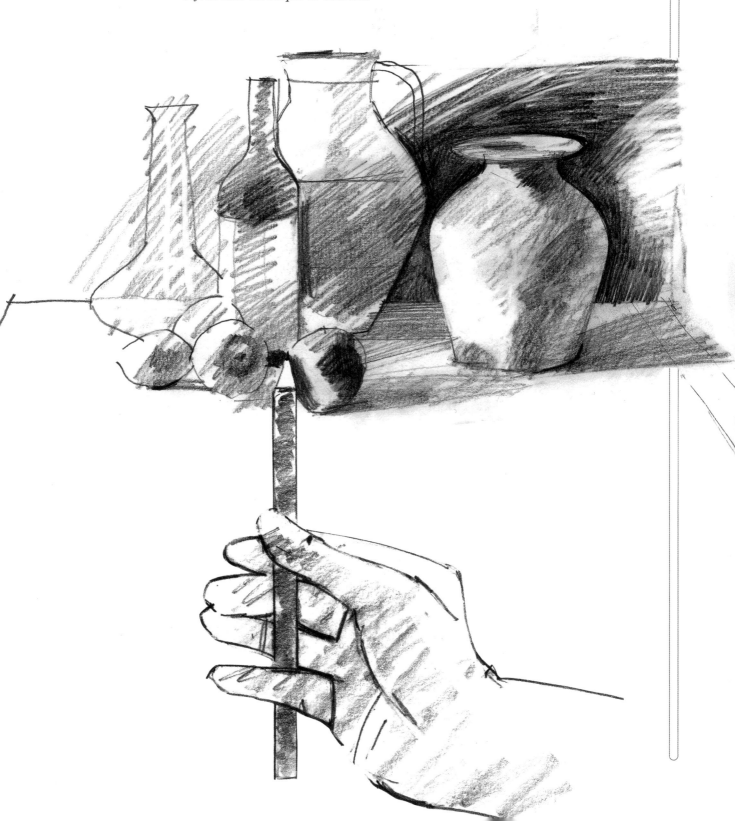

STEP 3

*I have left one side of
the drawing at an
earlier stage to show
the contrast between the
finished drawing and
the start.*

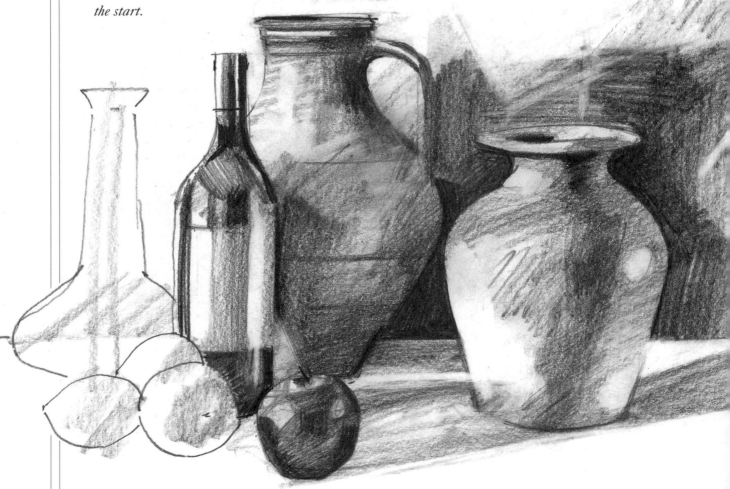

SECTION 4

Figures

In earlier times, before students in art academies were allowed to draw the live figure, they had first to practise on "the antique". This was a term used for plaster models of sculptures taken from classical Greek and Roman originals. These were often large figures of idealized heroes, gods and goddesses that familiarized the students with accepted notions of classical beauty.

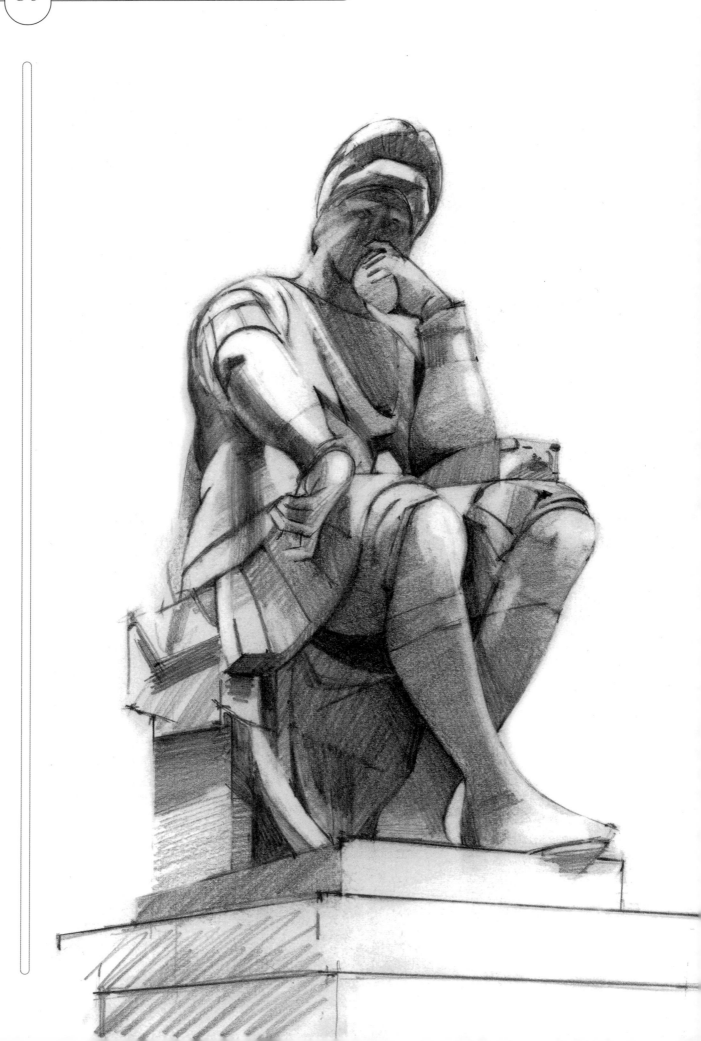

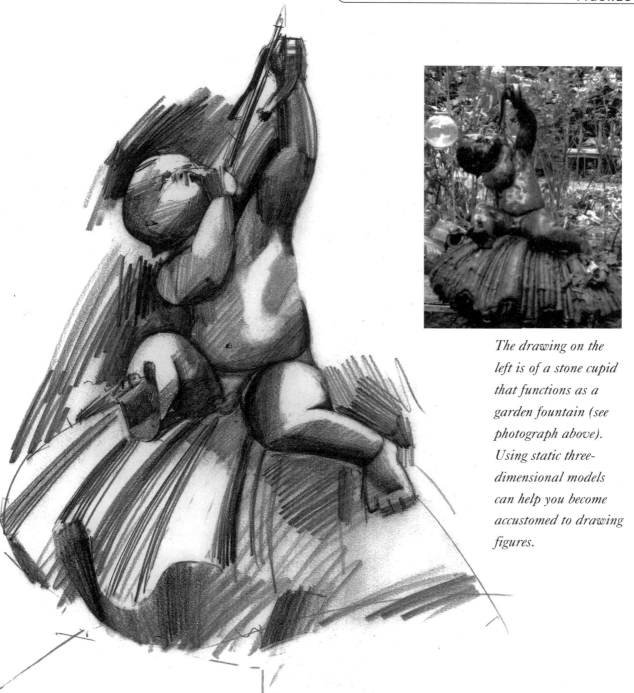

The drawing on the left is of a stone cupid that functions as a garden fountain (see photograph above). Using static three-dimensional models can help you become accustomed to drawing figures.

One advantage of drawing from antique figures was that they were static and, in the main, white. This made it easier to see the differences in tone when drawing the form, without the sometimes confusing complication of colour.

However, I do not want you to look upon drawing the figure as anything different from drawing the still lifes that we have been doing. So, to bridge the gap from still life to figure, I suggest you start by using a doll or a teddy bear or any other objects you have around the house that have the characteristics of a figure. Even a garden gnome would do to start with.

OPPOSITE

Drawing taken from a plaster cast at the V & A Museum, London, of a figure from Michelangelo's Tomb of Lorenzo de' Medici *(1524–31).*

DRAWING A TEDDY BEAR

As with your previous drawings, place the object against a plain background and then measure and plot the basic shapes. Begin by plotting the overall size, then work from the larger shapes to the smaller ones.

Once you have plotted in the major basic shapes, look at the tone. Again look for the darkest areas and put those in and gradually move from darks to light.

Treat the head, arms, legs and so on as basic shapes. Then, as you start putting

Teddy bears are ideal to start with. Most of us have a teddy bear somewhere in the house.

Don't forget to...

- *Sit comfortably and hold the same position throughout your drawing.*
- *Keep your arm outstretched when measuring.*
- *Double check a measurement before using it as the basis for another.*

EXERCISE 1
Drawing a teddy bear

STEP 1
Using a simple viewfinder, cut from card or created by your fingers, will help you decide where you want to place your figure on the paper.

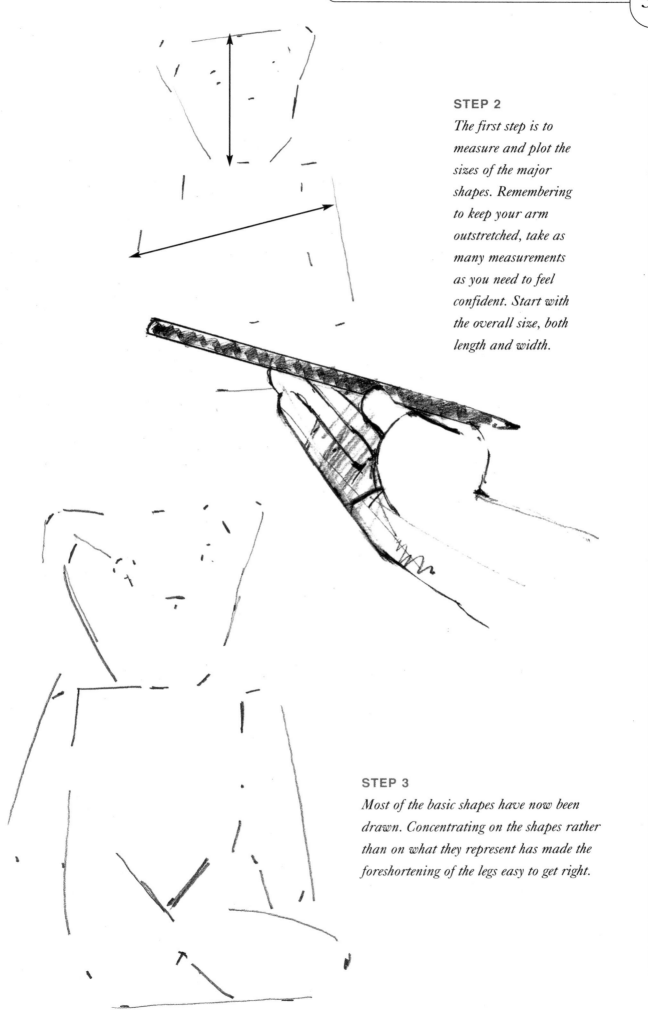

STEP 2

The first step is to measure and plot the sizes of the major shapes. Remembering to keep your arm outstretched, take as many measurements as you need to feel confident. Start with the overall size, both length and width.

STEP 3

Most of the basic shapes have now been drawn. Concentrating on the shapes rather than on what they represent has made the foreshortening of the legs easy to get right.

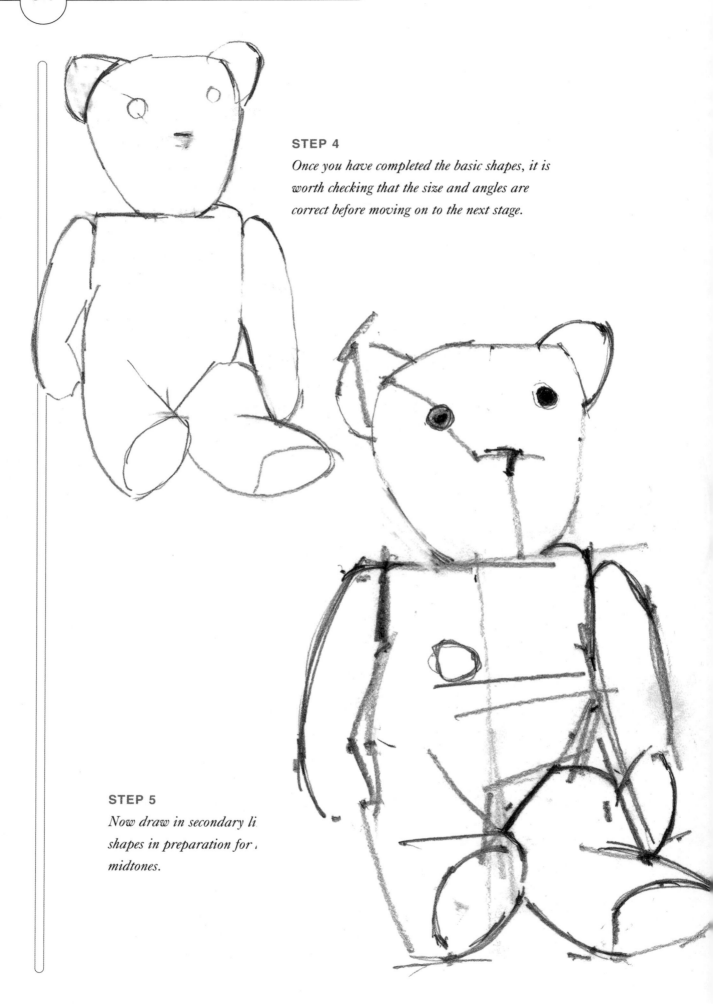

STEP 4

Once you have completed the basic shapes, it is worth checking that the size and angles are correct before moving on to the next stage.

STEP 5

Now draw in secondary li shapes in preparation for midtones.

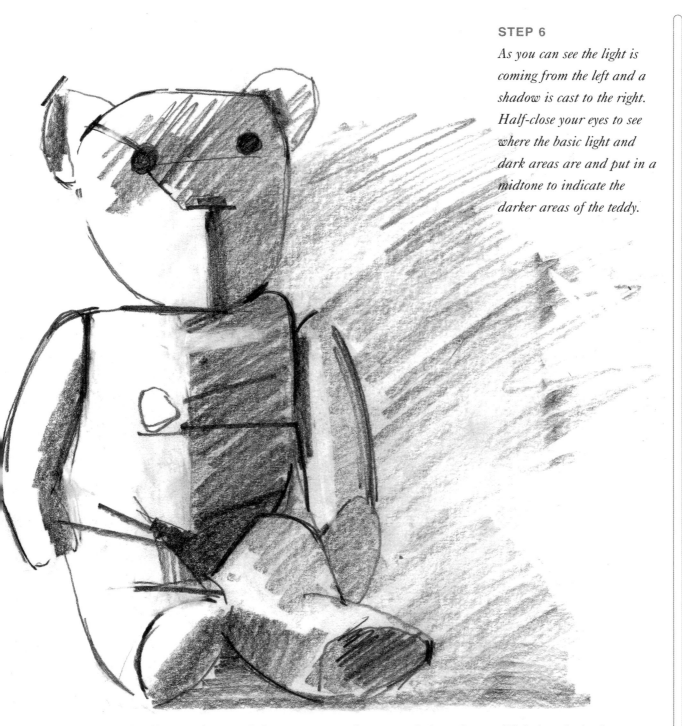

STEP 6

As you can see the light is coming from the left and a shadow is cast to the right. Half-close your eyes to see where the basic light and dark areas are and put in a midtone to indicate the darker areas of the teddy.

in the tone, gradually see them gaining volume and having form. Do not worry about such things as the character in the face; this will come as you build up the drawing. Take your time. It is better to have a half-completed drawing that is right than a completed one that is wrong.

Whatever you are drawing at this stage, concentrate on it as a collection of first shapes and then forms. This is relatively easy with jars and bottles but with figures becomes more difficult. The solution is to be able to see the shape of a form from a single viewpoint. Remember, three-dimensional forms change their shape every time we change our viewpoint, but in our minds they stay the same form that we know them to have in reality.

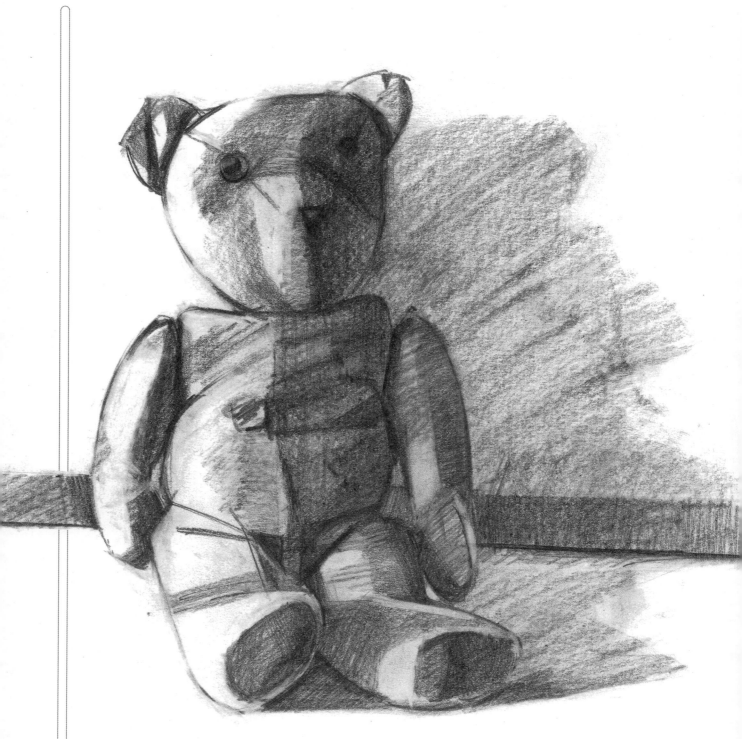

After the general midtones have been put in, turn to the darkest areas. Next shade the gradations between the light and midtones and the midtones and darkest tones. An eraser has been used here to highlight the lightest areas. The teddy bear now appears to have volume and form as well as shape.

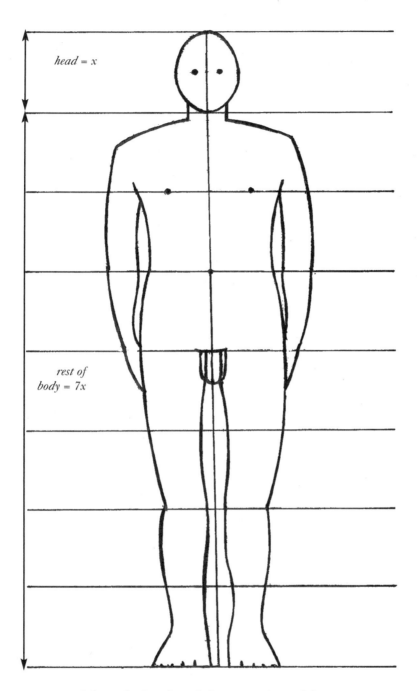

head = x

rest of
body = 7x

*Schematic drawing of the proportions of the
male figure*

THE HUMAN FIGURE

For this you need to find a friend who is prepared to pose for you. As your drawing will take more than one sitting to complete, you need to make the environment as simple as possible so that you can easily repeat it – for instance, a table and chair or an armchair against a plain background. As the first sitting will take between half an hour to an hour, bear in mind your model's comfort. Make sure that he or she can wear the same clothes for further sittings.

Adult figures – both male and female – have certain basic proportions that it is helpful to know.

First, the body is seven times the size of the head. Because we are more aware of the head of a person than any other part of their body, we tend to draw it bigger than it is. Check your measurements here.

Second, as you can see from the schematic drawings, the body can be divided into seven sections that are all the same length as the head by sectioning it across the nipples, the navel, the crotch, the mid-thigh, the knees and mid-calf.

Third, the measurement from the shoulder to the hip, from the hip to the

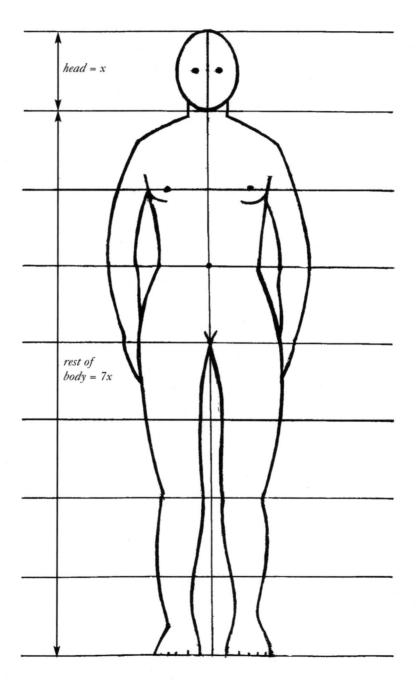

head = x

rest of body = 7x

Schematic drawing of the proportions of a female figure

knee and from the knee to the foot are about the same size.

However, these guidelines do not apply to babies and children, where the head is much bigger in relation to their bodies.

Throughout this book I am asking you to look at what shapes are like from a single viewpoint and to try to put your concepts of what objects look like in three dimensions out of your mind. When it comes to the human figure this is often the most difficult thing to do and students often fall into the trap of making heads too big and legs too short. A basic knowledge of the proportions of the human body can help to overcome these preconceptions.

TIP

When drawing the human figure, start by looking at it as a whole rather than as individual parts.

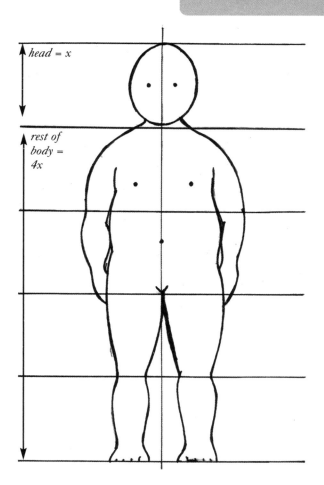

head = x

rest of body = 4x

Schematic drawing of the proportions of a three-year-old child

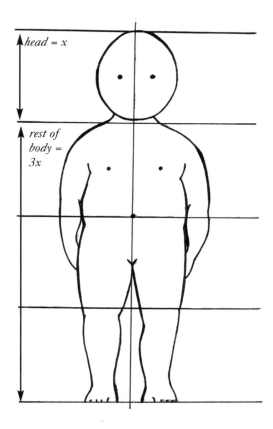

head = x

rest of body = 3x

Schematic drawing of the proportions of a one-year-old child

A SEATED FIGURE

Once you are sure your model is comfortable, make yourself comfortable also, some distance away from her or him.

If you want the drawing to fill the whole of the paper, measure how many pencil lengths the figure is and check this against the size of the paper. If the size of the figure is too small, move closer to the model. If it is too big for the paper, move further away.

Start as you have been doing up until now – plotting the overall size then the main shapes and angles of the head, shoulders, arms, torso and legs, as well as the immediate environment of a table, chair and so forth.

STEP 1

It is important to approach drawing a figure in exactly the same way as the objects you have already practised with. Measure and plot the overall structure and the main direction of the arms, legs and head.

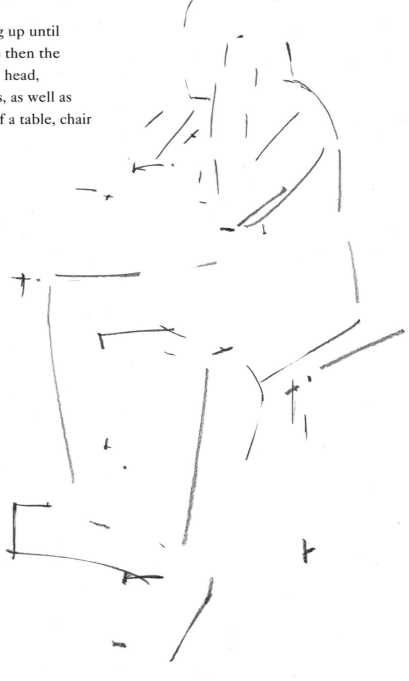

It is important you do not go into any detail too quickly, especially on the face. At this stage, what you should be looking at is the interrelationship of the shapes and the relative size.

Where you see complicated areas such as the face, hands and feet, always draw the basic larger shape first. Do not worry about the smaller shapes within it until later.

Now look at the steps shown here to see how to move forward. As this drawing will require a number of sittings, make sure you make a note of the position of any furniture you have included so that you are able to re-create the situation the next time your model is with you.

TIP

Before you start drawing make sure you are comfortable and that you can see the objects and your drawing without too much turning or movement of your head.

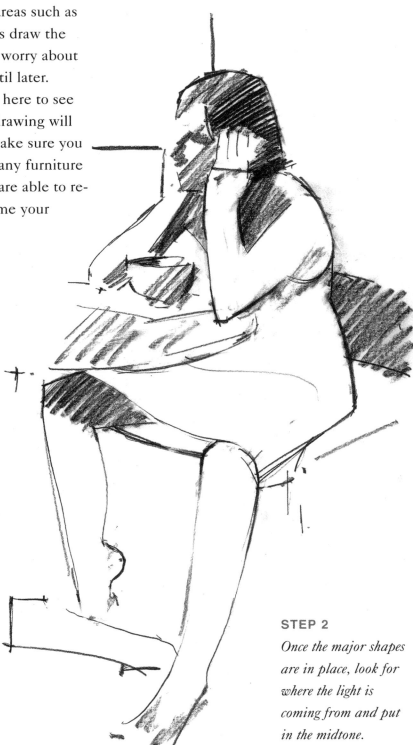

STEP 2

Once the major shapes are in place, look for where the light is coming from and put in the midtone.

STEP 3

*Half-close your eyes and look for the
major light and dark areas and start
putting these in. At this stage only look
at the size, shape and structure of the
face. It is important not to see the hands
and face as any more special than the
rest of the drawing.*

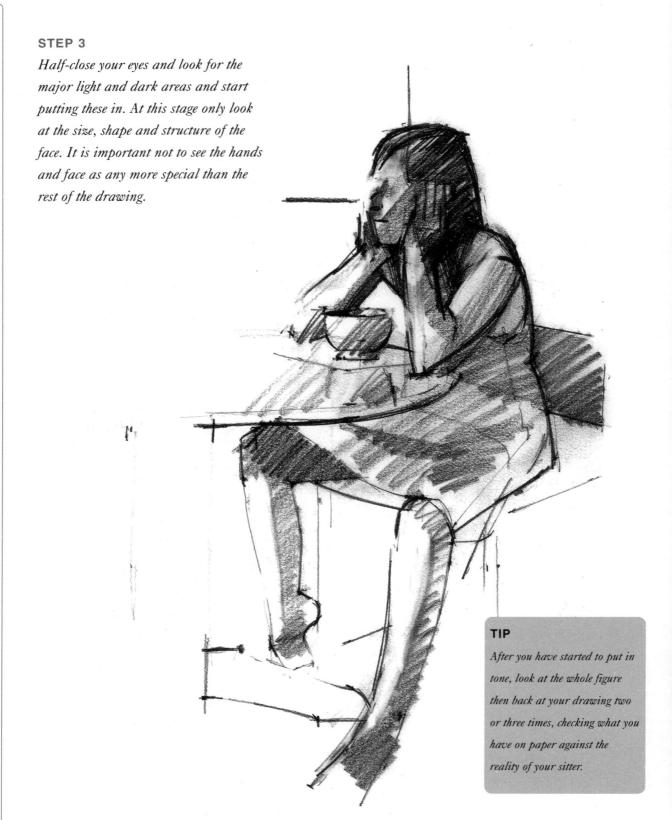

TIP

*After you have started to put in
tone, look at the whole figure
then back at your drawing two
or three times, checking what you
have on paper against the
reality of your sitter.*

STEP 4

Develop the tone, taking in the immediate environment. Particularly note any reflections, such as those of the bowl and arms in the shine on the table.

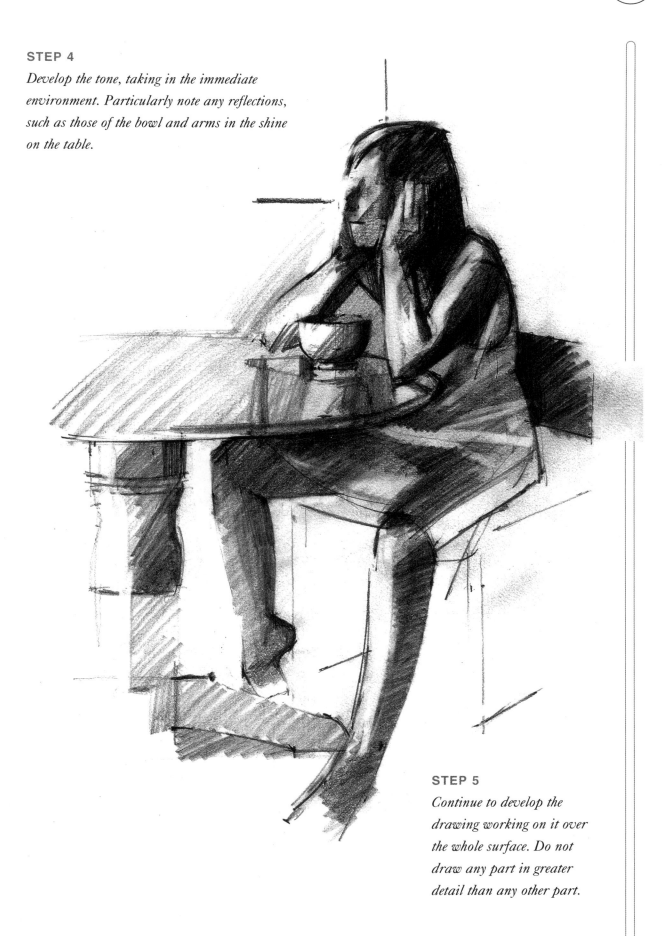

STEP 5

Continue to develop the drawing working on it over the whole surface. Do not draw any part in greater detail than any other part.

STEP 6

Continue to develop the drawing, working on it as a whole. Do not go into too much detail in any one part of it. Check constantly that the size relationships are right, that the figure looks as if it has weight, that the seated position is convincing and that the light is coming from a consistent direction.

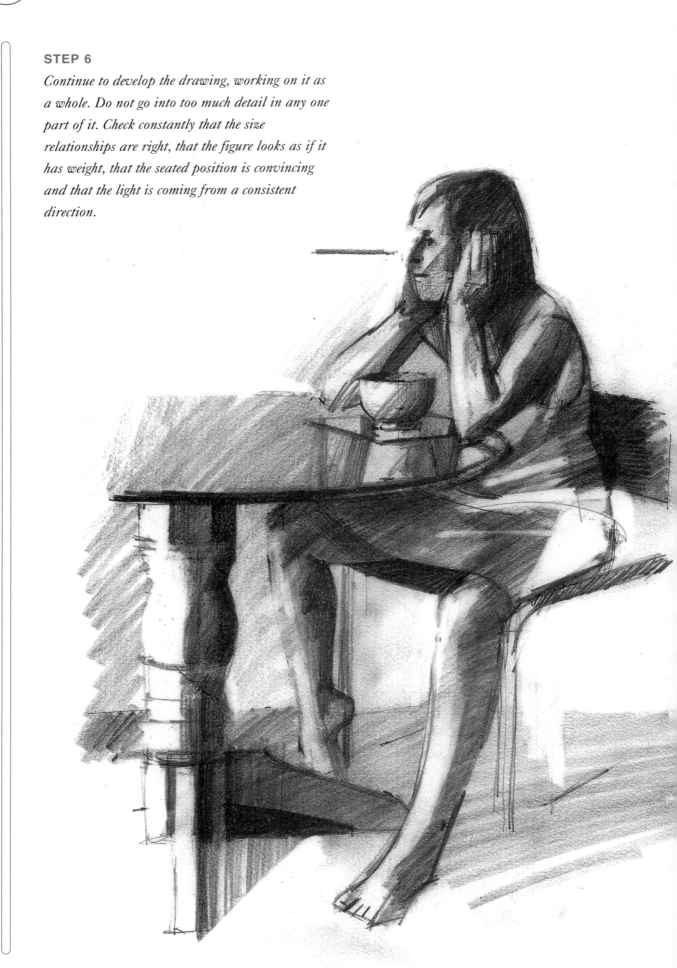

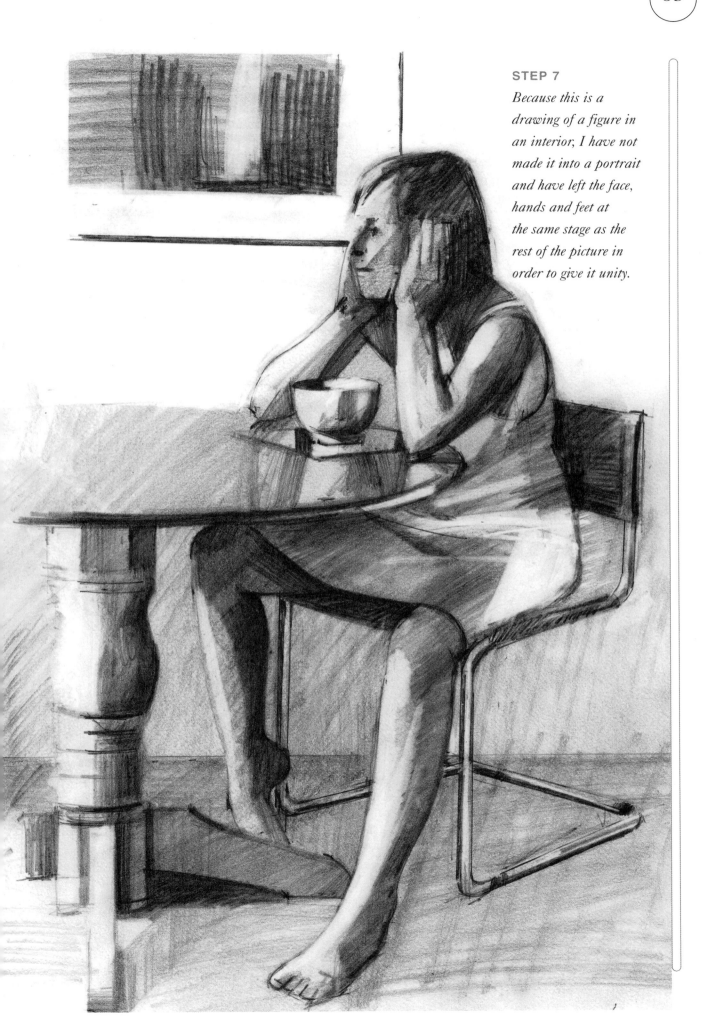

Because this is a drawing of a figure in an interior, I have not made it into a portrait and have left the face, hands and feet at the same stage as the rest of the picture in order to give it unity.

SECTION 5

Perspective

The rules of perspective provide a way of bringing the appearance of three dimensions to a two-dimensional drawing. A basic understanding of the key points of perspective will greatly enhance your ability to draw. You will be able to give the viewer the impression that some elements of the picture are closer while others recede into the distance, thus creating an illusion of reality.

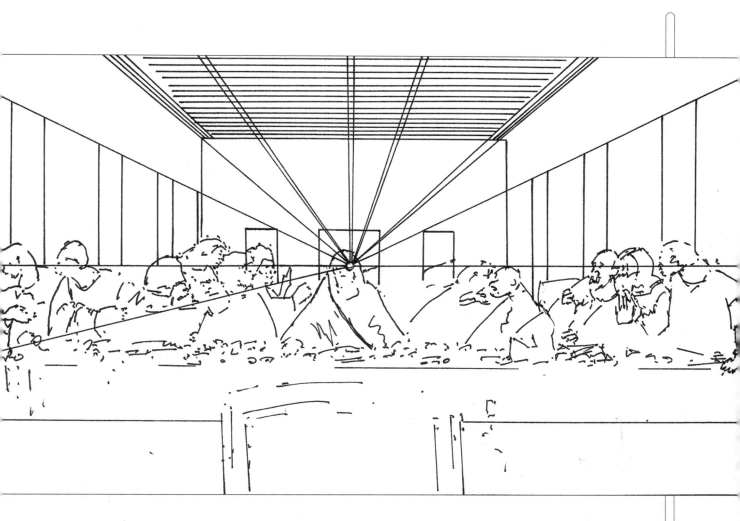

Although the rules governing perspective go as far back as the ancient Greeks, it was not until the Renaissance that they came into common use by such artists as Brunelleschi and Leonardo da Vinci.

Initially, you do not have to learn the more complicated theories that lie behind perspective. However, you do need to know that they are based on how things look to an individual at a fixed point. Therefore, they are not just theories – they are directly about you, as an artist, depicting a scene in such a way that it will also be recognized by the viewer standing in front of your work.

In this schematic drawing taken from Leonardo da Vinci's fresco The Last Supper *(1495–97) in the Convent of Santa Maria delle Grazie, Milan, I have put in the horizon line and extended the perspective lines in the room to show how they converge on the focal point – Christ's head.*

Basic principles

First, the horizon line is the imaginary line that marks where land appears to meet sky - or, in an interior, where land would meet sky if the walls weren't there. The horizon line is always at the eye level of the viewer, no matter whether they are standing up, sitting or lying down.

Second, objects appear smaller the further away from us they are. If we are in a landscape that is very flat and we can see the horizon, they will become so small they will disappear as they approach the horizon line. When we use perspective, we are thus giving objects the appearance that they are going into the picture rather than lying on the surface of the paper.

There are three types of perspective normally used in drawing. These are known as one-point, two-point and three-point perspective.

horizon line

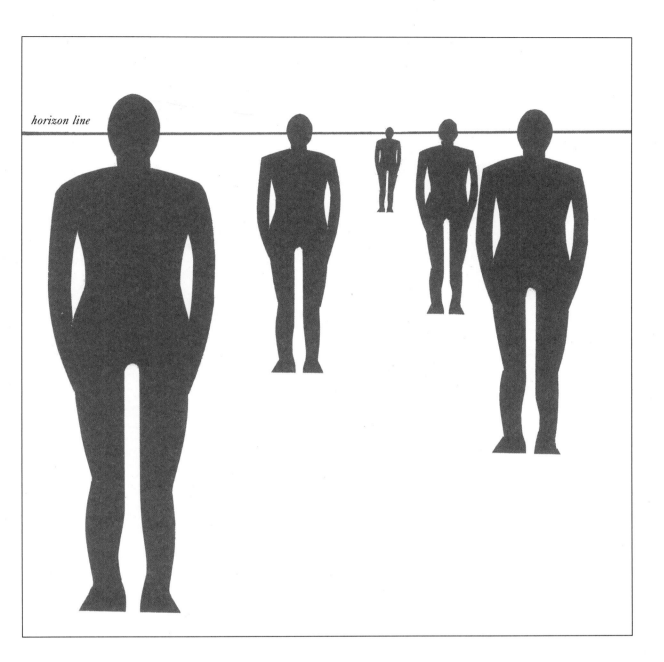

horizon line

LEFT

The horizon line is the line where the land appears to meet the sky. It is always at your eye level whether you are standing up, sitting or lying down.

ABOVE

Objects appear to diminish in size the further they recede from us. In this illustration the same figure is shown becoming ever smaller as he approaches the horizon line. Note that, because the figure used is on the same level as the observer, the eyes are always level with the horizon line.

ONE-POINT PERSPECTIVE

One-point perspective is used for those objects that stand parallel (flat-on) to you. The side planes of these objects converge at a fixed point in the centre of your vision and on the horizon line. This point is known as the focal point.

The sides of objects that are above the horizon line (eye level) move down towards a focal point and those sides of objects that are below the horizon move up towards the focal point.

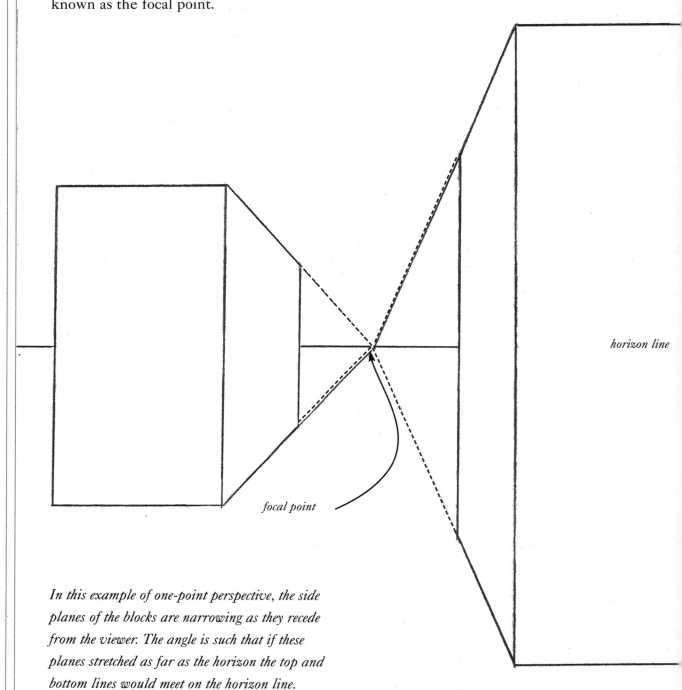

focal point

horizon line

In this example of one-point perspective, the side planes of the blocks are narrowing as they recede from the viewer. The angle is such that if these planes stretched as far as the horizon the top and bottom lines would meet on the horizon line.

EXERCISE 1:
One-point perspective

Even with quite complex arrangements, where objects are flat-on to you they all converge at a single focal point, which is in the centre of your vision on the horizon line.

Try this for yourself. Draw an imaginary landscape using flat shapes (squares or rectangles) as in the example below. Then draw in the lines converging on the focal point as in this picture. Do not put any objects over the focal point as you will not be able to see their sides, as they will be converging behind the flat shape.

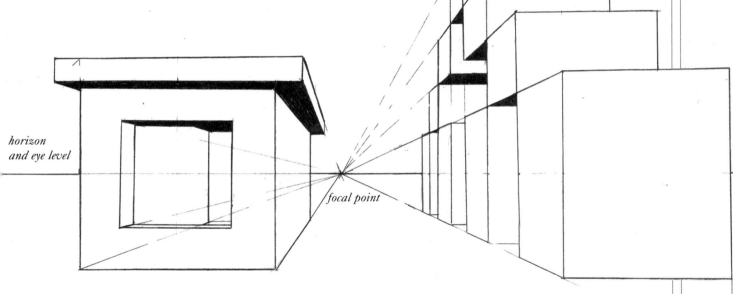

horizon and eye level

focal point

TIP

The principles of perspective work from only one viewpoint. If you move, you will change the horizon line, the focal point and the vanishing points.

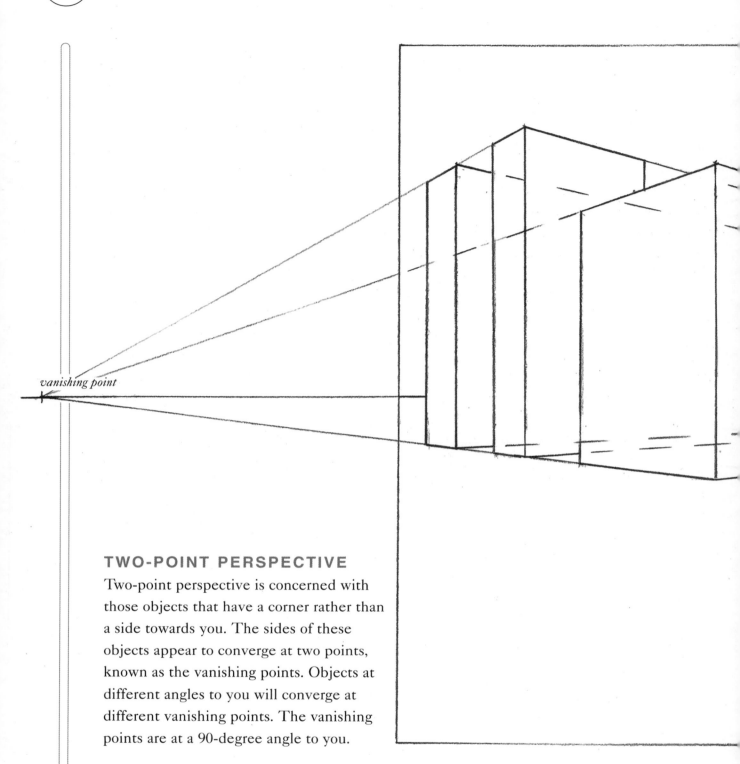

vanishing point

TWO-POINT PERSPECTIVE

Two-point perspective is concerned with those objects that have a corner rather than a side towards you. The sides of these objects appear to converge at two points, known as the vanishing points. Objects at different angles to you will converge at different vanishing points. The vanishing points are at a 90-degree angle to you.

vanishing point

EXERCISE 2

Two-point perspective

In *two-point perspective the sides of the objects that have their corners towards you seem to converge at two points on the horizon line. These two points are known as vanishing points and are at approximately 90 degrees to the viewer. They are often outside the boundaries of your picture. In this example the focal point is behind the first block and can only be imagined.*

As with the one-point perspective, try an imaginary landscape with, this time, the corners of objects towards you, as shown here.

Receding objects

When drawing objects such as railway tracks, fences, trees, tiled floors – in fact any line of evenly spaced objects – it is useful to know how objects recede in perspective.

Do not worry if you find this too daunting; you can come back to it later when you need it.

STEP 1

Draw in the horizontal line then, in the centre of this, mark your focal point. Mark the two vanishing points. Next, draw in a vertical line downwards from your focal point. Anywhere along this line, draw a line parallel with the horizontal line. It can be any length as long as it extends equally both sides of the centre line. Call this line AB. Then draw lines from A and B to each vanishing point and the focal point. Where lines to the vanishing points cross the lines to the focal point, draw a new line, CD. This construction will give you a square plane, or tile, in perspective.

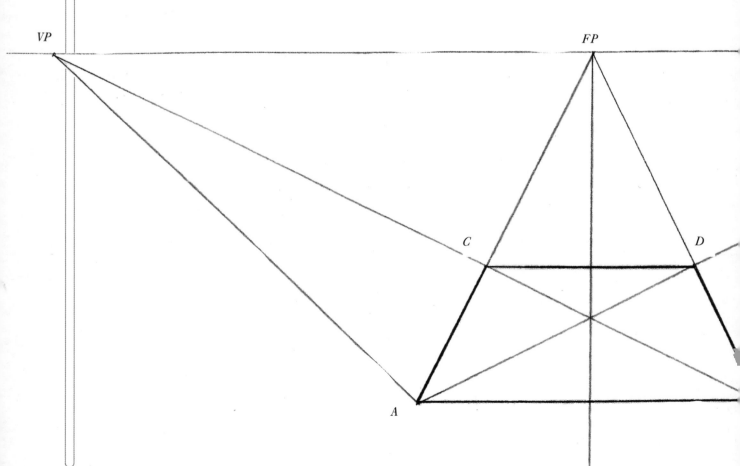

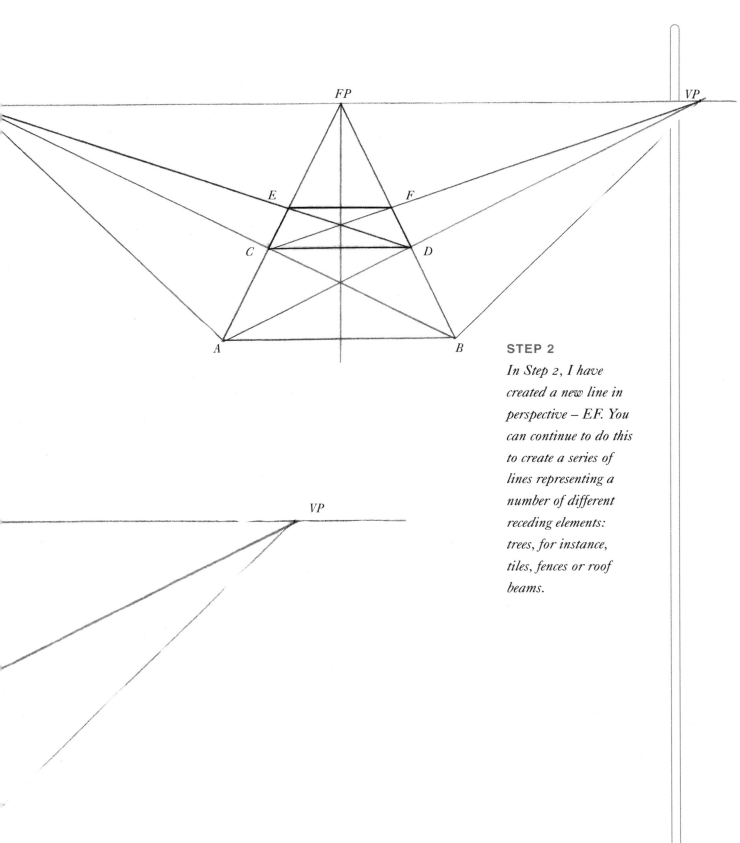

STEP 2

In Step 2, I have created a new line in perspective – EF. You can continue to do this to create a series of lines representing a number of different receding elements: trees, for instance, tiles, fences or roof beams.

STEP THREE

By continuing to draw further construction lines on the same basis as Steps 1 and 2, I have constructed the basic grid used when objects recede into the distance.

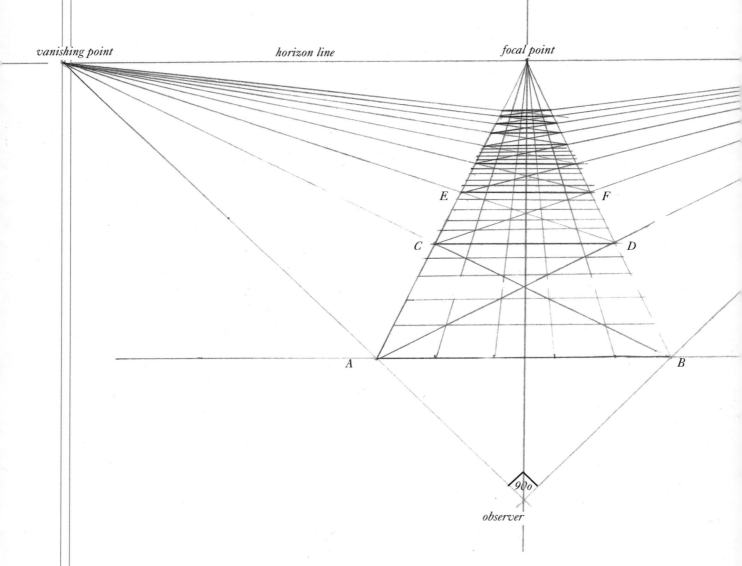

vanishing point　　　　　　　　　　horizon line　　　　　　　　　focal point

E　　　　F

C　　　　D

A　　　　　　　　　　　　　　　　　　B

90o

observer

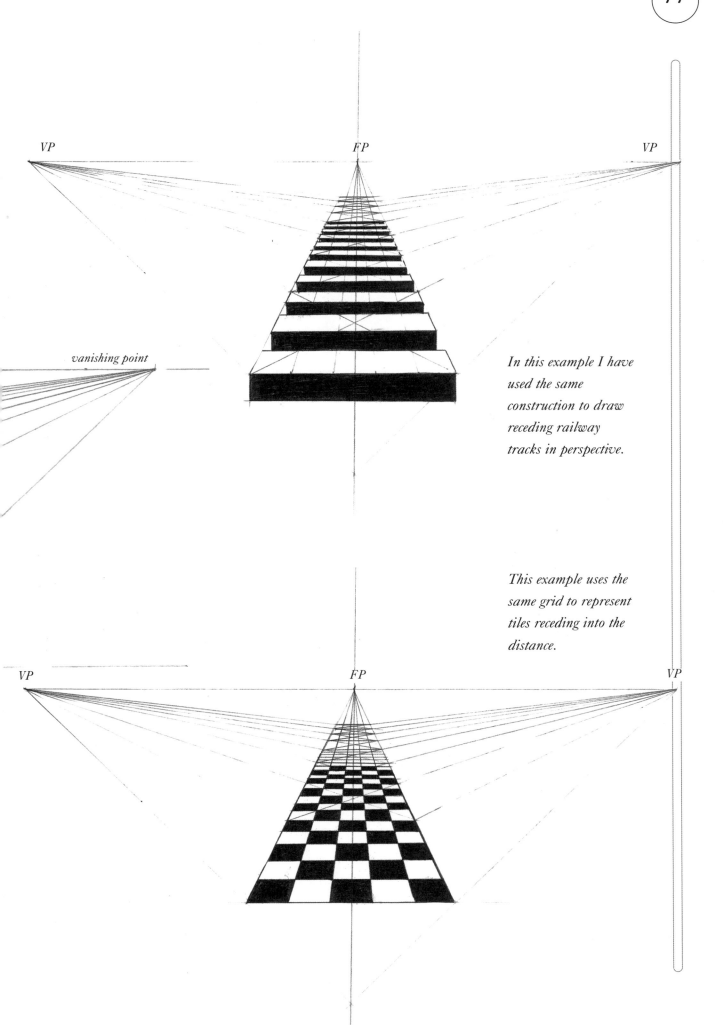

VP

FP

VP

vanishing point

In this example I have used the same construction to draw receding railway tracks in perspective.

This example uses the same grid to represent tiles receding into the distance.

VP

FP

VP

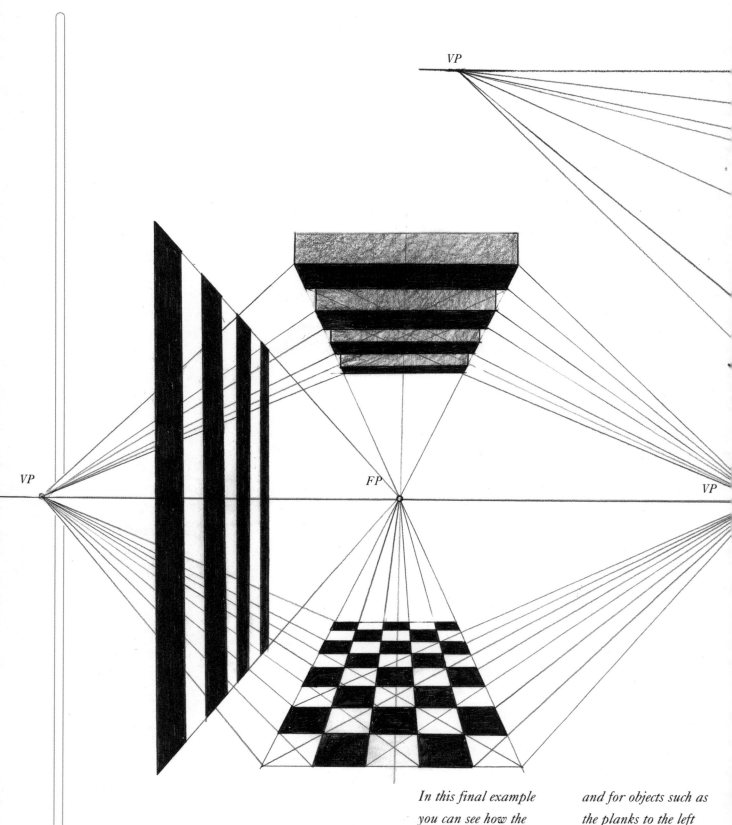

In this final example you can see how the same construction can be used for objects above the horizon line, such as beams, and for objects such as the planks to the left of the picture that go both above and below the horizon line.

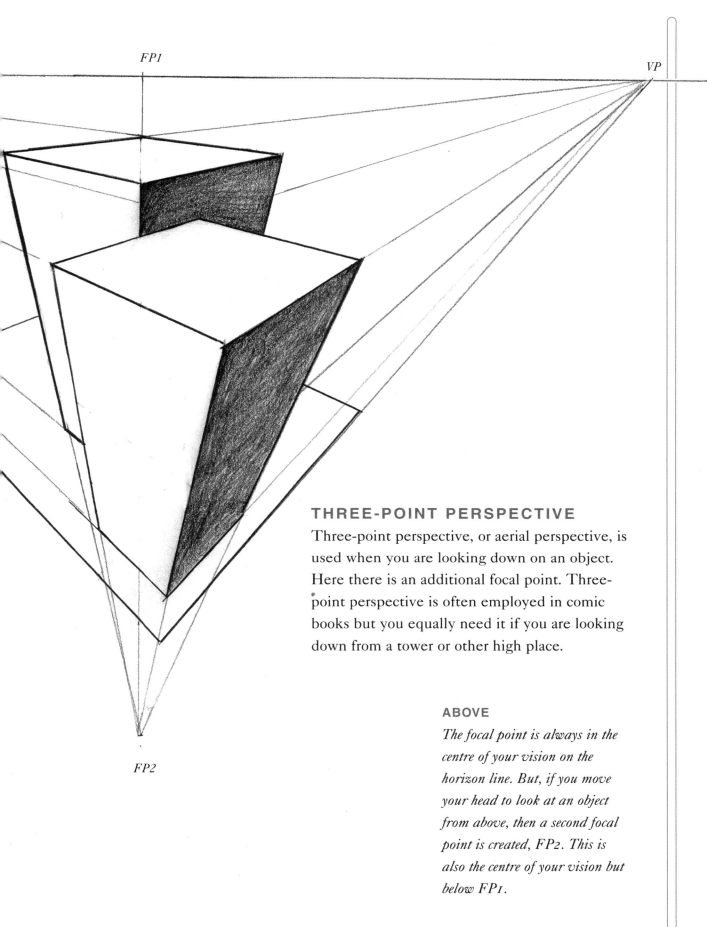

FP1

VP

FP2

THREE-POINT PERSPECTIVE

Three-point perspective, or aerial perspective, is used when you are looking down on an object. Here there is an additional focal point. Three-point perspective is often employed in comic books but you equally need it if you are looking down from a tower or other high place.

ABOVE

The focal point is always in the centre of your vision on the horizon line. But, if you move your head to look at an object from above, then a second focal point is created, FP2. This is also the centre of your vision but below FP1.

Using perspective in your drawing

While recognizing that there are some basic rules to perspective, you will also undoubtedly see that any particular scene or collection of objects will probably include objects at varying angles to you. If you tried to use two-point perspective on all of these, it would involve you having two different vanishing points every time the angle of an object changed in relation to you. This is where the simple rules I started with become more and more complicated, so I suggest you just keep in mind two basic ideas: the use of the focal point for objects parallel to you and the use of vanishing points for objects that have a corner facing you. Use the method of assessing the angles of the sides of objects with the pencil, as described previously in the book.

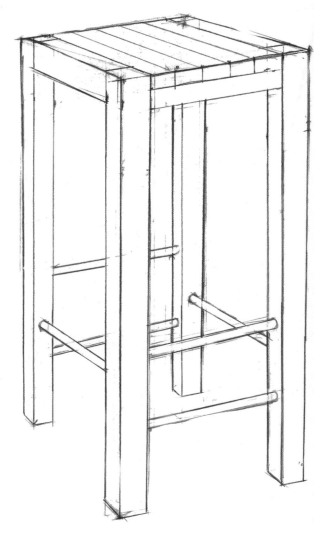

EXAMPLE 1

A stool in perspective

Take a simple object such as this stool and draw it as you have all the other drawings in this book, by measuring and plotting a sight-sized drawing.

To get the right angles, use your pencil to line up with each angle and then transfer the angle to the picture as you have done before. You will see that the points concerning perspective apply, but it is far more complex when you are drawing a real object.

DON'T FORGET TO...

● *Keep your arm outstretched when measuring.*

● *Double check a measurement before using it as the basis for another.*

TO FP

EXAMPLE 2:

*A stool in
perspective*

*This drawing is of the
same stool, but drawn
looking down on it.
Although its sides go to
vanishing points as we
have discussed, you
will notice that the
lines of its legs also
converge. As the object
is looked at from
above, three-point
perspective comes
into play.*

FP2

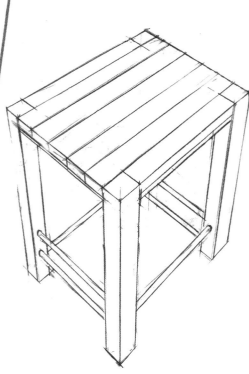

*In this drawing of a stool, because I am looking
down at it, there is three-point perspective.*

STREET SCENE

Now it is time to put what you have learned about perspective into practice by going out and trying a street scene. Because the sides of buildings either converge or move in what at times can seem like odd angles, it is important to check the angles of any walls that are not parallel to you. Use the method already described of moving the pencil in line with the angle, seeing what the angle is and transferring this to paper.

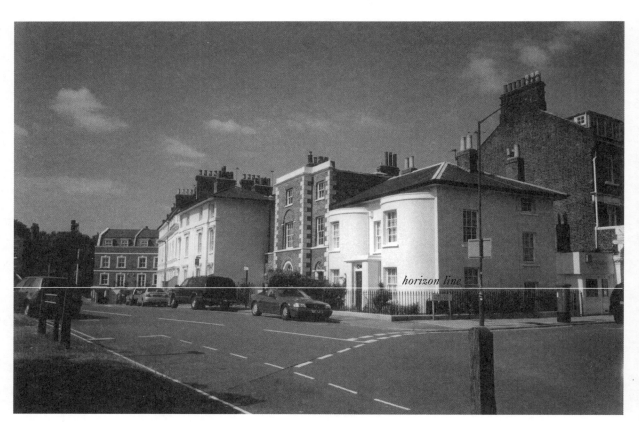

horizon line

This photograph shows a rather complicated street scene. The buildings are of different shapes and sizes; the street is on a slight hill; and it has a gentle curve to it. Note that because I was sitting on a stool at the top of the hill the horizon line is quite low down. Because of all these factors, trying to plot the vanishing points is difficult. It is best to remember the general principles about lines below and above the horizon moving up and down respectively to the horizon line.

TIP

While I think lampposts and other items of street furniture should usually be represented in your drawing, it is up to you whether you include movable objects such as cars.

STEP 1

Because composition is not the point of this exercise, just choose a group of buildings whose primary interest is that they have some perspective. They should have walls facing towards you and also receding from you.

Decide where your eye level is, as this will be where the horizon line will be. Putting in the horizon line will provide you with a useful guide.

Next, measure and plot in the basic shapes. It is vitally important that the angles of the roofs are right, so use your pencil to find the angle: stretch out your arm, put your pencil in line with the roof and keep it at that angle as you move it down to your paper. You may find it easier to have two pencils so that you can use the second to draw the line of the angle of the roof without moving the first pencil off the paper.

DON'T FORGET TO...

- *Sit comfortably and hold the same position throughout your drawing.*
- *Keep your arm outstretched when measuring.*
- *Double check a measurement before using it as the basis for another.*

horizon line

TIP

When working on a drawing over a number of days, a failsafe way to check that your perspective is the same as before is to quickly trace a few key construction lines and hold them up to the building. When your construction lines correspond to those of the building then you know you are standing in the right place. Obviously the paper needs to be transparent for this to work; acetate is ideal.

STEP 2

Once you have plotted in the basic shapes, decide where the light is coming from and put in the basic lights and darks (tone) as you have done in your previous drawings.

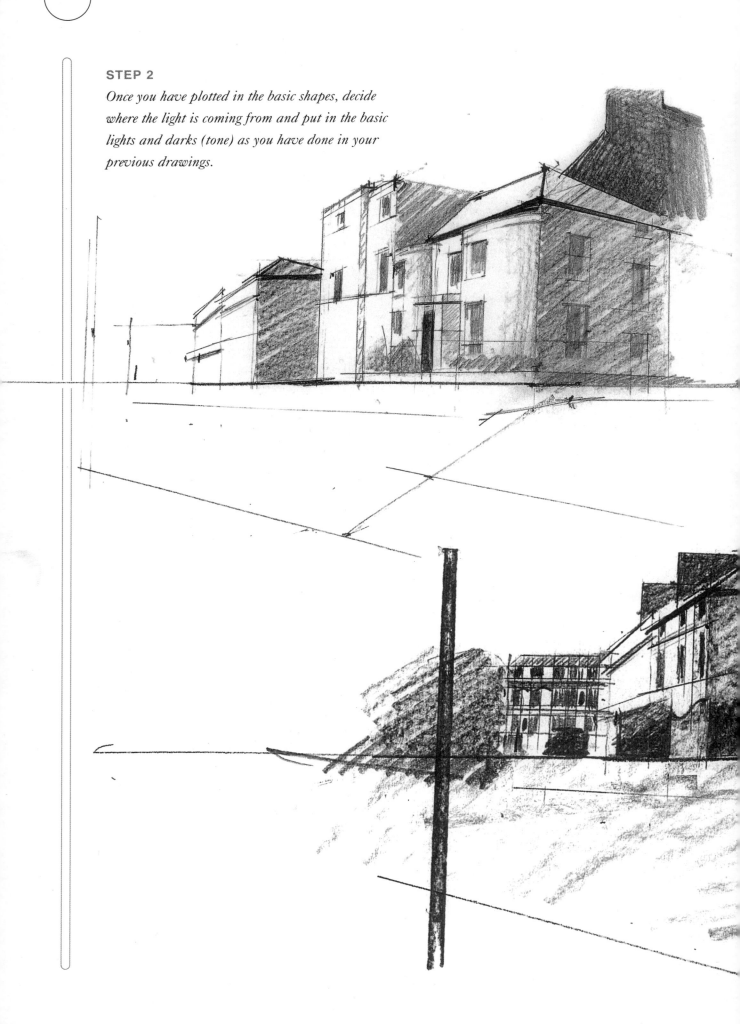

STEP 3

Continue to work on the whole picture, putting in more detail and variation of tone. Do not forget to keep checking your measurements and angles continually so as to make sure your proportions are correct throughout.

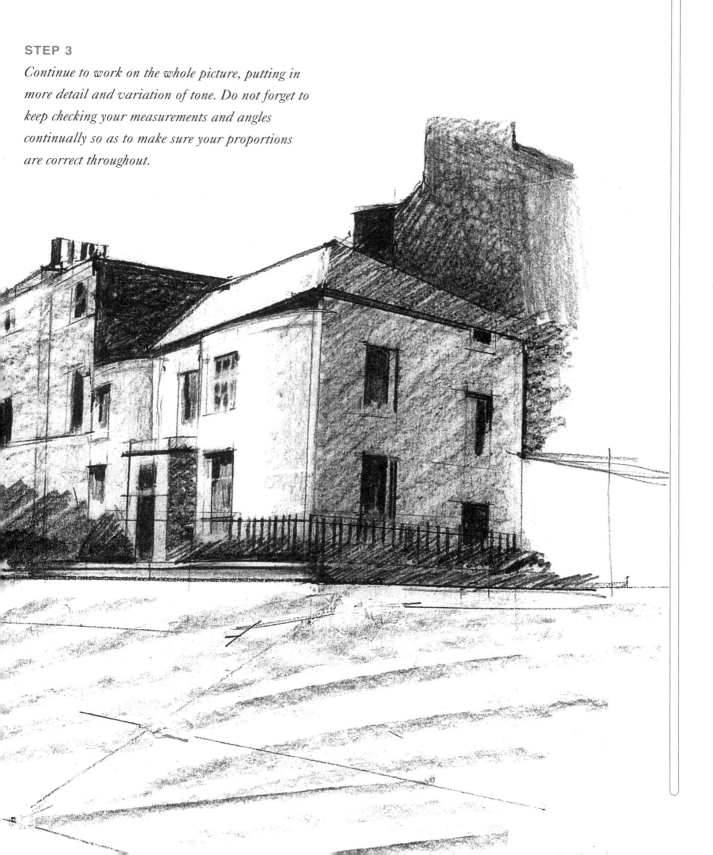

STEP 4

When your drawing is finished is a matter of choice. You need to decide what you are trying to put down. Do you just want an impression of the scene or do you want a picture with a lot more detail? You should work over the whole of the drawing as you go along. Apart from this being the best method to tackle the drawing, you should also be able to judge more easily when it is finished. It is always more difficult to do this if you go into more detail in some parts of the drawing than in others.

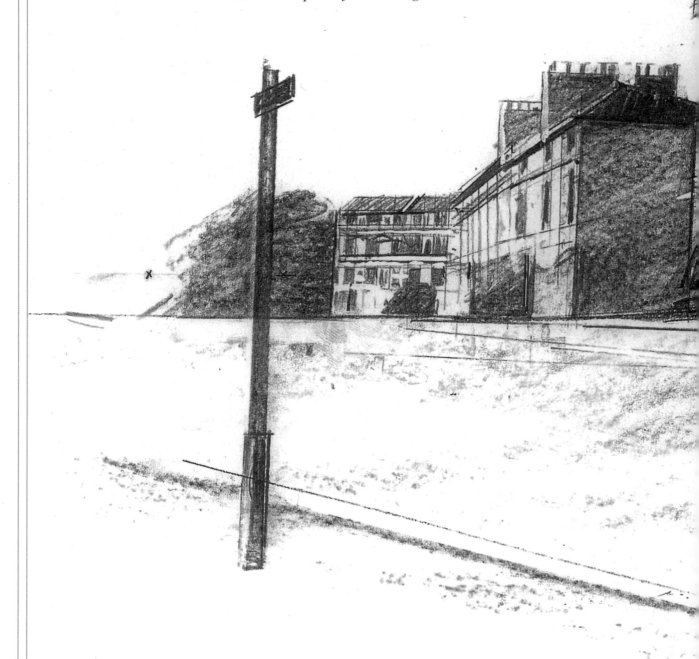

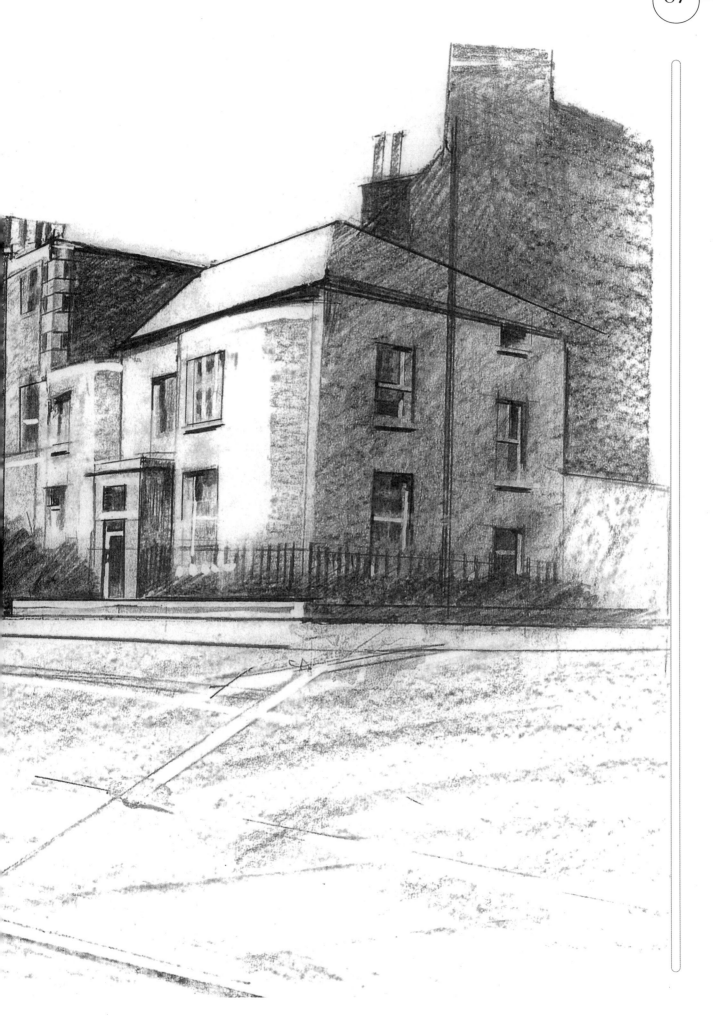

SECTION 6

Foreshortening

Another subject closely related to perspective is what is termed foreshortening. The rules of perspective also apply here, but foreshortening is primarily thought of in relation to figures, both human and animal, rather than buildings or landscapes. It is used to give the impression that parts of the body are either advancing towards the viewer or receding in the picture plane.

Foreshortening occurs when an object, usually a figure, has some parts very close to you and other parts that are further away. It makes torsos, arms or legs, for example, look much shorter than you know them three–dimensionally to be. This creates the same kind of visual problem as perspective, where the size of objects is affected by their distance from you.

This detail, drawn from Caravaggio's Supper at Emmaus *(c. 1601) shows St James's outstretched arms and the use of foreshortening to take you into the picture and also give the feeling of objects coming out of the picture plane. Note how short the arms are in two dimensions compared with what we know them to be in a three-dimensional world.*

For instance, if you ask a friend to stretch out their arm and hold their hand very close to your face, you will see how large the hand becomes in relationship to your friend's head and how short the arm becomes when it is pointing straight towards you. This shortness of the arm is what is termed "foreshortened".

This foreshortening can help to create the feeling of three dimensions. Many artists in

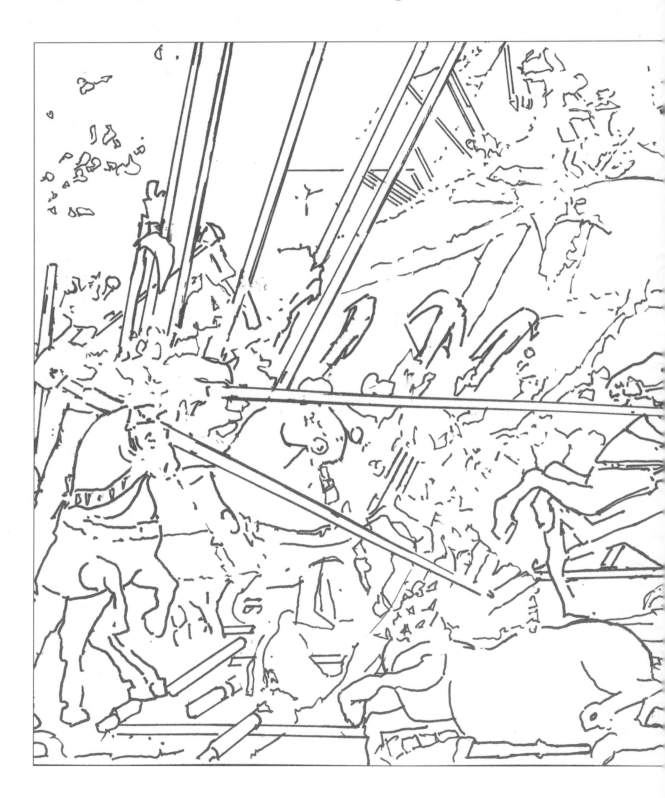

the past have used foreshortening to take you into the picture or, in some cases, make you feel that a person or object is coming out of the picture plane towards you.

If you look at pictures in which people or animals are prostrate – perhaps on a beach or often in pictures of battles, such as Paolo Uccello's *The Battle of San Romano* – the bodies are often foreshortened to take you into the picture.

Shown here is a schematic drawing taken from Paolo Uccello's The Battle of San Romano *(c.1456), now in the Uffizi Gallery in Florence. Uccello did a number of paintings of this battle, all of which use the principles of perspective and foreshortening to a large degree. You can see by looking at the central figure on a horse how a side view shows the length of the horse's body and legs. If you now look at the other horses you will see how they are foreshortened to a greater or lesser degree. The horses on the left of the picture have foreshortened bodies because they are seen in three-quarters view from the front, while the horses at the right of the picture are foreshortened from the back view. The fallen horse in the middle foreground has foreshortened legs, while the fallen horse on the right has a foreshortened body because it is lying at a different angle to the viewer.*

In fact, foreshortening affects most of what we see from a single viewpoint. When we looked at vases and bottles at the beginning of this book we saw how what we know to be circles in the three-dimensional world are, from a two-dimensional point of view, ellipses. The circle in this case has been foreshortened. Anything in perspective that is moving away from us into the picture is foreshortened towards the focal or vanishing points.

The difficulty we have concerning foreshortening is the confusion between what we know to be the real (three-dimensional) length of, say, an arm and the size it appears when it is foreshortened.

In this drawing of a teddy bear only the legs are foreshortened. The teddy's body is upright, while his legs advance in the picture plane.

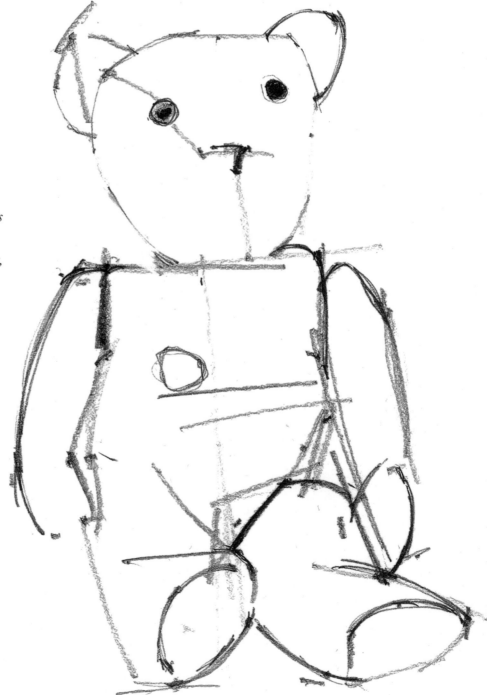

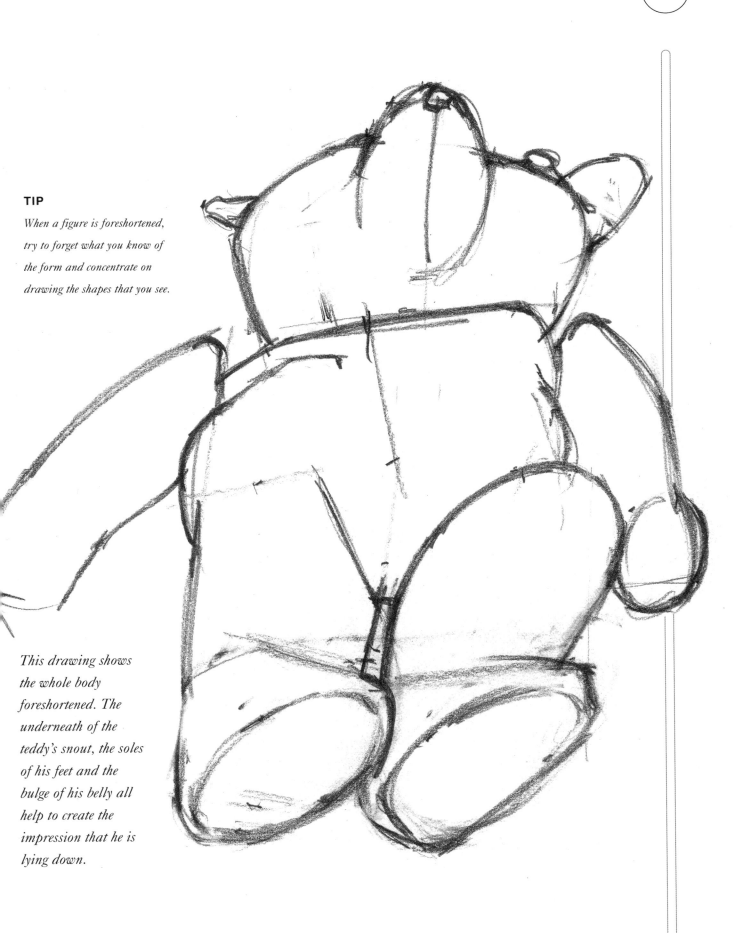

TIP

When a figure is foreshortened, try to forget what you know of the form and concentrate on drawing the shapes that you see.

This drawing shows the whole body foreshortened. The underneath of the teddy's snout, the soles of his feet and the bulge of his belly all help to create the impression that he is lying down.

DIFFERENT VIEWPOINTS

As you can see from these drawings of the same model boat from different points of view, the sails and hull have taken on very different shapes. Some of them are more foreshortened than others.

It is by using the method of measuring described in this book – looking at the shapes in front of you, measuring them as accurately as possible and trying to forget initially what you think they might look like in three dimensions – that you will be able to handle the foreshortening and just see what is there as shapes, as you have done with everything else in this book.

This rear view of the boat clearly shows how looking at an object from a particular viewpoint can considerably alter our general idea of its relative shapes and proportions. The shape of the hull can become quite complicated.

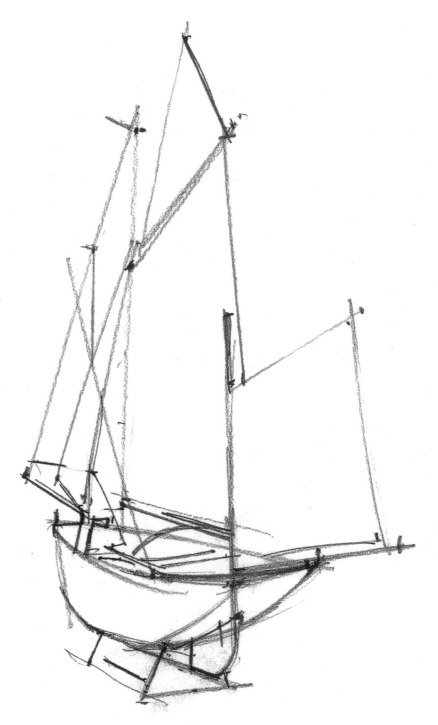

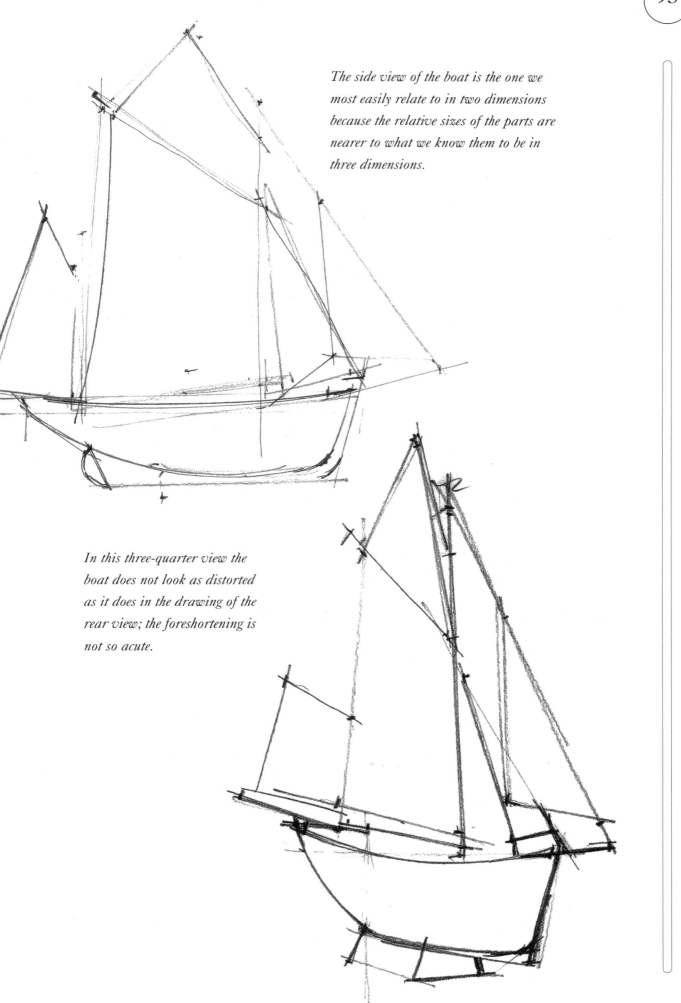

The side view of the boat is the one we most easily relate to in two dimensions because the relative sizes of the parts are nearer to what we know them to be in three dimensions.

In this three-quarter view the boat does not look as distorted as it does in the drawing of the rear view; the foreshortening is not so acute.

So that you can more clearly see the shapes of the sails and hull of the model boat, I have simplified the three sketches on the previous pages.

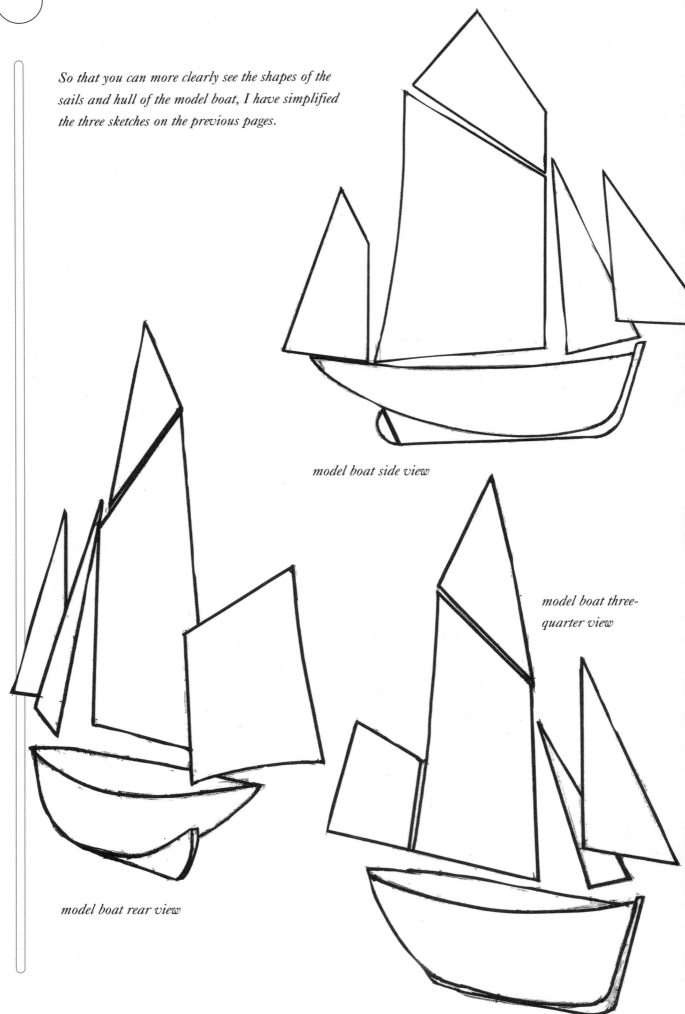

model boat side view

model boat three-quarter view

model boat rear view

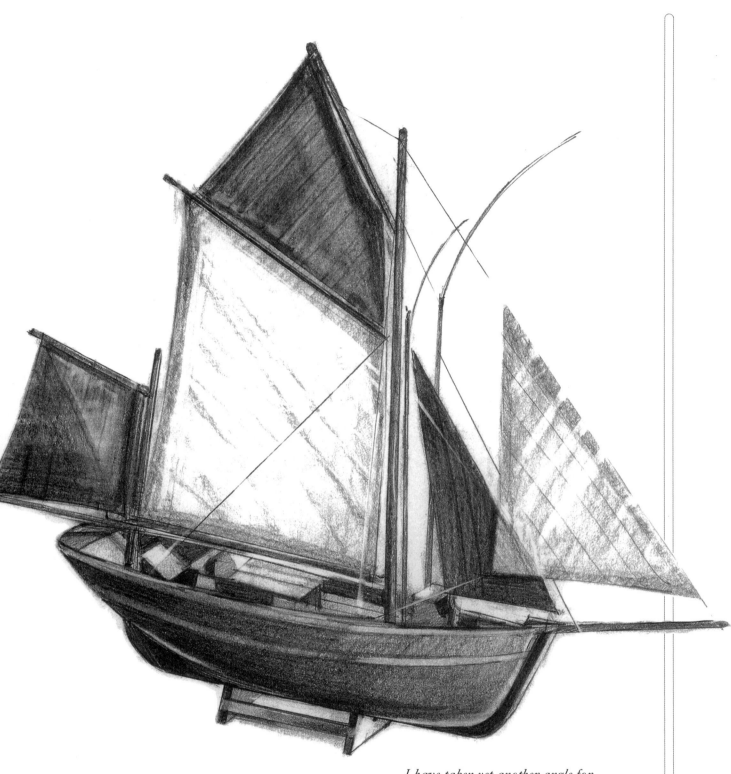

I have taken yet another angle for a final picture, somewhere between a side view and a three-quarter view and from a slightly higher position.

SECTION 7

Composition

To become aware of what makes a good composition, it helps to know about theories that artists have used for centuries. Essentially, however, composition is concerned with the arrangement of objects in a picture, and the aim is to make the picture interesting to look at, with a pleasing unity and balance. By using composition thoughtfully, you can direct the viewer's eye around the picture.

In their pursuit of beauty and harmony, the Renaissance painters used elaborate geometrical structures as the underlying basis of many of their paintings. However, you do not need to understand all of these before you can begin to draw pictures, and the simple rules given in this chapter will enable you to grasp basic theories of composition without any problem.

Composition is basically the arrangement of the shapes, lines, colours, forms and tones that make up a picture. You probably know more about it than you think, because when you decide how to arrange objects on your desk or furniture in your room you do it in a way to achieve your own particular ideas of beauty or harmony. For instance, if you position your objects in a regimental way, you may be looking for a sense of order and balance. If you allow them to be a little more random, there may be a feeling of movement to your arrangement.

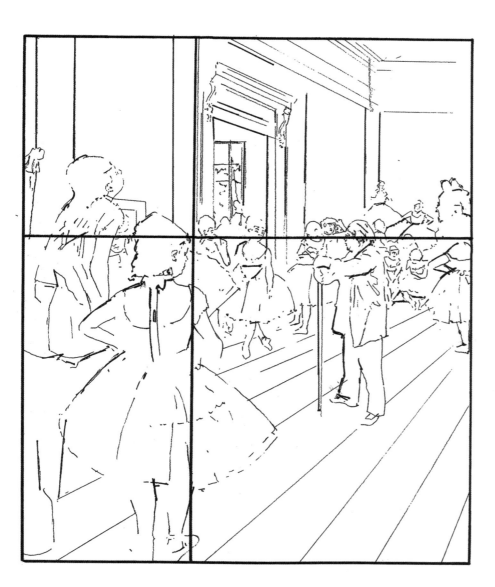

In this schematic drawing of The Dancing Lesson *by Edgar Degas, I have drawn two lines intersecting at the Golden Mean, a compositional theory that has been used by artists since the days of the Ancient Greeks. Note how the main alignments of the picture relate to the placing of the intersection.*

The main aim of a good composition is to lead viewers into your picture and to keep their interest. This can be done by creating rhythms or directions to lead the eye through the arrangement of the objects, spaces and tonal contrast in the picture.

One of the best ways in which to begin learning about composition is to study the great paintings of the past. Seeing whether you can spot just how you are being visually led into and around the picture can be both informative and fun.

The Golden Mean

The theory of the Golden Mean, or Golden Section, was known to the Pythagoreans (c. 600–500 BCE). They believed it had also been used by the Egyptians. Plato (c. 428–c.347 BCE) speaks of it and it was used in classical Greek architecture.

The concept was formulated again by the Roman architect and scholar Vitruvius in his treatise *De Architectura*, written in the first century BCE. In the 13th century the Italian mathematician Fibonacci published a

numerical progression corresponding to the Golden Mean, and it was discovered that these numerical relationships recur throughout nature, from the spirals in a shell to the scales in a fir cone. Renaissance artists, drawing on Greco-Roman theories of proportion, frequently based their composition on the Golden Mean.

The theory of the Golden Mean states that there exists a harmonious relationship between unequal parts of a whole if the proportion of the smaller part to the larger is equal to the proportion of the larger part to the whole. This can be expressed as 0.618 is to 1 as 1 is to 1.618. This may look a bit complicated but in fact most people find this proportion aesthetically pleasing and

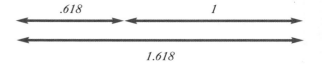

artists often use it quite unconsciously.

The following illustrations show variations of the proportions of the Golden Mean in a rectangle. They show how the above theory translates when applied in two dimensions.

In this example, the rectangle is divided into planes so that the square GHDF is in the same proportion to the square EFBC as EFBC is to the whole rectangle ABCD.

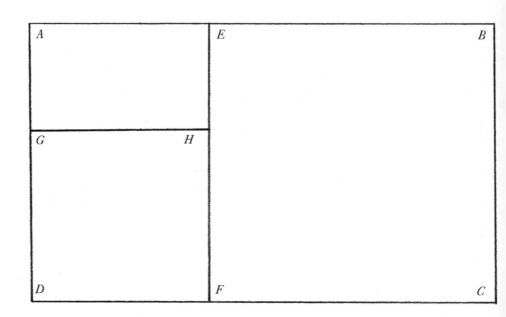

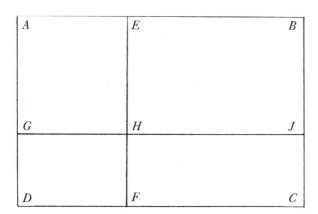

In this example the lines GJ and EF intersect at the point of the Golden Mean of the two lines.

In this example the four lines BI, CH, JE and KF all intersect at the point of the Golden Mean. Many of the Renaissance artists used this as a compositional device.

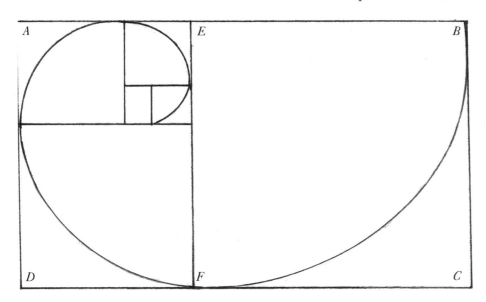

In this example, after dividing the rectangle into two sets of Golden Mean proportions based on the two rectangles AEDF and ABCD, you can see how the spiral associated with natural forms such as sea shells is formed.

Here is the picture plane divided into thirds horizontally and verticially. Many artists use this as an alternative to the Golden Mean as a basis for their compositions. The intersections of a picture divided into thirds are the focal points of many well-known paintings.

DIVIDING INTO THIRDS

Another idea, probably derived from the Golden Mean, is that of dividing the picture plane into equal thirds. Many artists find that this division also creates dynamic intersections towards which the eyes tend to move and which the mind finds pleasing.

Human beings soon find symmetry boring. We prefer a dynamic balance rather than the balancing of equal weights – for instance, the balancing of two smaller trees against one larger one, rather than the balancing of two trees of equal size.

The eastern tradition of balancing emptiness against fullness that influenced many European painters at the end of the 19th century expanded our ideas of good composition. So did the advent of photography at around the same time, as it introduced unusual arrangements such as showing just part of a person at the edge of the picture. Notions of composition moved away from the strict classical tradition and took on new ways of capturing attention and interest.

In the Raft of the Medusa *(1819, Louvre, Paris), Théodore Géricault depicted the real-life tragedy of a raft of survivors from a shipwreck, trying to attract attention. In the first drawing from the picture, I have divided it into thirds to show how much of the major activity happens on these division lines.*

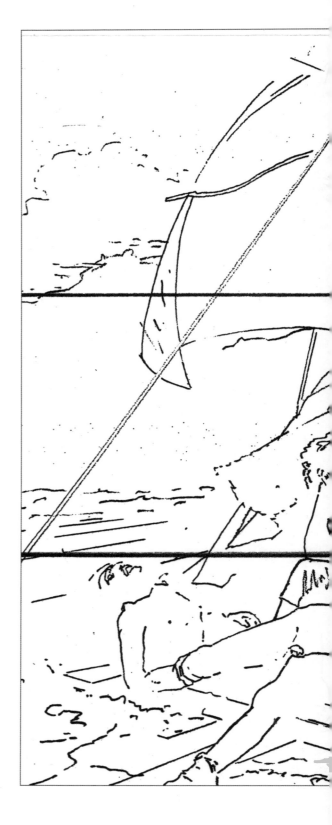

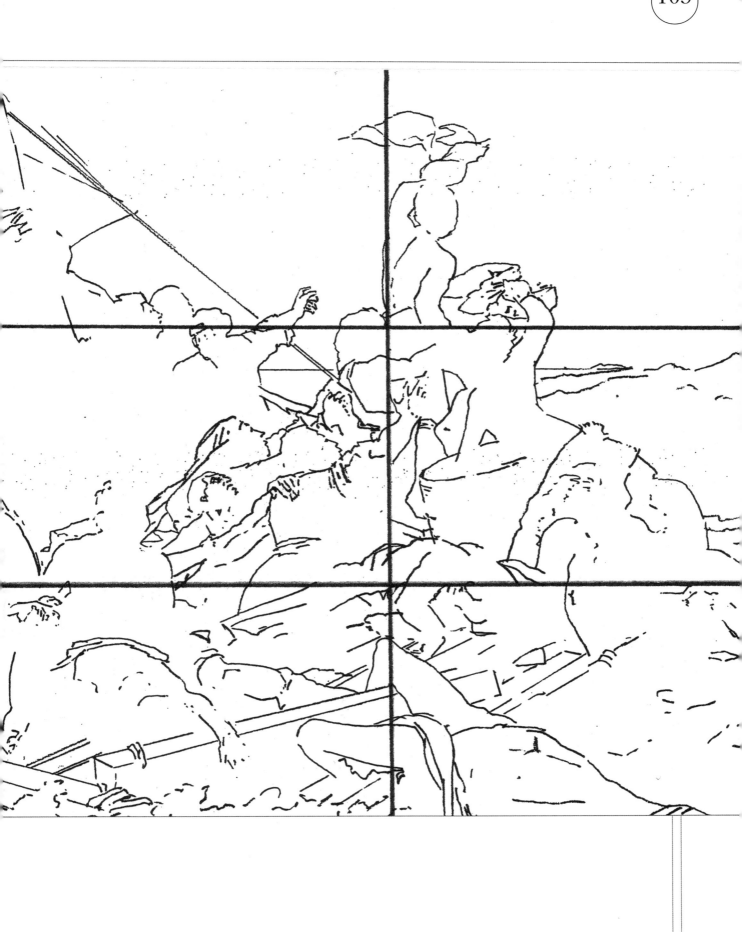

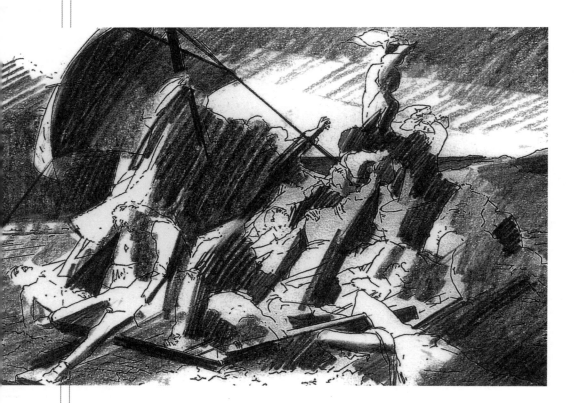

ABOVE

*In the second drawing
I have put in the
major tonal areas of
the picture. You can see
how the contrast
between the light and
dark areas gives
movement and drama
to the painting.*

RIGHT

*In the third drawing I
have shown the major
movements within the
picture. Some are there
through the structure
of the shapes, others
through the use of light
and dark tones. Notice
how the movement
tends to lead you out
of the picture, a
movement that is
countered by strong
lines leading you back
in again.*

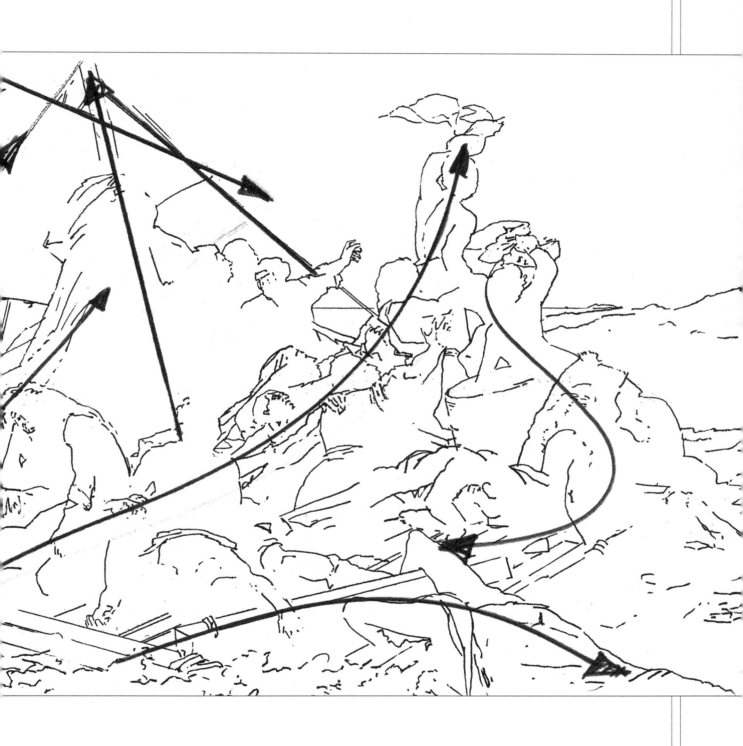

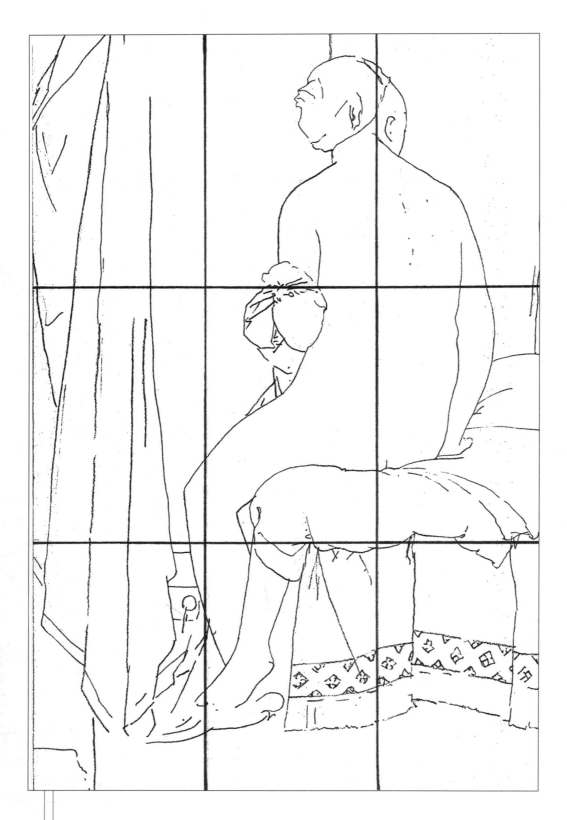

In my first drawing of The Bather of Valpinçon by Jean-Auguste-Dominique Ingres (1808, Louvre, Paris), I have divided the picture into thirds again. The major vertical and horizontal axes of the picture, the sitter's back and the bed, are on two of these division lines.

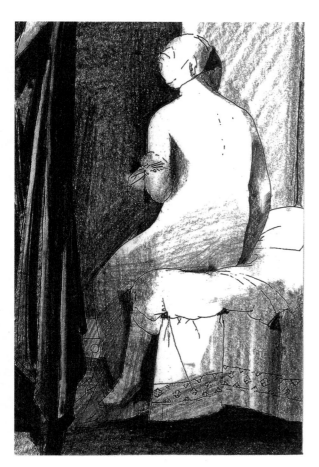

ABOVE AND RIGHT

The second drawing shows the major tonal areas and the third the major movement of how my eye travels round the picture. The main focus in the picture appears to be the left shoulder, which is not only the lightest part of the picture but also, by the way the shoulder turns, brings your eye back into the picture when other movements are taking it out.

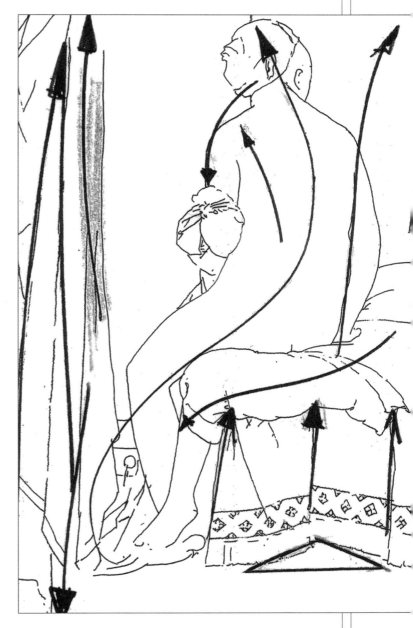

My third example is The Astronomer *by Jan Vermeer (1668, Louvre, Paris).
Again, in the drawing of the picture divided into thirds, you can see that the
major vertical movement is on one of these division lines and that, while one of
the major horizontal movements is on the centre line, the next is on one of the
third divisions.*

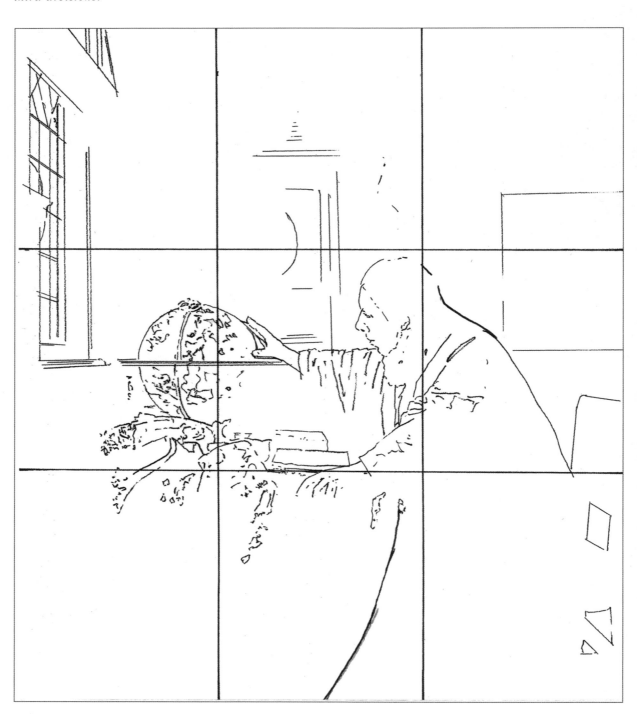

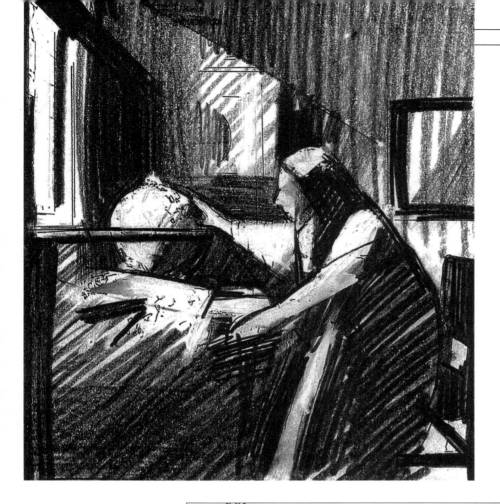

ABOVE AND RIGHT
In the tonal drawing you can see that the interplay of light and dark is an important element in this picture and, as shown in the third drawing, makes a major contribution to the way the eye moves about the picture.

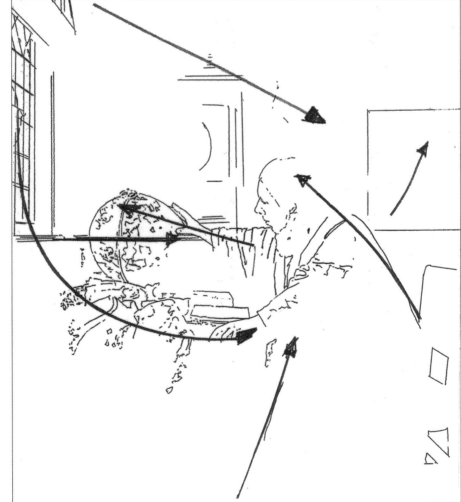

Deciding on your composition

The first thing you need when looking for a good composition is a viewfinder, particularly in a landscape subject; being able to isolate a view from the rest of the environment is vitally important if you want to get the composition right without going through many trial runs.

On page 28 we discussed a simple square or rectangle made from a piece of card or even your fingers. However, you can easily make a more sophisticated version with cotton or thin string fixed across it in a grid of squares to help get the proportions correct. This will provide a good guide to refer to whenever you are not sure where to place an object on your paper.

A viewfinder that has been 'strung' can act as both a guide to the composition and to the size and placement of the objects in the picture. It can also help you check your measurements and angles. In fact, in the past, a system such as this was used instead of measuring with the pencil.

COMPOSITIONAL TIPS

- If one object is of particular interest to you, it is usually best not to position it in the centre of the picture since this can quickly become boring. It is better to let the viewer's eye move around the picture and come across this object again and

again rather than for it to remain a static focal point in the centre.

- Think about how best to frame what you are interested in. For instance, if there are trees, drapes or objects that could frame your area of interest, these could be used to lead viewers into the picture.

While an object such as this tree can make a strong image if positioned in the centre of the picture (above), if it is placed to the side and moved further back (right) the picture takes on a more spatial quality and the angles of the branches get your eye moving more around the picture surface.

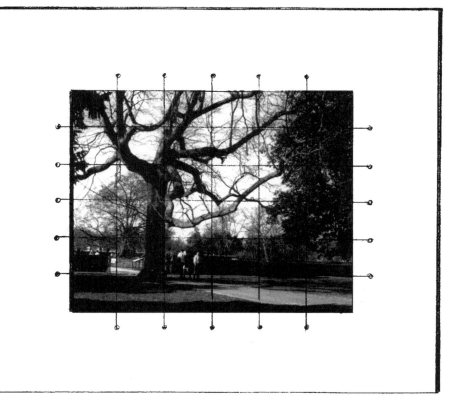

- Diagonal lines in a picture usually create movement, energy and interest.
- While you don't have to stick rigidly to them, don't altogether ignore the theories about dividing a picture into thirds, or at the Golden Mean. These intersection points have an energy that can give your picture a charge.
- Use horizontals and symmetrical structures if you are trying to achieve balance and calm in a picture.

BELOW

The viewfinder has been divided by six horizontal and six vertical strings. This can help you check the proportions and relationships within your drawing. Stringing the viewfinder like this can also be useful when deciding on your composition, especially if you want to use the division of the picture into thirds. Note also how the diagonal line of the mast gives that extra touch of movement in contrast to the straight lines within the picture.

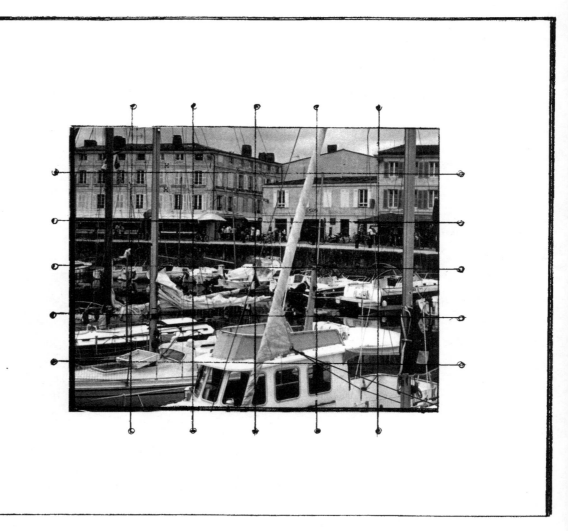

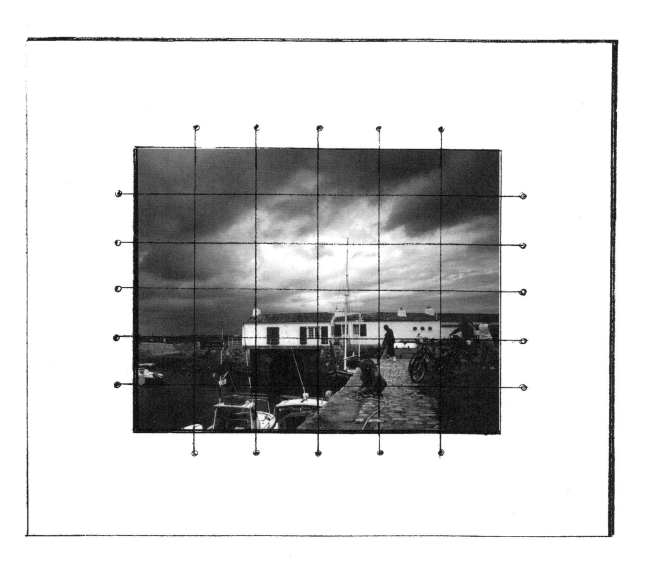

- Asymmetry has more energy and dynamism than symmetry.
- The objects that attract you in particular may be interesting because of their relationship with other objects or spaces you have not consciously noticed. Be careful not to miss out those things that give a scene its particular quality.

- In the end it is your own judgement, observation, experience and intuition that matter and these improve with practice.
- Don't fall into the trap of deciding you have found the right composition straightaway. It is often worth doing a few simple roughs first to see which you prefer.

ABOVE

By placing the horizon line in the lower third of the picture the sky acquires more prominence. This is useful if the cloud fomation is one of the main aspects of the picture.

SECTION 8

Landscape

While photographs can be useful as reminders of what a scene was like, it is important in the beginning to draw in front of the subject, so that you can get the feeling of the landscape – the light, its expanse, the sounds, whether it is windy or sunny. These elements may not have a direct effect on the shapes you are seeing, but they will help you decide what aspect you want to draw.

ABOVE

Sunflowers, France. *Most drawings of landscapes are
preparations or studies for paintings. It is therefore worth
noting that, even in a watercolour such as this, there is still a
lot of drawing – first with a pencil then with a brush and
paint. The same kind of measuring and looking at the shapes
and proportions still needs to go on.*

When you study a landscape or seascape with a view to drawing it, your first consideration is to decide on the overall composition of your picture. This can be done by using a viewfinder (see pages 110–113). The most important element to position is the horizon line, even if you cannot see it because of objects such as trees, buildings or mountains being in the way. Remember that the horizon line is always level with your eyeline and directly in front of you, and that in the middle of this line is the focal point.

Landscapes and seascapes depend for their effect as much on the light and atmosphere as on the shapes. Therefore the relationship between the land, sea and sky is very important.

If the picture is about the dramatic effect of the clouds, for instance, these need to play a predominant part and should therefore have a high proportion of the picture devoted to them. On the other hand, you may want the picture to be more concerned with mountains and valleys, trees, buildings or boats. In this case the proportion of land to sky should be greater.

The second major element in the picture is the light source. This will give you the basic areas of light and dark and provide the key to the atmosphere of the drawing – whether it is about the dramatic effect of a storm or showing the strong shadows of bright sunlight.

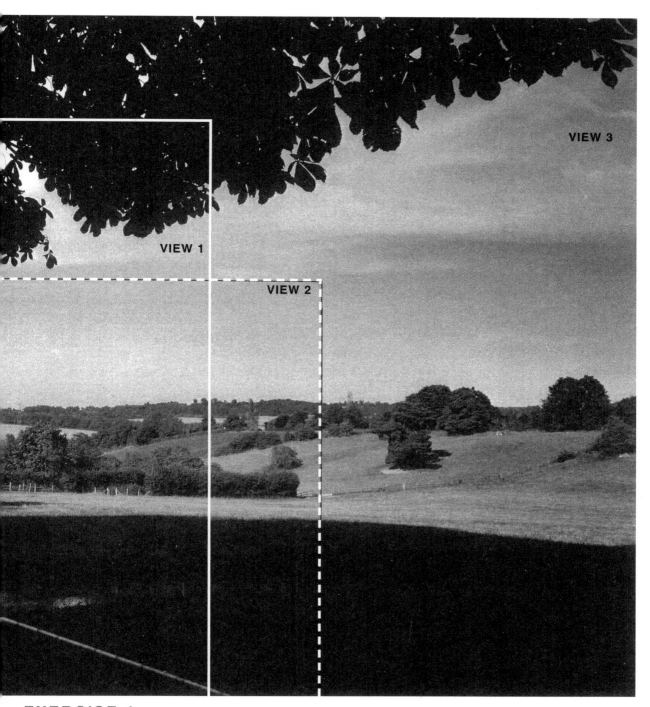

VIEW 3

VIEW 1

VIEW 2

EXERCISE 1

Kentish landscape

It is often difficult to decide how to tackle a landscape – how much to put in, and what the proportions of the picture should be. This is where a viewfinder is vital.

In this scene, because of the bright sunlight, there are very strong contrasts. You need to decide whether these contrasts – such as the shadow on the

field or the overhanging tree – are going to be the important elements in the picture, or whether you want to make more of the feeling of space and distance. This is where doing small tonal sketches can be very useful.

I made three quick sketches of the basic structures and tones of the three different views outlined in white on the photograph before I chose my composition for the finished drawing.

VIEW 1

*In this sketch, the
square format gives
the picture an intimate
quality and
concentrates the eye on
the distance in the
centre of the picture.*

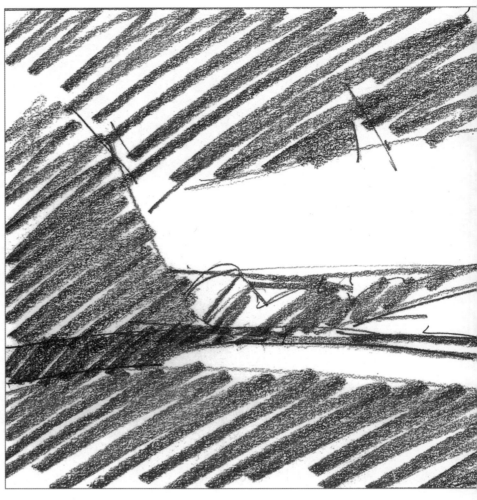

VIEW 2

*This sketch uses a
"landscape" format,
where the width is
greater than the height.
I have led the eye into
the picture by
removing the dark
overhanging trees at
the top and
concentrating on the
movement and shapes
going on in the
distance.*

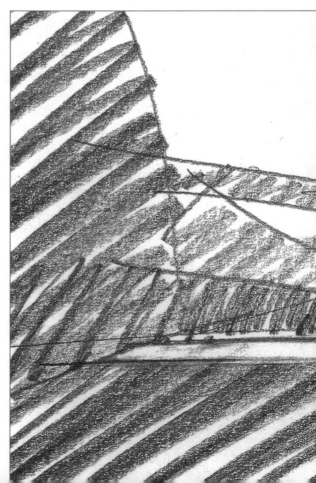

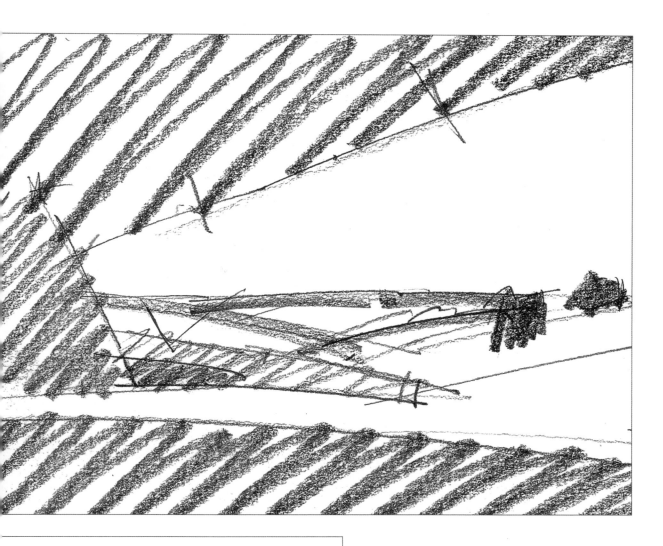

VIEW 3

This sketch takes in most of the view and has two strong tonal areas at the top and bottom of the picture. These lead the viewer into the picture and give an indication of its spatial potential.

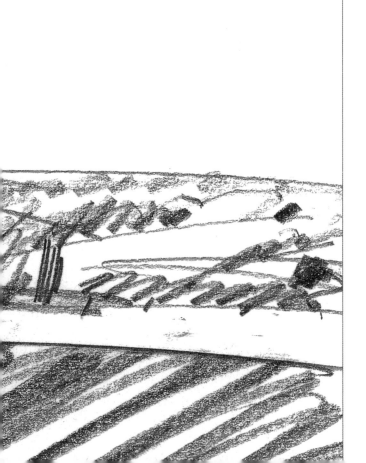

Mapping your landscape

Once you have decided upon your composition and the division between the sky and the earth or sea, you need to map out the major basic shapes that make up the picture. These will probably be groups of trees, buildings, mountains or clouds.

In most landscapes the major lines will be directional lines, perhaps showing the shape of a group of trees, buildings or hills.

Gradually break these dominant groupings down into smaller areas – and continue, if necessary, to individual trees or buildings.

Depending upon the distance objects are away from you, you will be able to see their elements more or less distinctly. For instance, leaves on trees can only be seen individually if they are very close to you. Further in the distance, you can discern only groups of leaves and, further away still, only the shape of the whole tree. At a greater distance you may only be able to pick out a group of trees. Do not try to put in detail that is not visible, either in landscape or architectural subjects.

STEP 1

After deciding on view 2 as the composition I wanted, I started the main drawing. First, I put in the horizon line and the major areas I had already identified in my sketch. I then started to measure and plot the shapes and angles of the fields and trees. In looking at the shapes and forms within the landscape it is important, as with all drawing, to focus on the major basic shapes and gradually break these down into manageable areas.

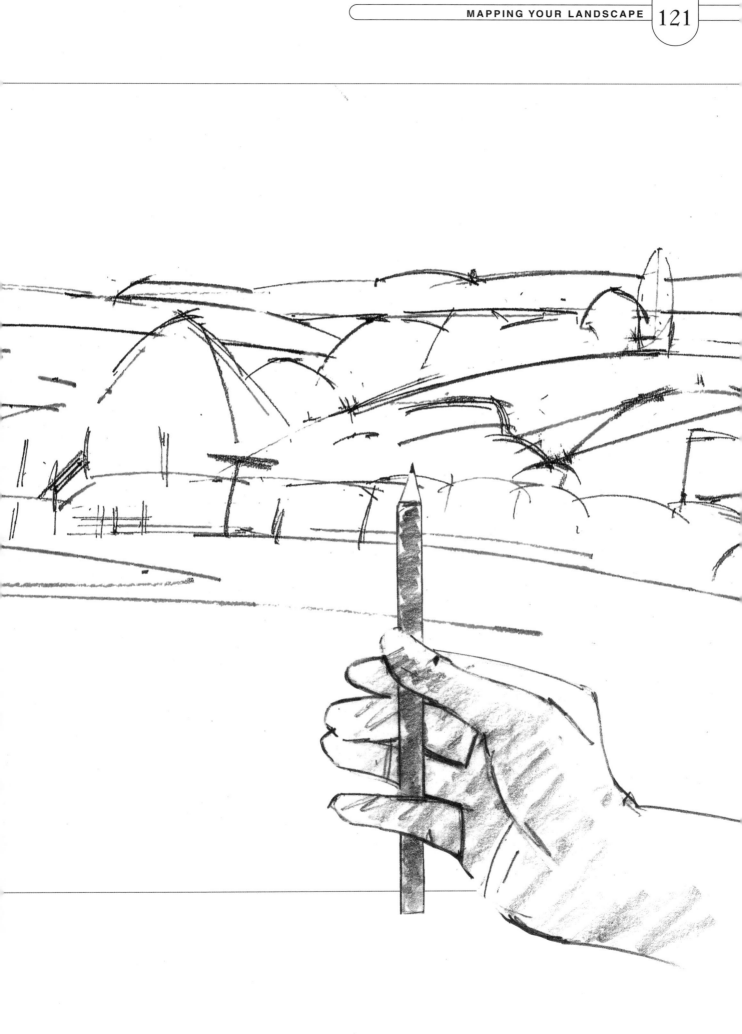

STEP 2

Having established the basic shapes I have now moved on to the tonal relationships within the picture. You can continue to break these down into smaller units until you have reached the detail of tone you require.

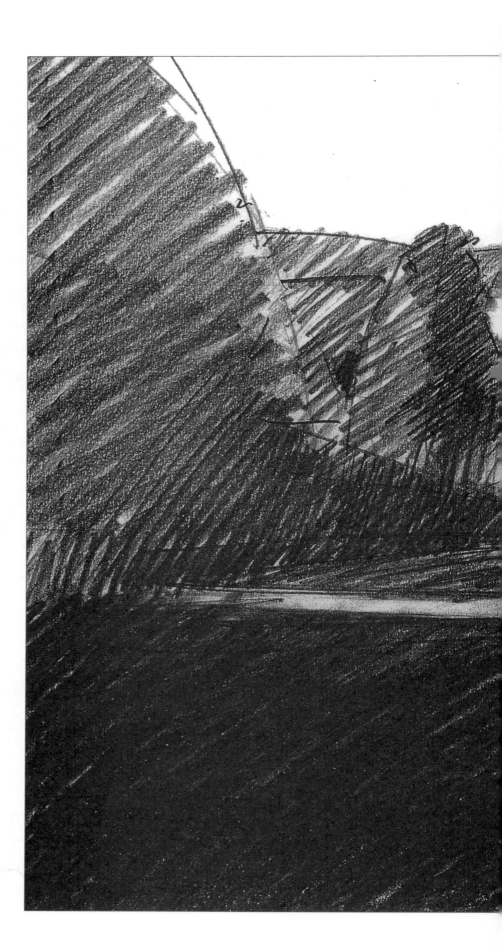

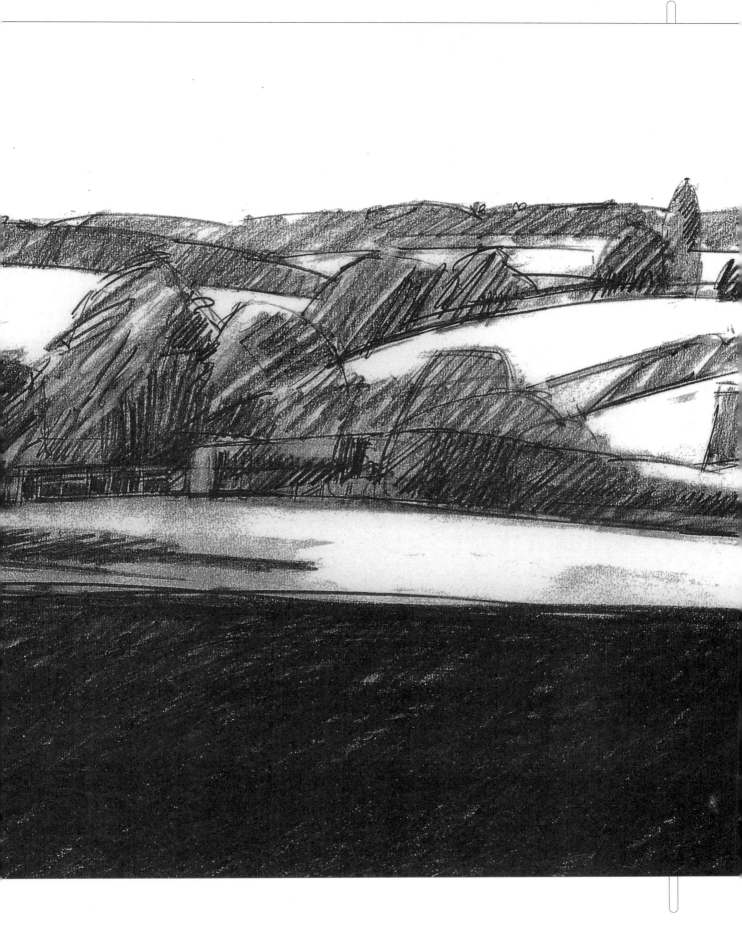

The fleeting image

There are a number of factors that will influence the outcome of your landscape drawing: how much time you have; what it is that you like about a particular scene and how long that will last if it is affected by sunlight or wind; what you intend the drawing to be for.

Most landscapes are changing continually, with the sun moving round and changing the shadows, clouds scudding across the sky, the tide ebbing and flowing; all will seem to be in constant flux. Even if you have enough time to spend on location, the landscape might not give you the time to complete the elements you want to draw. This is where taking a photograph as well as doing the drawing can come in useful.

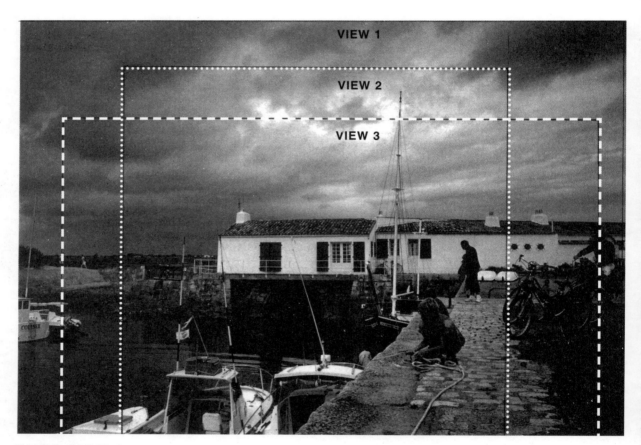

EXERCISE 2

French harbour

When I was sitting in front of this landscape, what attracted me was the isolation of the house and the storm clouds. The boats in the foreground were

coming and going, so I decided to ignore these and concentrate on the atmosphere and light. As with the Kentish landscape on the previous pages, I looked at three different compositions before deciding which one to take further.

VIEW 1

*This sketch shows the
major tonal areas.
The building occupies
a smaller proportion
of the picture, the sky
being the dominant
element here.*

VIEW 3 BELOW

Here I have made the building a more important part of the picture and reduced the area of sky.

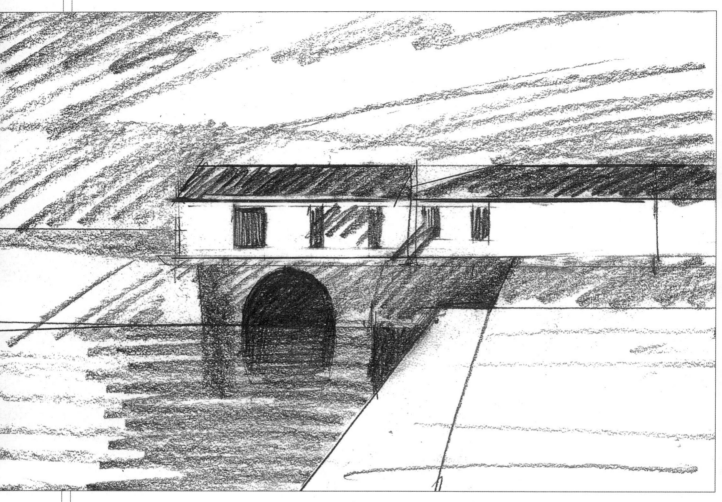

VIEW 2 OPPOSITE

The square format of this drawing gives the sky more prominence. I used a eraser to get certain effects in the sky and water. This was achieved by first cutting an eraser into small and medium-sized chunks and then using the edges of these to draw lighter lines or areas back into the picture. Depending on how much detail you want, you need to be ready to stop before you start to overwork the picture. Putting buildings in landscapes tends to be difficult for beginners because they focus too much on the detail of the buildings to the exclusion of the other elements in the picture. The buildings can therefore become more prominent in the picture than they are in reality. Always remember to work over the whole surface of the picture and gradually bring the whole drawing along in stages.

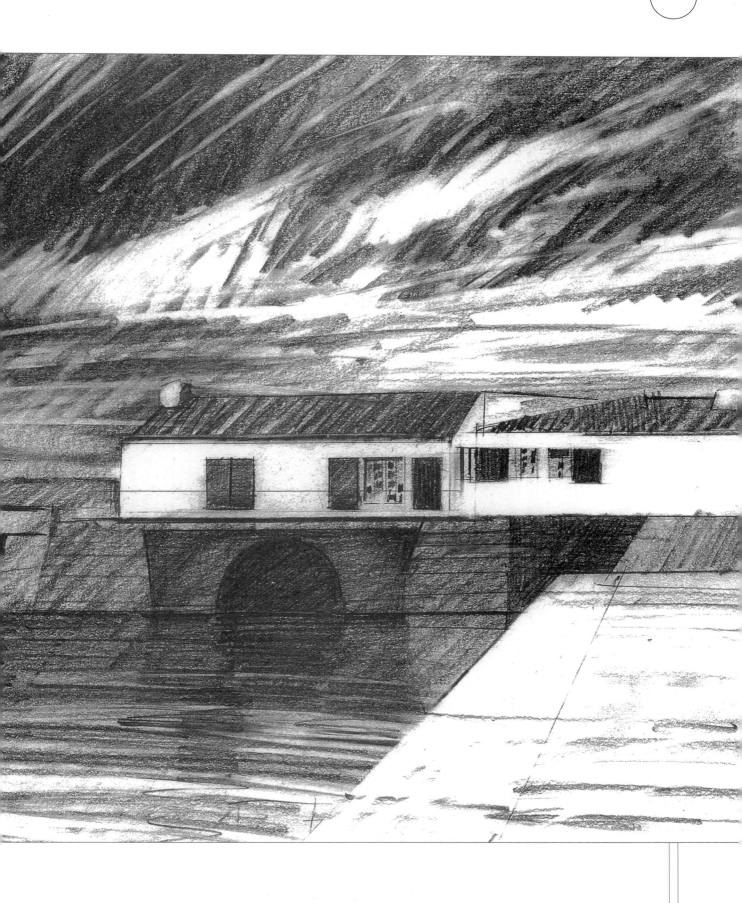

Working with limited time

If you do not have much time, you will probably only be able to do a sketch of the subject and therefore will only be able to jot down the basic elements.

If you are drawing some trees and are interested in their branches and the way they twist and turn, rather than the atmosphere of a particular day and time, you will probably be able to go back to it on another day and go into more detail. This will also apply if you are trying to make a record of a particular building.

EXERCISE 3

Tree at Greenwich

STEP 1

It may be that it is not the landscape as a whole that attracts you. It could be just the visual contortions of the branches of an individual tree. This was the case with me with a particular tree in Greenwich Park, London.

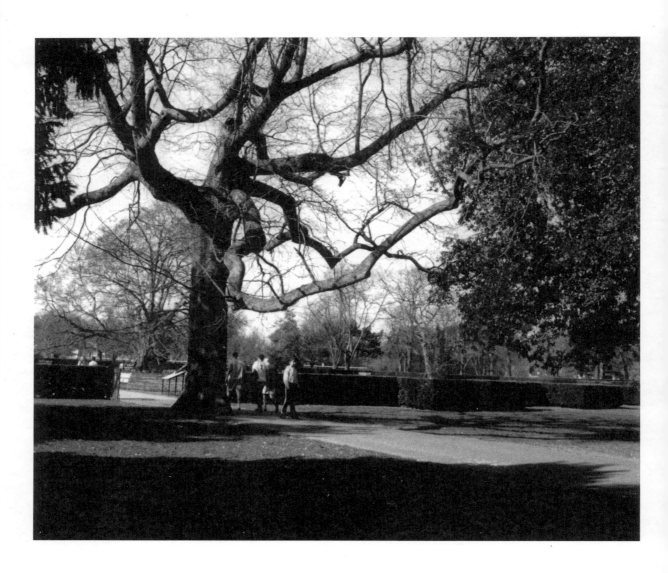

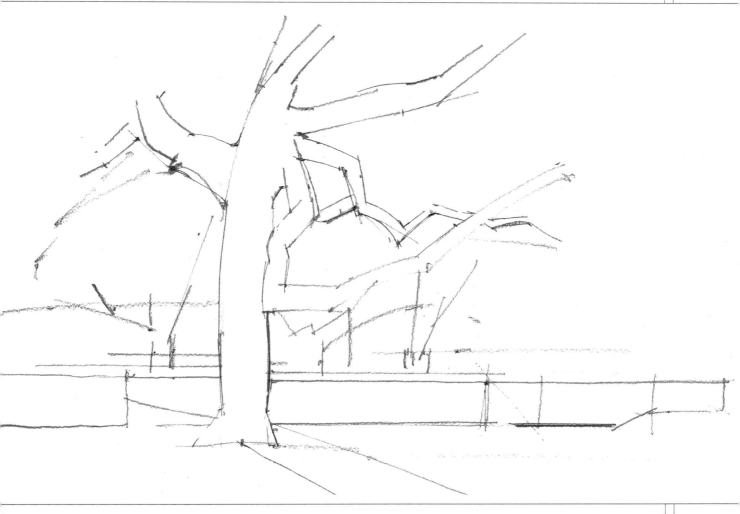

STEP 2

Because my interest in this tree was in the relationship between the branches, I took these as my starting point. Rather than work out a composition, I started plotting and measuring the structure immediately.

TIP

Keep practising. Take a sheet of paper and pencil with you wherever you go and do a little measured drawing when you can.

The Impressionists returned again and again to their painting sites, always at the same hour of day so that they could paint the same quality of light and find the same colours and shadows.

When time is limited it is important to get the basic proportions right and to make sure your initial measuring and plotting is done. This includes making sure that the major angles of trees are right. If the picture has buildings in, check their perspective as, drawn correctly, it will give an indication of space in the picture.

The ability to select the most important features of a scene is vitally important when time is limited. We deal with this subject fully in the chapter on sketching, but even at this point I would suggest you get used to asking yourself a few questions to clarify your thinking about what you are drawing. For example – Is it the atmosphere that attracts me? Is it the shape or shapes of a particular object? Is it the arrangement of the light and darks? Is it the rhythms of the trees or buildings within the landscape?

When you have some idea of what you are interested in, concentrate on that particular aspect of the scene in your drawing.

STEP 3

After drawing the major shapes and structure of the branches and trunk I moved on to the tones, since the way the sun was falling on the branches started to intrigue me. I decided to leave the drawing at this stage because I felt I had drawn what I was first attracted to. Do not feel that all drawings have to be taken to the same kind of finish; it is enough to have put down something that captures perhaps quite a small visual sensation.

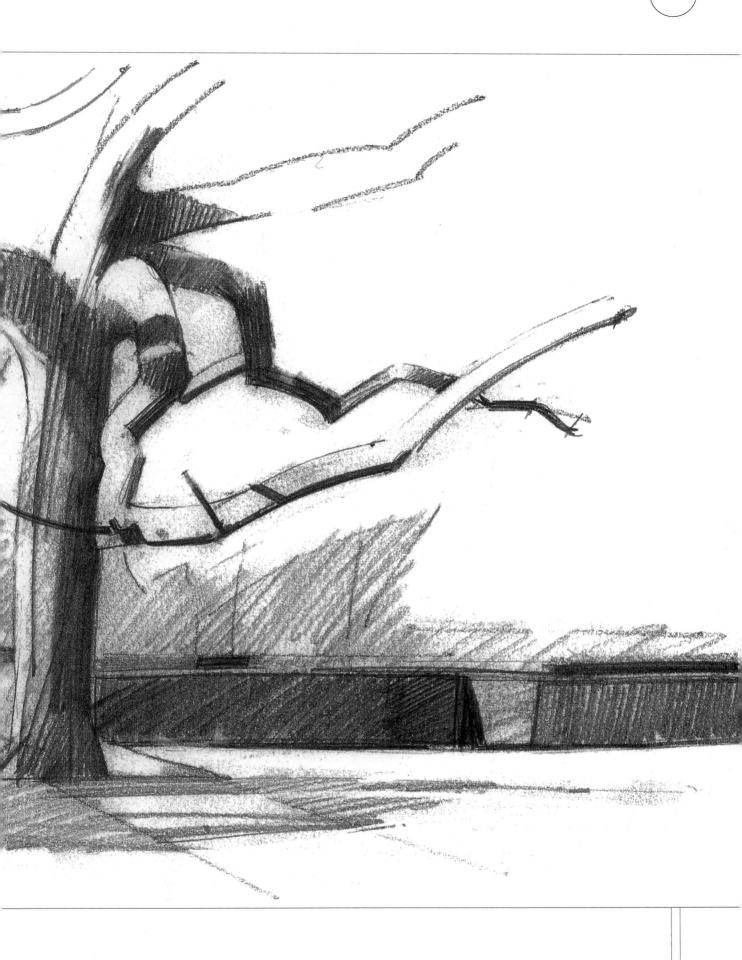

SECTION 9

Sketching

The term "sketching" implies something quick and unfinished. However, it can also mean something new, fresh, spontaneous, creative, having energy and life. In a sketch you try to capture the essential elements of a scene in as short a time as possible.

In most cases sketches are done on the spot, in front of the landscape, interior, still life or model.

M any of the best masters, whether from Europe or the East, have done drawings using just a few economical lines. Nevertheless, these drawings have the power and energy to touch and captivate us.

Some of Constable's sketches, for example, which perhaps took him only 30 minutes, have an immediacy that captures the mood of a landscape more powerfully than many paintings laboured at over a long period.

This sketch was done on location in Venice with a black ink pen and two magic markers – light and dark grey. It was initially plotted and measured to get the size and proportions, and special attention was given to the perspective of the buildings as this gives the picture its depth. Then, using the markers, the shadows made by the sunlight were put in and, last, the main lines and areas of dark tone.

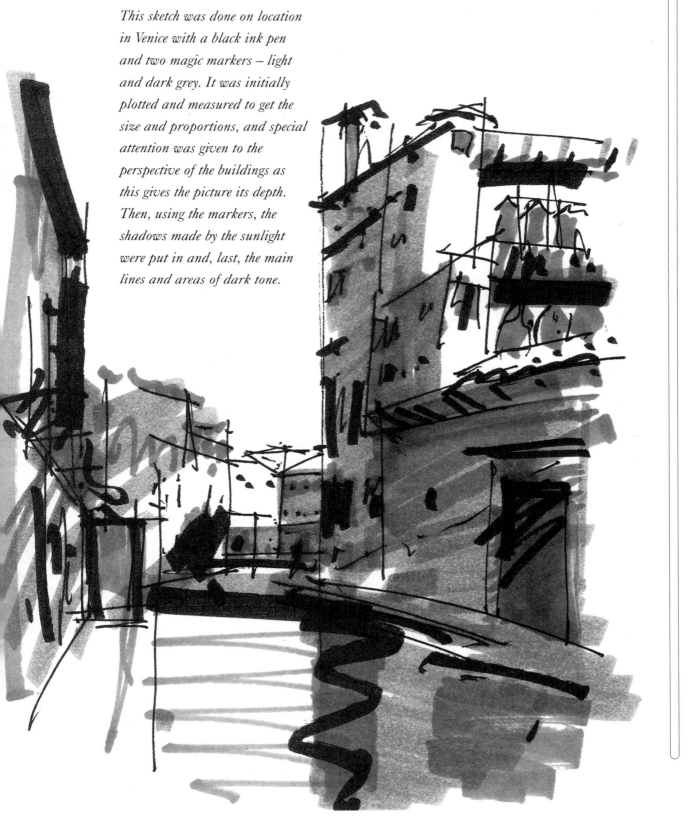

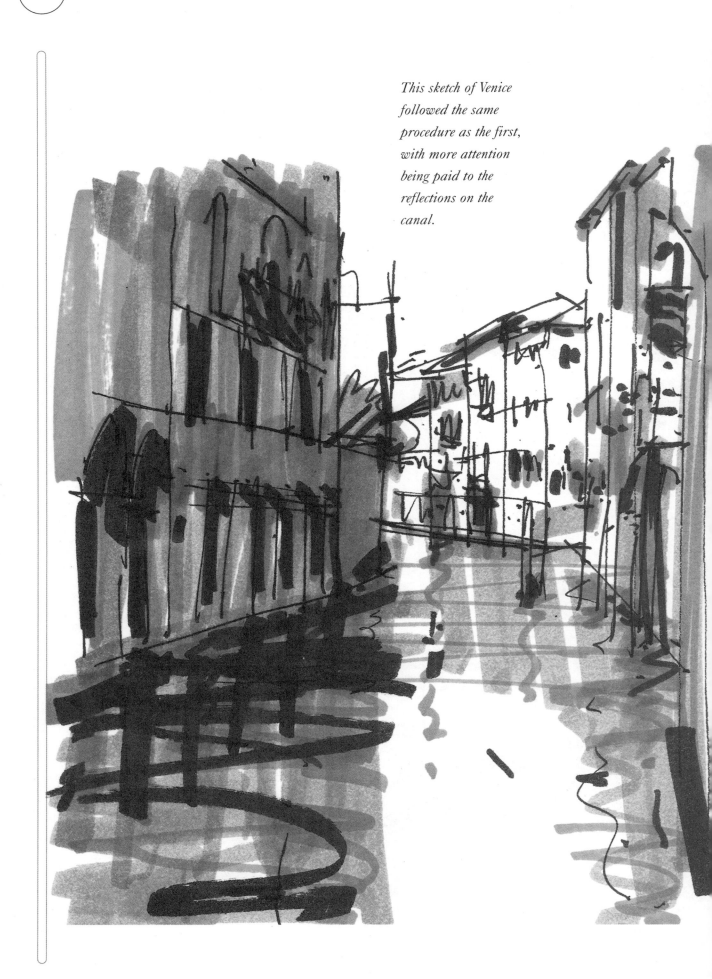

This sketch of Venice followed the same procedure as the first, with more attention being paid to the reflections on the canal.

This drawing is also from the Venice sketchbook. It is worth noting that these are very quick sketches, and although some of the vertical lines are a bit wobbly, this does not detract from their overall feel. In fact, it tends to give them a certain amount of energy.

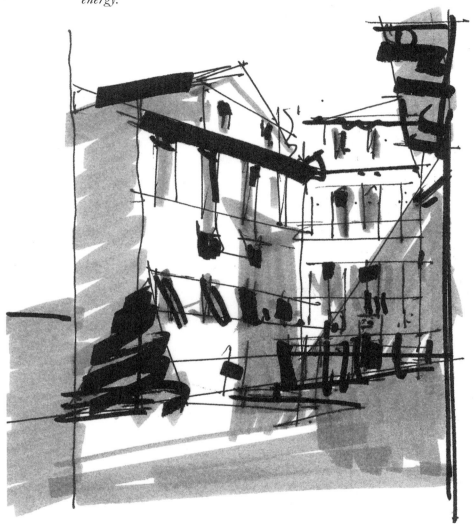

Selection and simplification

The essence of a good sketch is selection and simplification. As in many of the exercises in this book, the first step is to select the view using either a viewfinder or your hands. Once you have the boundaries of the sketch, you need to select the most important shapes and lines contained within those boundaries. Beware of fiddling with small areas of your drawing until you have plotted these major shapes.

The key to a good sketch is knowing what to leave out rather than what to put in. It is helpful to half-close your eyes to eliminate some of the less important features of the picture, especially if you are doing a landscape or townscape.

What is important is the direction of the light source. It is this that often creates the effects of atmosphere, whether dramatic or calm, within a picture. Do not just look at the objects in your picture but also at the areas of light and dark, and how the shadows fall.

It is also important that you remember to work over the whole of the picture and not get tied up with one part. You need to keep the whole area of your sketch at a similar stage to be able to judge when you have done enough to give that first all-important impression of the view.

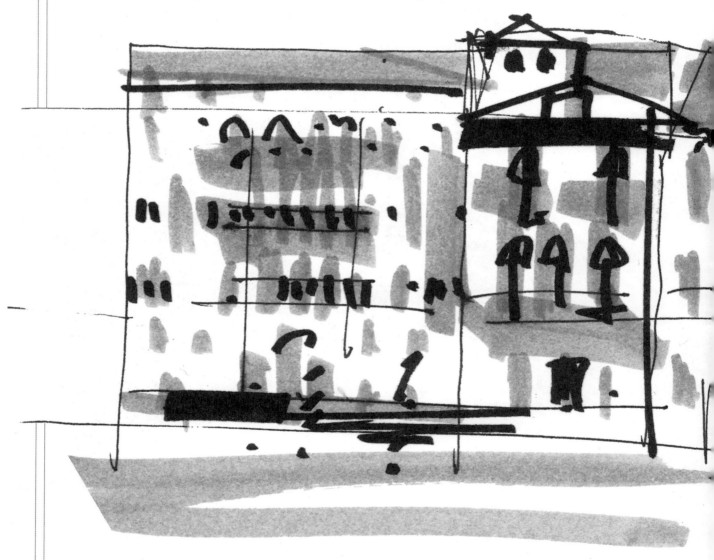

Travelling light

When I go out I try to take as little with me as possible. I first decide whether to take a portable sketching stool. This depends on whether I think the location I am going to has plenty of places to sit, such as steps or benches. If you do not like people coming up behind you and looking at your drawing, a sketching stool is essential so that you can sit with your back against a wall or tree.

I have two sizes of sketchbook: 20 x 20 cm (8 x 8 in) and 25 x 25 cm (10 x 10 in). There is no hard and fast rule about size; use what you feel

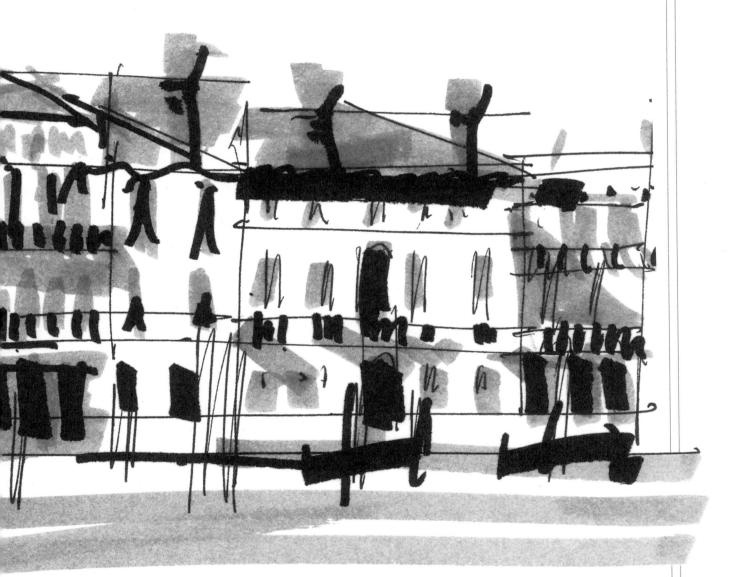

Although from the same Venice series, there is little perspective in this drawing because the buildings on the Grand Canal were flat–on to me.

What interested me was the variety of shapes and proportions of the windows and the differences in size and scale of the buildings.

most comfortable with. I find a square sketchbook easy to handle and when opened flat my 20 x 20 cm (8 x 8 in) sketchbook extends to 20 x 42 (8 x 16 in), allowing me to make a panoramic drawing across two pages.

When I am sketching I use either pencils (B, 2B, 4B) or black ink pens and two or three grey tones of magic marker. I also have an eraser, pencil sharpener and 15 cm (6 in) ruler.

This equipment is fairly light and portable. The sketches in this chapter were all done over one summer, in Italy and France, with a black pen and magic markers.

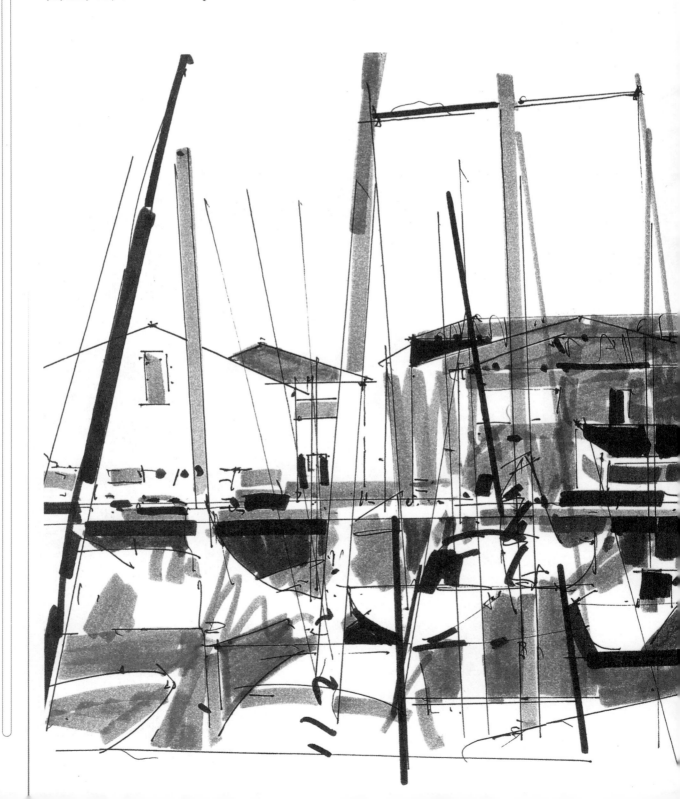

This drawing is of a small harbour in France, using a black pen and three shades of grey magic marker. I have tried to capture the essential elements of this bustling harbour with its houses, boats, rigging and so forth. It is often helpful if you half close your eyes when trying to put down the major elements of a picture since by doing so you eliminate a lot of the superfluous detail.

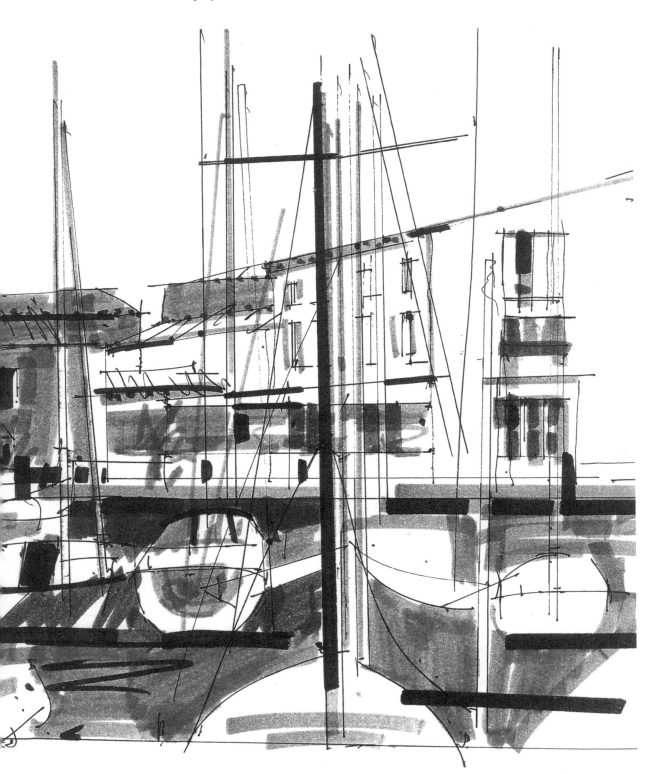

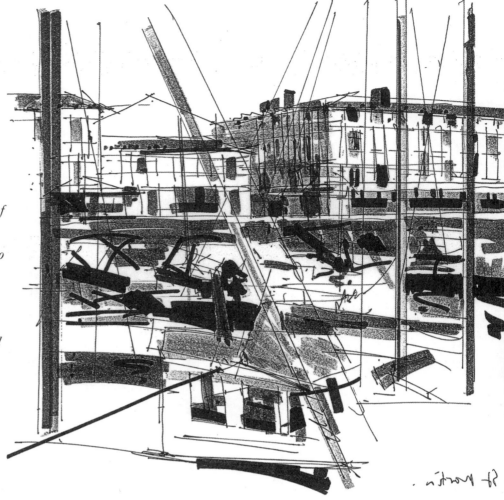

This is another view of the French harbour. This drawing was also started by plotting the major shapes and angles and then putting in the essential tones.

In this drawing of a French town, the car in the foreground arrived while I was drawing some market stalls that were then obliterated by the car. I decided to continue and make the car part of the picture.

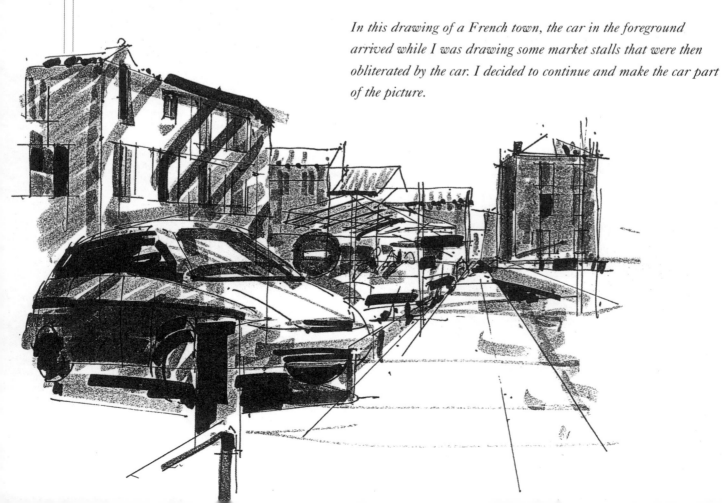

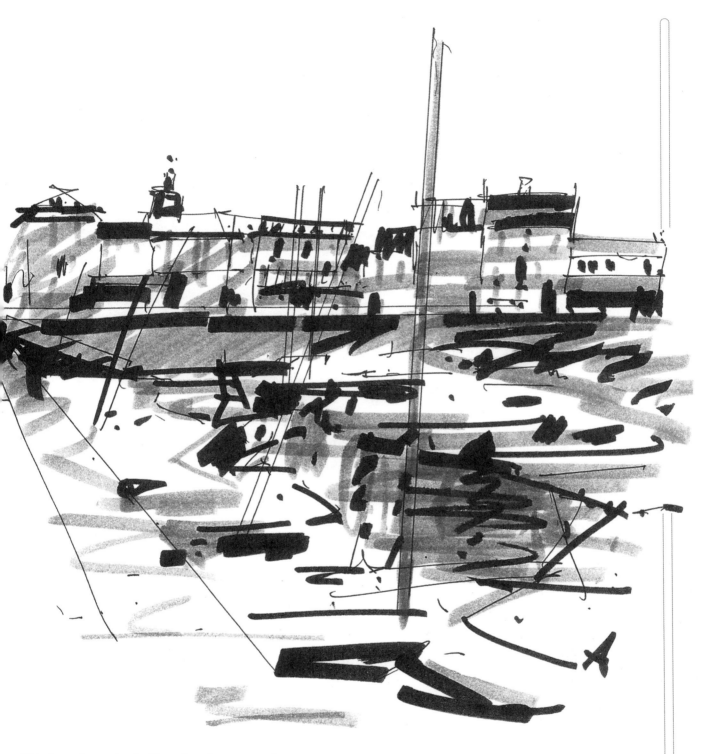

This last picture in the French series was again a harbour scene. However, because I had very little time, I was only able to put down some indications of buildings and boats. As the drawing seems to convey a lot of the life of the harbour, I felt it was successful, even without more detail.

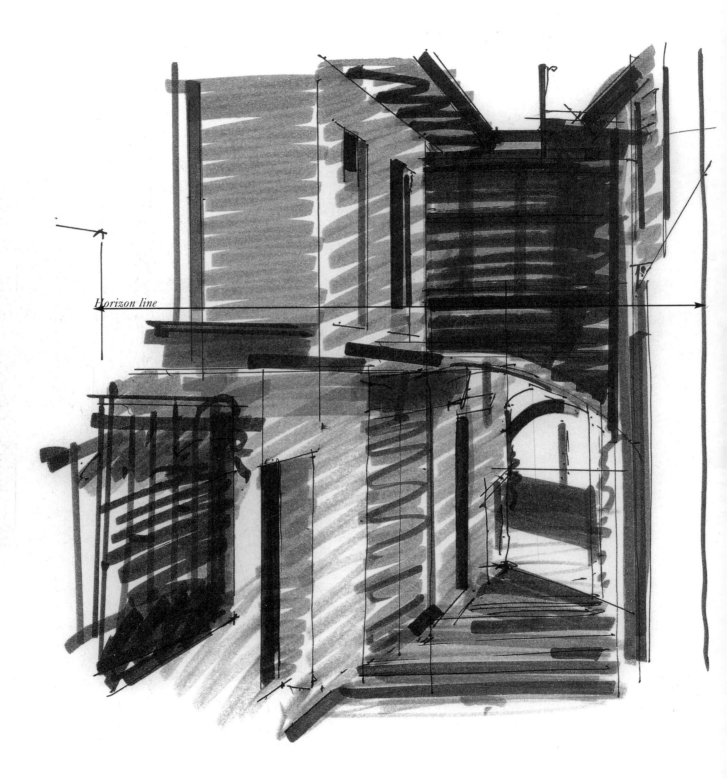

Horizon line

This sketch was done in the Italian Lakes in a hillside town with numerous steps. In this case the horizon line is in the middle of the sketch, so I had to pay special attention to the angles of the windows and the roofs in order to create the feeling of the steps going down into the picture.

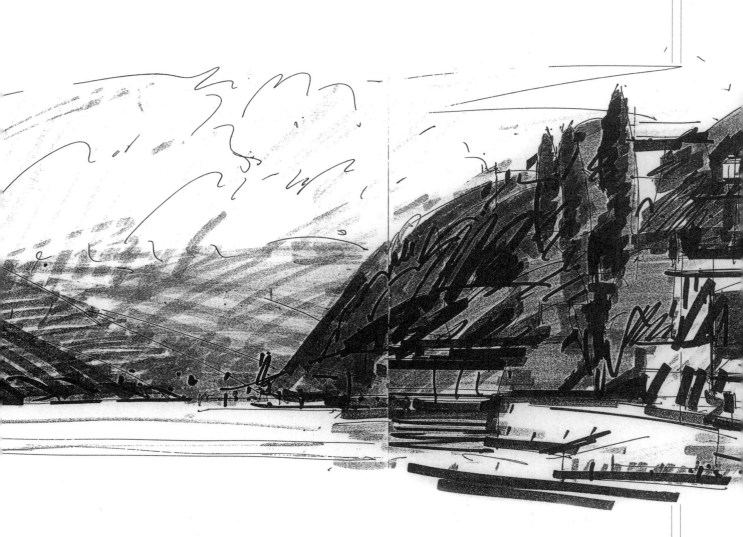

This sketch is of Lake Como, in Italy. As you can see from the division in the centre of this picture I worked across two pages of my sketchbook. I only had time to get the basic structure of the hillsides leading down into the lake. However, I still made sure that the relative sizes of the hills, buildings and trees were correct before I put any tone in the picture.

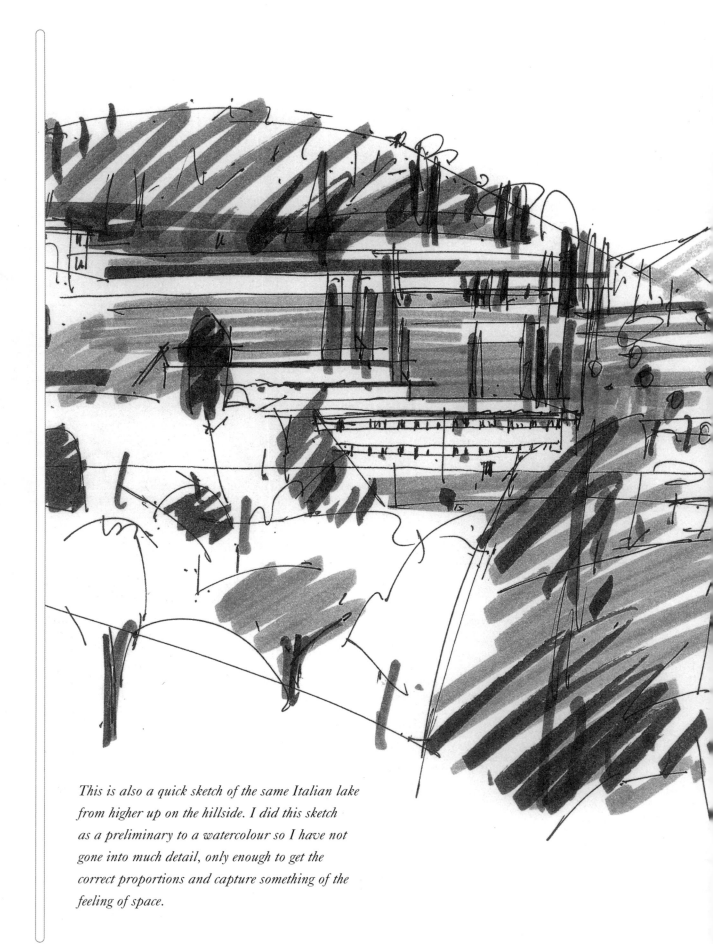

This is also a quick sketch of the same Italian lake from higher up on the hillside. I did this sketch as a preliminary to a watercolour so I have not gone into much detail, only enough to get the correct proportions and capture something of the feeling of space.

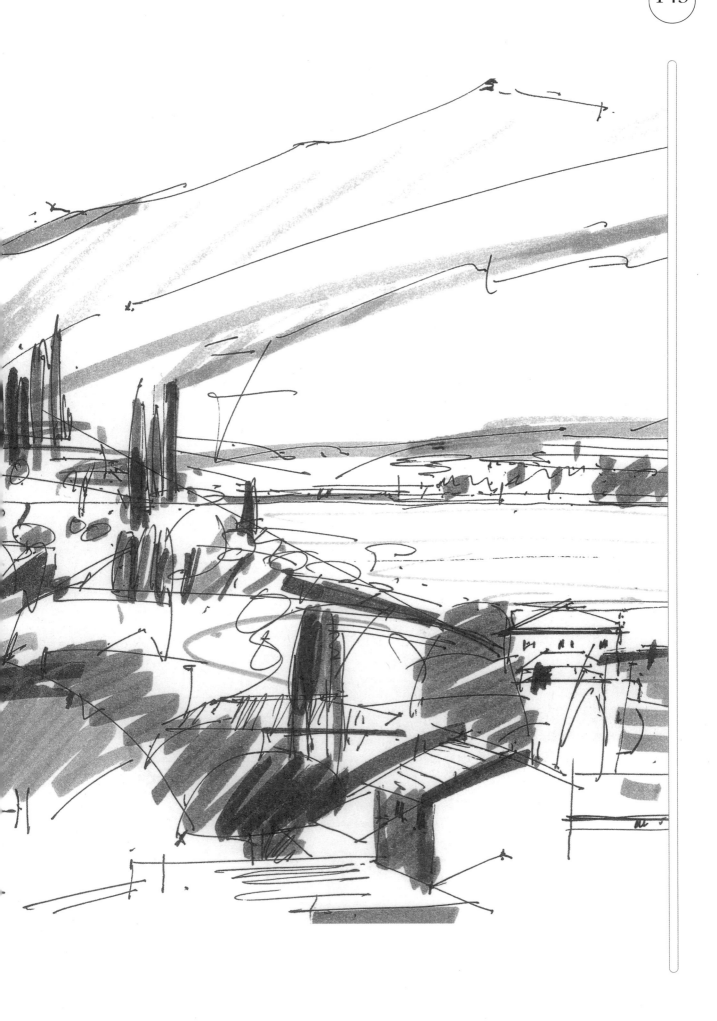

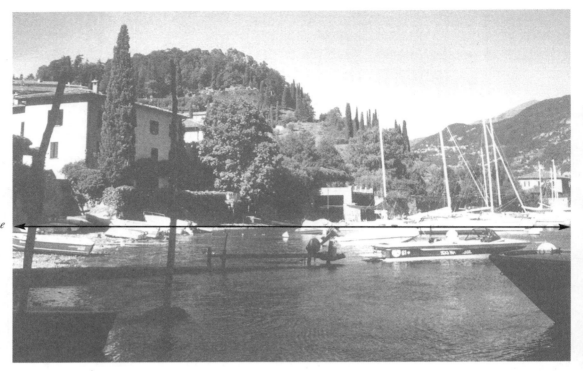

horizon line

This photograph shows a
small lakeside harbour on
Lake Como.

↓ *I have combined a sketch with the photograph to
show what I identified as the major basic shapes in
this landscape.*

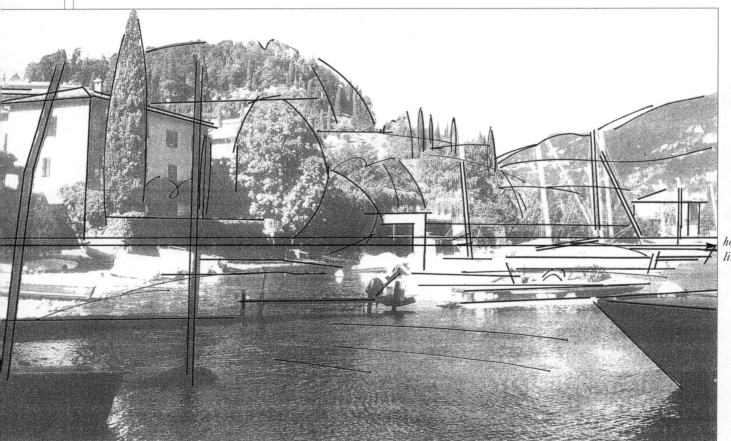

*hor
line*

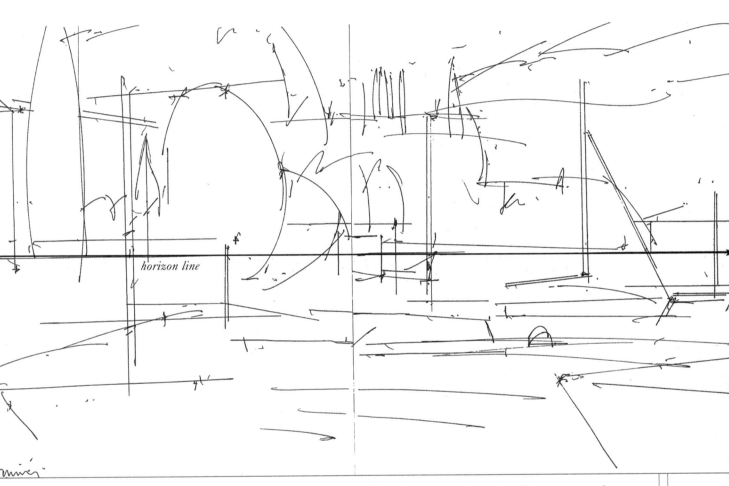

horizon line

Identifying the major shapes is all-important when
starting any sort of representational drawing. You
must not think that because you are doing a sketch
you need not bother with thinking it through as you
would a more formal drawing. Getting this first
stage correct will underpin the next stages.

This is a chalk pastel and charcoal drawing of the Law Courts in London by Brian Johnston. He had very little time and wanted to capture the imposing presence of the building behind the bustle of the people moving past.

OPPOSITE

*In this chalk pastel and charcoal drawing of
the City of London by Brian Johnston the sense of
the size of the building is conveyed in a very
economical way.*

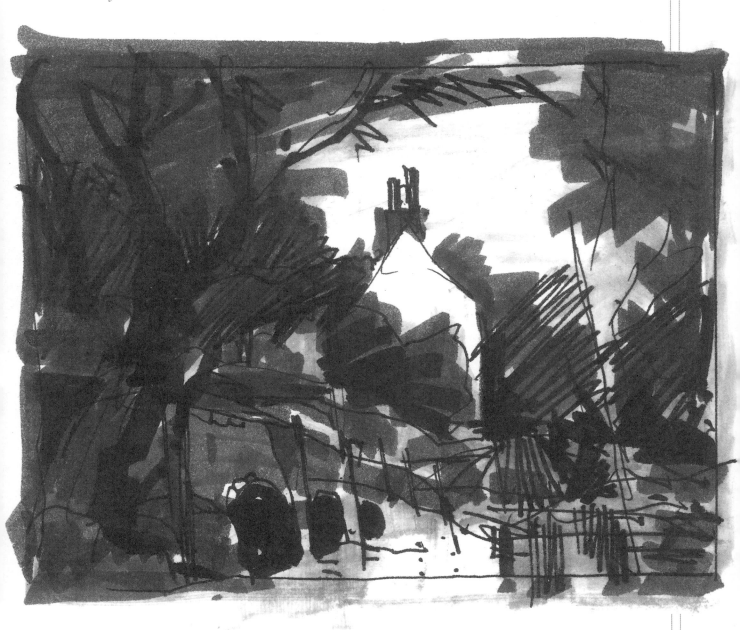

ABOVE

*This sketch by Brian Johnston, of evening light in a
Kentish village, is done with a variety of media:
pen, pencil, chalk and markers.*

SECTION 10

Portraits

In the making of a portrait, the aim is to capture

not only the likeness but also something of the

character of an individual, or group of individuals.

Although it can take in the whole figure, in the

main a portrait concentrates on the face. Most

artists have drawn or painted self-portraits,

most notably Rembrandt and, more recently,

Francis Bacon.

The basic proportions

You will probably know from your early experience of drawing that the head is basically egg-shaped when looked at from the front, and you will have some idea of what the skull looks like.

What often surprises people, on looking more closely, is the relationship between the parts of the head. For instance, the eyes are midway between the top of the head and the chin. Most people think they are much higher on the head and draw them so.

The tops of the ears are level with the eyes and the bottom with the mouth – and the side view of the head fits approximately into a square. These simple relationships and proportions are worth remembering as we mostly tend to draw heads from the side view, three-quarters view or full face.

However, if we look at the head from an unusual angle – from above or below, for example – these proportional relationships change because of foreshortening. This is

Seen in profile, the head fits approximately into a square. It is important to get the basic shape of the head right and to register how it fits on to the neck before going into too much detail. With a side view, you will need to plot the shape of the forehead, nose, mouth and chin as part of the basic shape.

why you should treat all the objects you draw as a collection of shapes before you start thinking of them as particular objects. The moment we are conscious of what an object is, we endow it with the qualities we know from previous experience. From then on, the way we see it is often distorted by our preconceived ideas.

ABOVE

Although the shape of heads may vary, because of such factors as race, age or gender, they still have the same basic proportions. In drawing this side view of a man it is important to make sure you have the overall shape, including the way the shape of the hair fits the head, before you go into too much detail. Most of the general character lies in these first few lines.

LEFT

Heads seen from the front are basically egg-shaped. The eyes are midway between the top of the head and the chin. The ears are placed between the eyes and the mouth. However, if the head is tilted, there may be a small amount of foreshortening. For this reason it is best to measure and plot the shapes each time to be sure of their position.

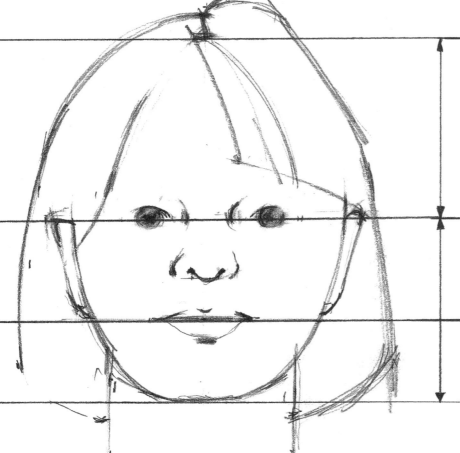

Drawing a head

When you are drawing a head, the same practical rules apply as when you are drawing a figure: make sure that both you and your model are comfortably seated and that you have made a note of both the lighting conditions and the respective positions of both artist and model. If you think the drawing might take more than one session you will also need to note exactly what the model is wearing.

The next step is to decide upon the basic composition of the picture – whether you are going to draw the head and shoulders or take in more of the figure, and whether your view will be full face, profile or three-quarter face. You will find it useful at this stage to use a viewfinder and perhaps make one or two quick sketches to decide which of the many choices of composition you are going to go for.

Once this is resolved, start in the manner in which you have been shown in this book, measuring and plotting all the basic shapes with your pencil held at arm's length as a guide. The four steps shown here take you through the whole drawing process.

STEP 1

First, measure and plot the overall shapes. In this portrait the figure has a small beard which should be seen as part of the overall shape of the head. I have also put in a guideline running down the centre of the head from the forehead to the chin to help with plotting the eyes, nostrils and mouth and calculating the width of the head. Most people, when sitting still, will incline their head one way or another, and it is vitally important to draw the angle accurately since this will have an effect upon the angle of the shoulders also.

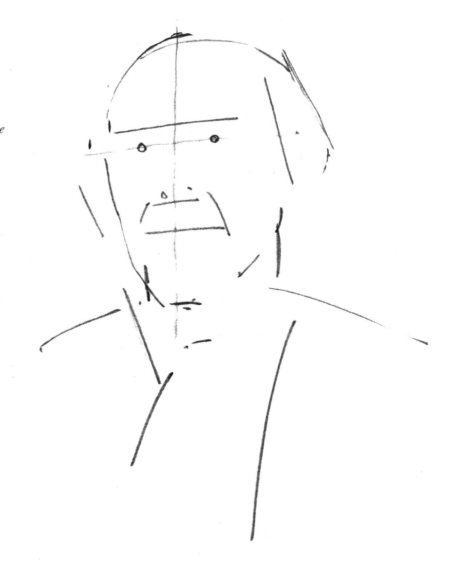

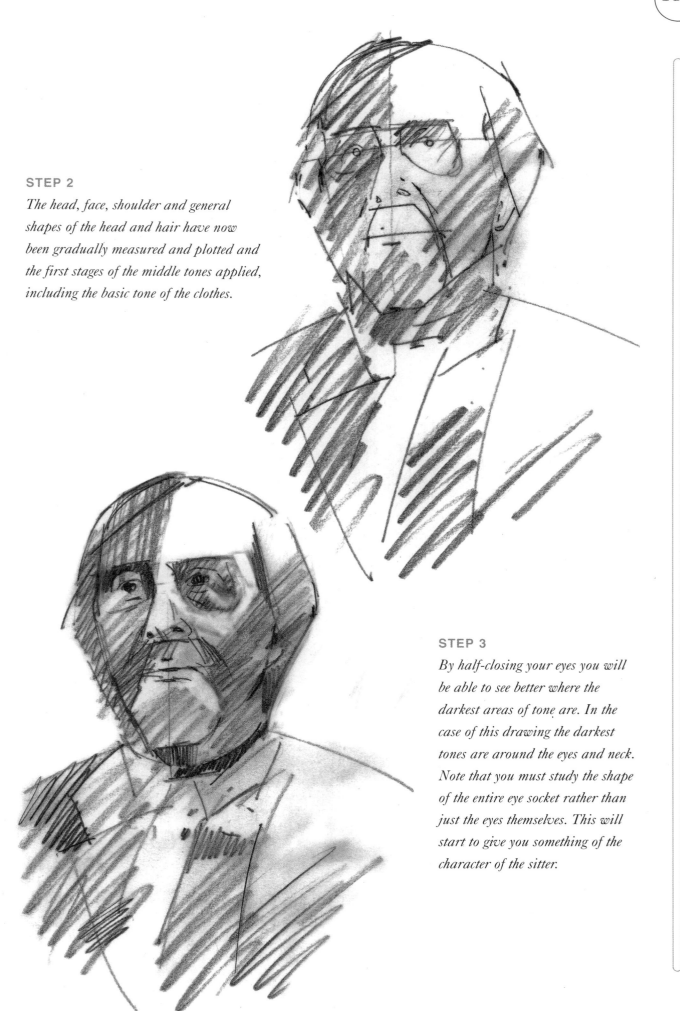

STEP 2

The head, face, shoulder and general shapes of the head and hair have now been gradually measured and plotted and the first stages of the middle tones applied, including the basic tone of the clothes.

STEP 3

By half-closing your eyes you will be able to see better where the darkest areas of tone are. In the case of this drawing the darkest tones are around the eyes and neck. Note that you must study the shape of the entire eye socket rather than just the eyes themselves. This will start to give you something of the character of the sitter.

STEP 4

As you continue to work into the drawing, refining the larger shapes into smaller ones and looking more into the graduation of the tones, the character and form of the sitter will emerge. By working over the drawing as a whole and not concentrating on too much detail in any one area you should be able to decide when you have achieved what you want from the drawing.

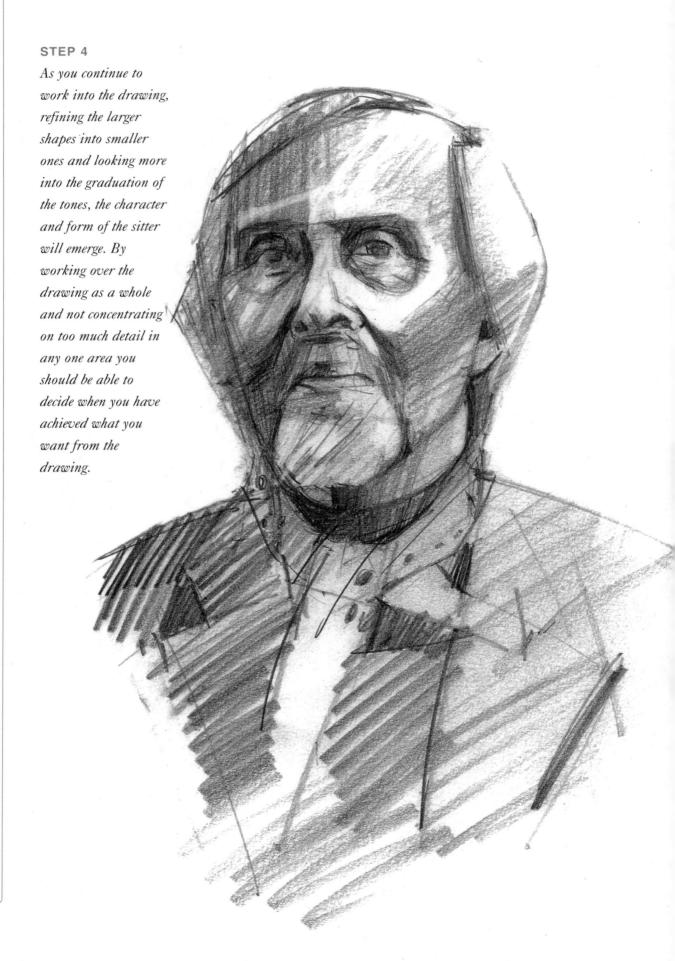

Portrait sketches

It is not always possible to have a model sitting for an hour or two. However, even in half an hour you can still do a useful drawing – the secret is to be able to select the basic elements of the head and shoulders that give the character of the sitter and capture something of the way the light falls, giving volume and atmosphere.

The following four examples were all done in less than half an hour. If you study them you will see how, even if the head is held at an unusual angle, the first thing to get down on paper is the shapes of the head, neck and shoulders. Only when these are right should you start to plot where the eyes, nose and nostrils are, and to make sure they have the right relation to each other. Finally, adding tone brings the three-dimensional quality that describes the character and form of your sitter.

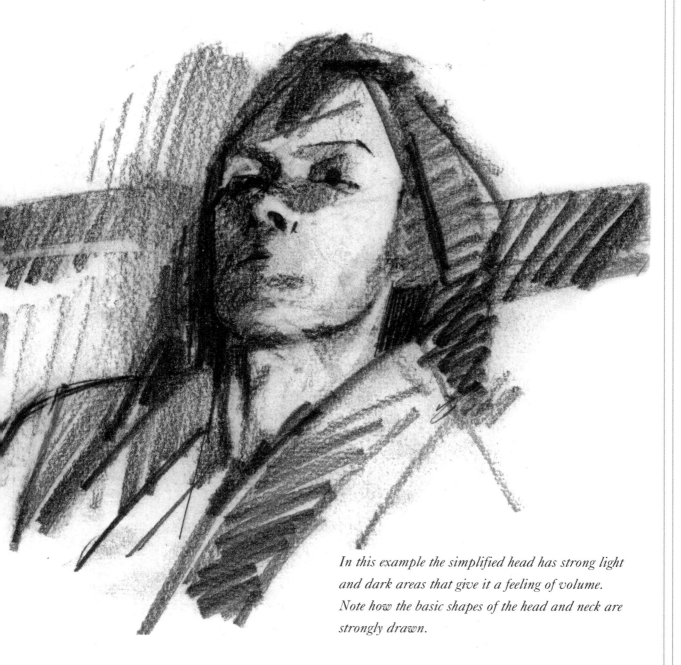

In this example the simplified head has strong light and dark areas that give it a feeling of volume. Note how the basic shapes of the head and neck are strongly drawn.

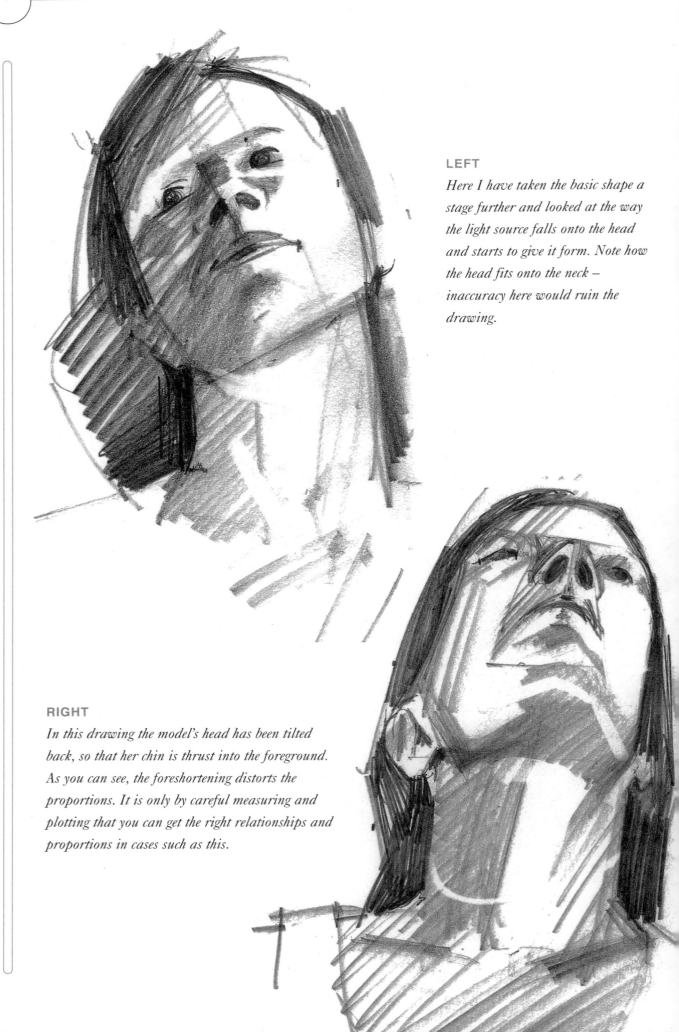

LEFT

Here I have taken the basic shape a stage further and looked at the way the light source falls onto the head and starts to give it form. Note how the head fits onto the neck – inaccuracy here would ruin the drawing.

RIGHT

In this drawing the model's head has been tilted back, so that her chin is thrust into the foreground. As you can see, the foreshortening distorts the proportions. It is only by careful measuring and plotting that you can get the right relationships and proportions in cases such as this.

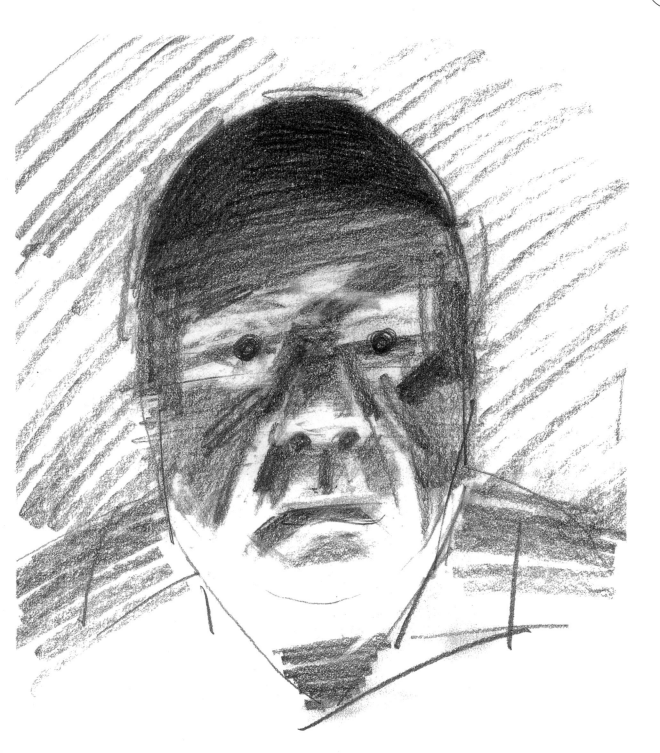

ABOVE

In this example there is a strong light source coming from beneath the model's head, giving him an ominous appearance. How the light source is deployed plays a major part in the overall mood of a portrait.

TIP

Asking the model to hold a position with the head tilted for any length of time may cause strain on the neck, so make sure you offer plenty of rest breaks.

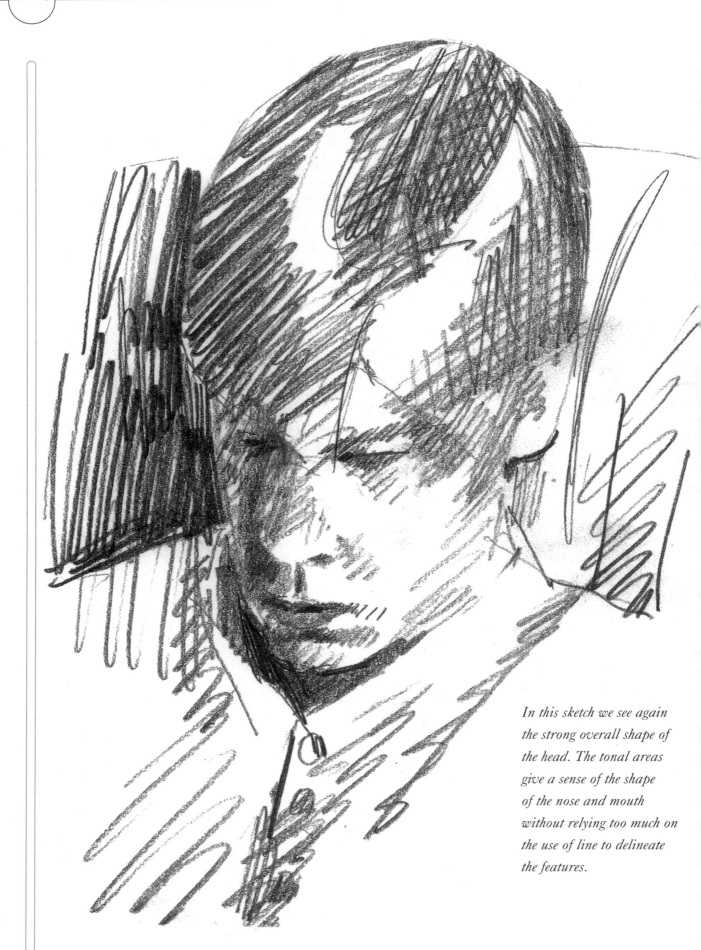

In this sketch we see again the strong overall shape of the head. The tonal areas give a sense of the shape of the nose and mouth without relying too much on the use of line to delineate the features.

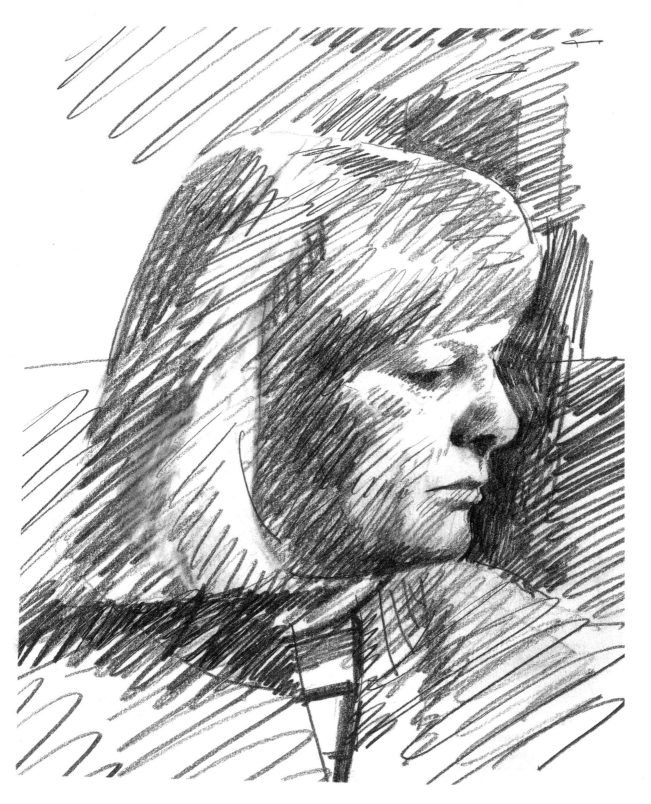

This example shows how cross-hatching can be used effectively to create the tone and volume of the sitter's head and also how a profile can be used effectively to give something of the character of the sitter.

Composition

Drawing the head is just one aspect of portraiture. It may be regarded by many as the most important but, if you look at portraits by famous painters such as Jan Vermeer and John Singer Sargent, you will see that the composition is also of major concern. You have to decide what sort of setting you are going to use and whether your portrait is going to be head and shoulders, to the waist, or a whole figure.

Also important is the strength and angle of the lighting. If you set a figure against a dark background with the light source on the head it will tend to stand out and have a dramatic quality. However, if the light is too directly on the face, it will flatten the features. If it comes from the side it will highlight the form but, if too strong, can look foreboding, while light from below has a theatrical, sinister character.

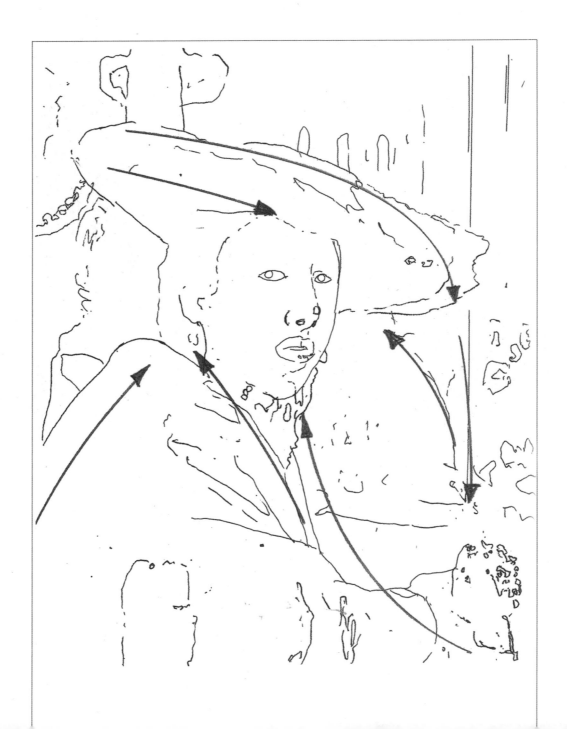

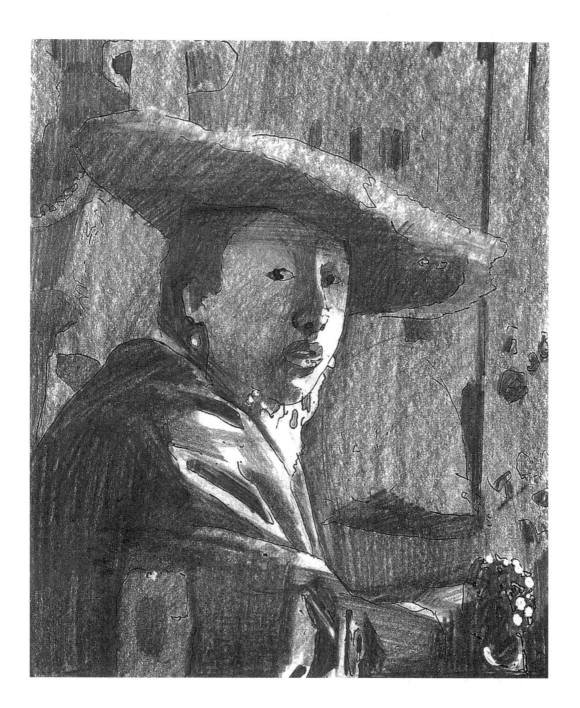

After Vermeer

Here I have taken Vermeer's Girl with the Red Hat (1665–6) *as an example of portraiture. Although the Vermeer is not a drawing but an oil painting, I have done a tonal drawing of it as I* believe it shows how composition and lighting is paramount in making a good portrait. My initial drawing (opposite) shows how both the composition and the tonal arrangement lead the eye round the picture.

After Singer Sargent

My second example is John Singer Sargent's Portrait of Henry James (1913). *As with the previous example, the composition and tonal arrangements are all important. What is interesting to note is how, in this and the Vermeer, the lightest parts of the picture are a very small proportion of the whole and the use of light gives both works their power and feeling of solidity.*

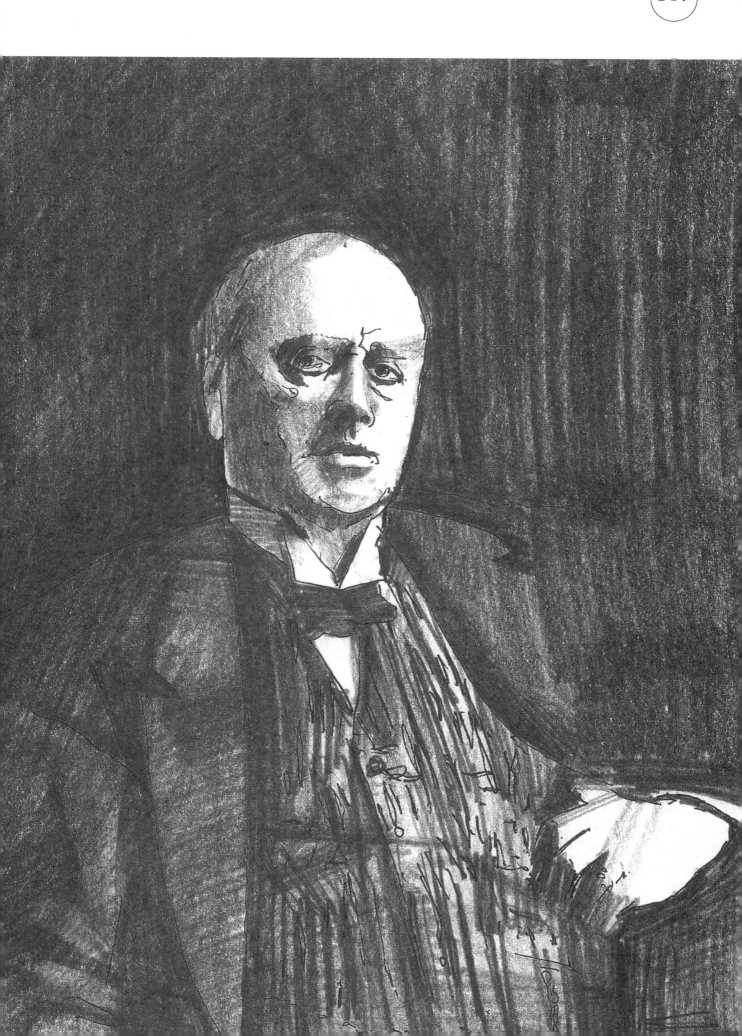

Self-portraits

To start with, seat yourself comfortably in front of a good mirror. If you are going to take more than one sitting to do the drawing, make a note of what you are wearing, the light conditions, how far away you are from the mirror and what you are sitting on.

You will see that it is quite difficult to keep an expression other than that of concentration when drawing yourself. I am often accused of giving myself a stern expression in self-portraits, when in life I tend to smile a lot. You will see in the examples of other artists that they have rather stern expressions. Do not let this put you off. It is more important to tackle the subject than worry about the expression.

Self-portrait

STEP 1

As before, it is vitally important to make sure the shape of the head is right. However, you will first have to get used to measuring when your reflected hand is in the way. Do not be misled into taking some measurements with your real hand and some with your reflected hand. You have to find the most convenient way of circumventing this by twisting your arm about or even doing the measurements with your other hand at times.

Once you have the basic shape of the head, indicate the other major points – nose, mouth, eyes and ears and how the head fits with the neck.

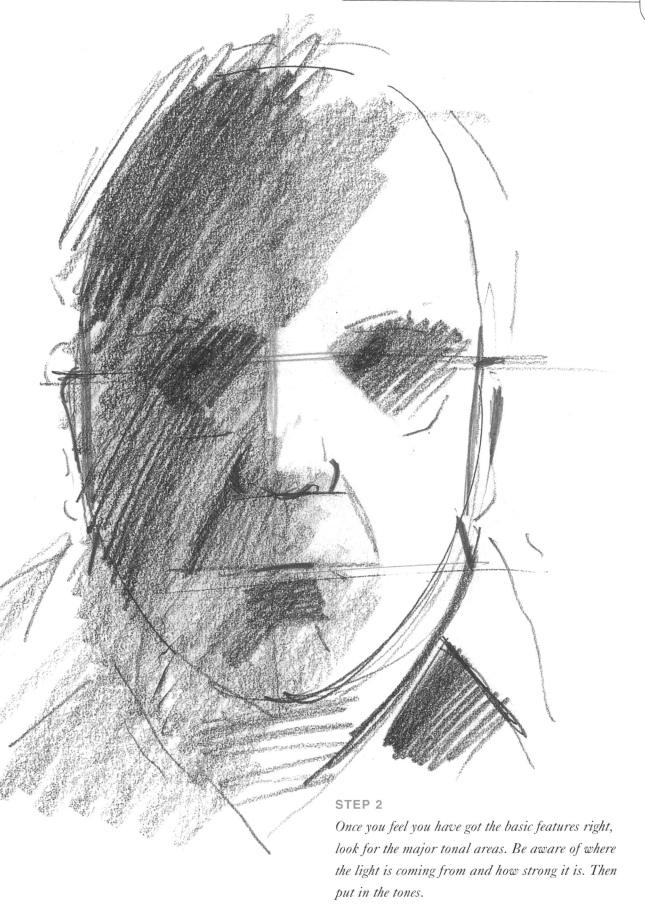

STEP 2

Once you feel you have got the basic features right, look for the major tonal areas. Be aware of where the light is coming from and how strong it is. Then put in the tones.

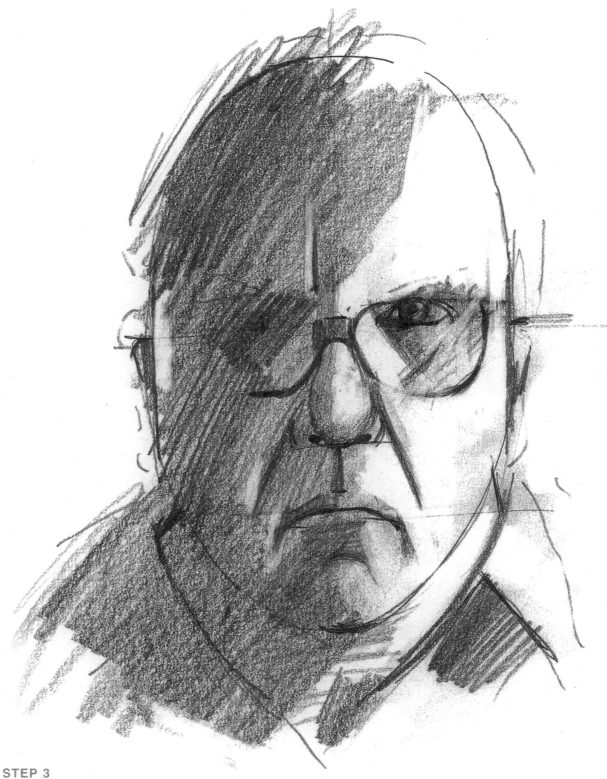

STEP 3

Now move on to put more detail in the features. Always work first on those that are the most visually prominent. For instance, the left eye is less dominant here than the right because of the shadow falling across that side of the face.

Do not forget to take frequent looks at the overall picture in order to make sure that it is working as a whole and you are not altering the basic shapes or unbalancing it by going into too much detail in one area.

STEP 4

As you continue to work up your drawing make sure, when looking at features such as ears, that you are looking for the shapes that are there, rather than what you know an ear to be like. There may also be reflected light which you need to be aware of. This self-portrait was done with strong sunlight to the right, therefore there are deep shadows. If you want less contrast, sit in more subdued light.

Should you want a side view rather than a front view you can use two mirrors, but this is often more difficult to set up and to replicate exactly.

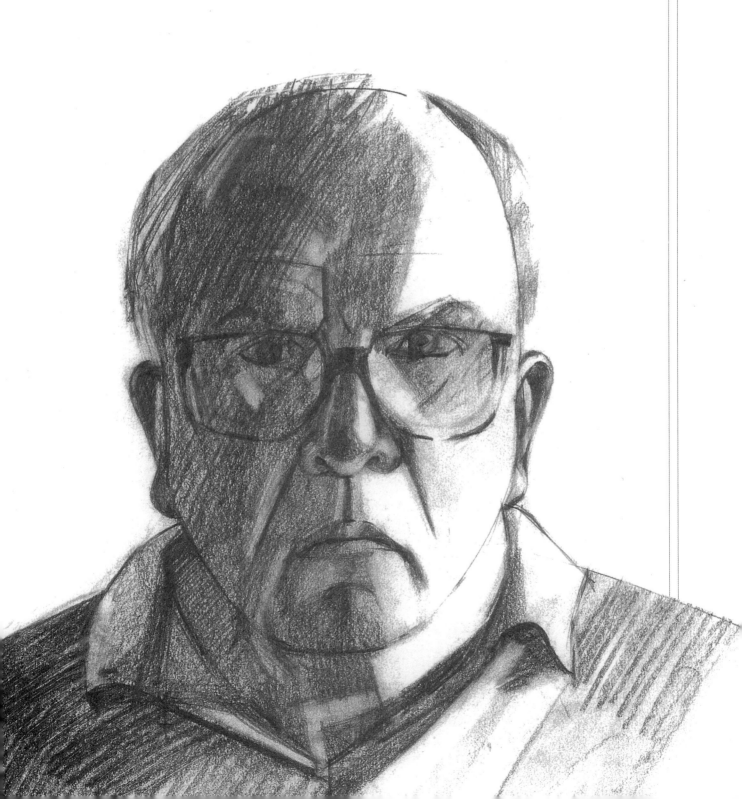

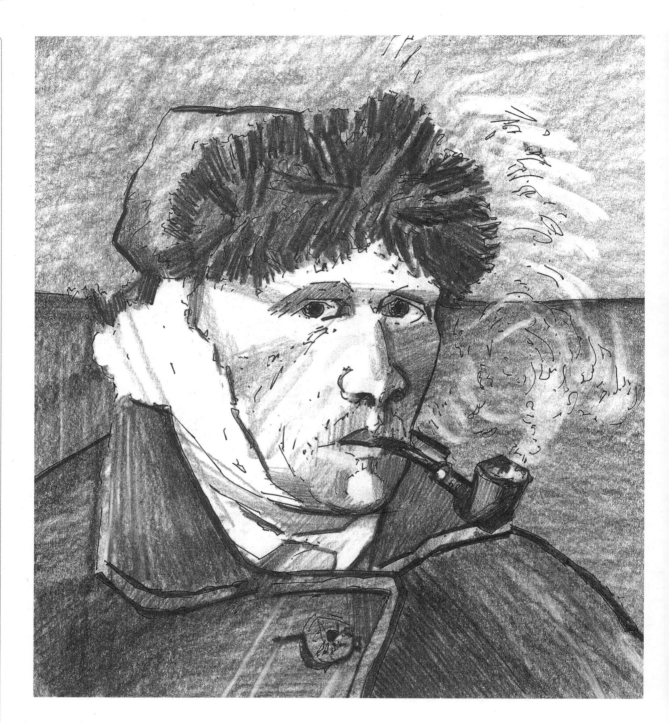

After Van Gogh

My tonal study of Vincent van Gogh's Self-Portrait
with a Bandaged Ear *shows how the focus of the
picture is around the eyes. Note how he has used the
interplay of light and dark tone to lead your eye
into the picture and on to the upper part of the face.*

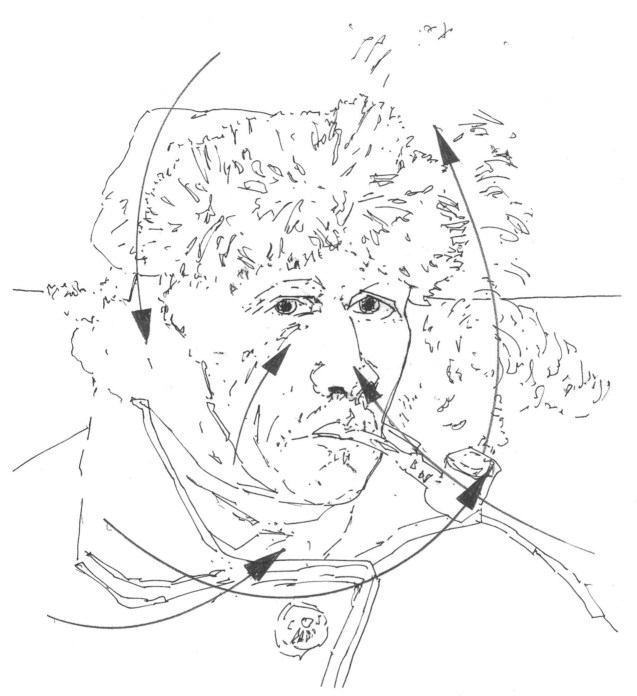

This schematic drawing shows how the strong lines around the face lead the viewer's eye to circle it, drawing the attention again and again to the stare of the eyes.

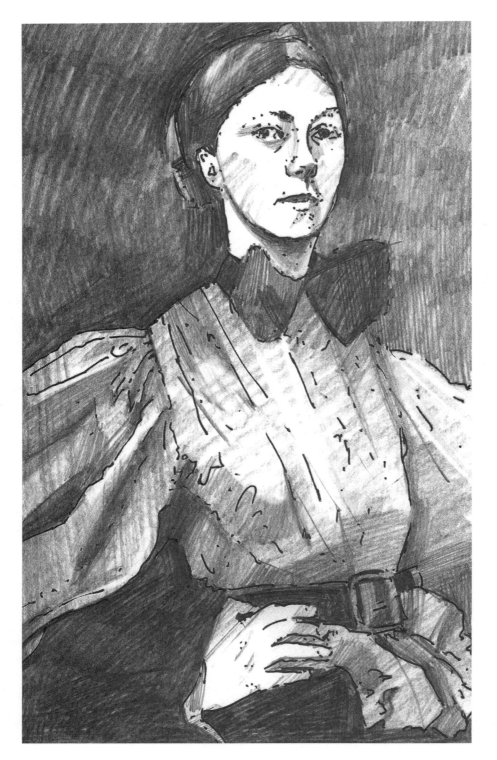

After Gwen John

In this tonal study taken from Gwen John's self-portrait you can see that she painted with her right hand – although, because she is looking in a mirror, it appears to be her left. Note also that this is a three-quarter length view, with the face and the hand the lightest areas of the picture.

OPPOSITE

This schematic drawing shows how some elements in the picture – the blouse, the large bow at the neck and the tone of the picture – help move the eye to the face, while the position of the hand brings the eye down in order to keep it moving round the picture.

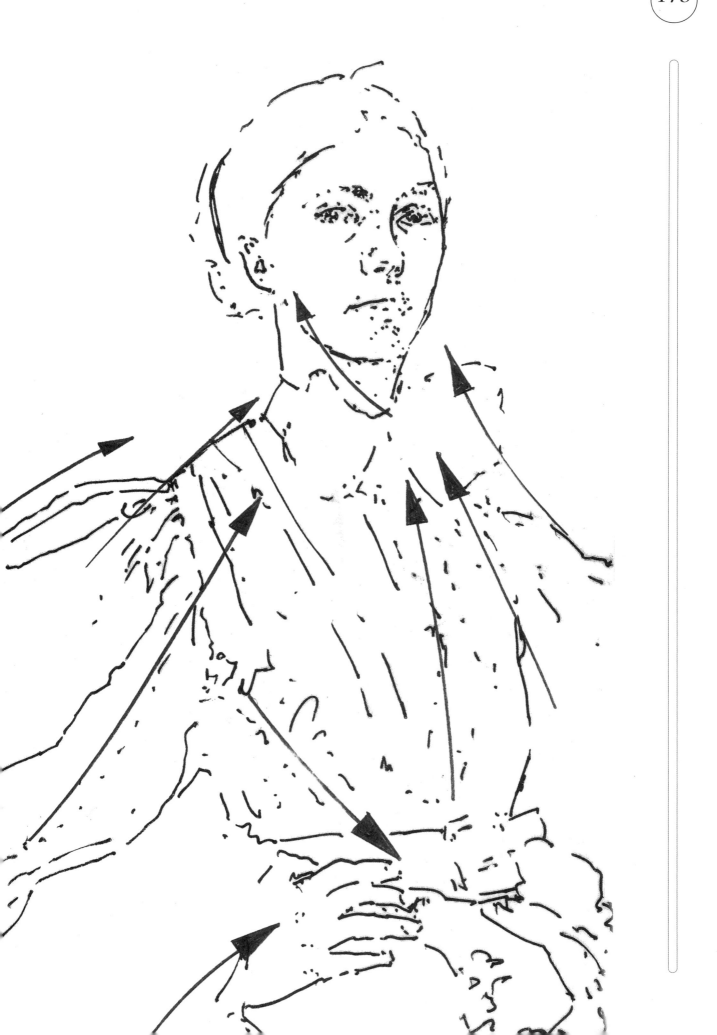

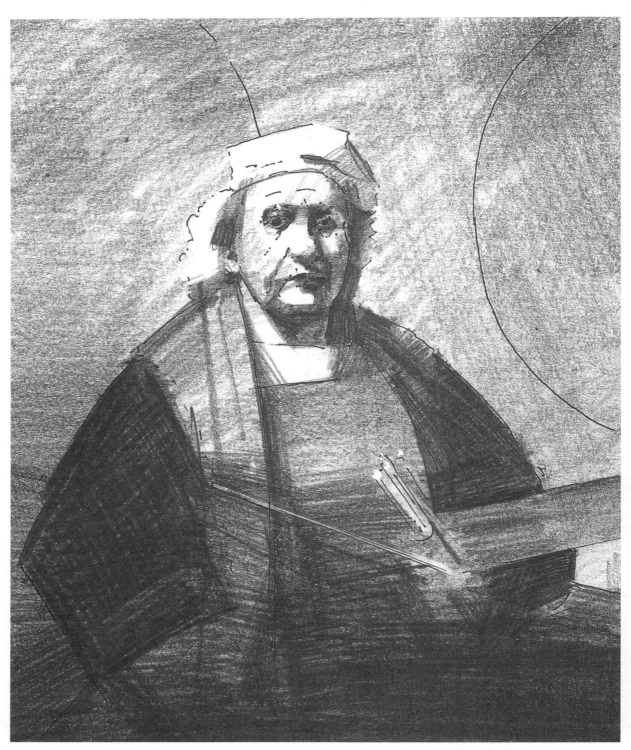

After Rembrandt

This tonal study, taken from Rembrandt's Self Portrait with Two Circles (1665–9, Kenwood House, London) shows how the light areas are concentrated on the face. The rest of the body is in shadow. The face also has more detail than the rest of the figure which, including the hands, blends into the darkness. However, the body still has a feeling of bulk and volume.

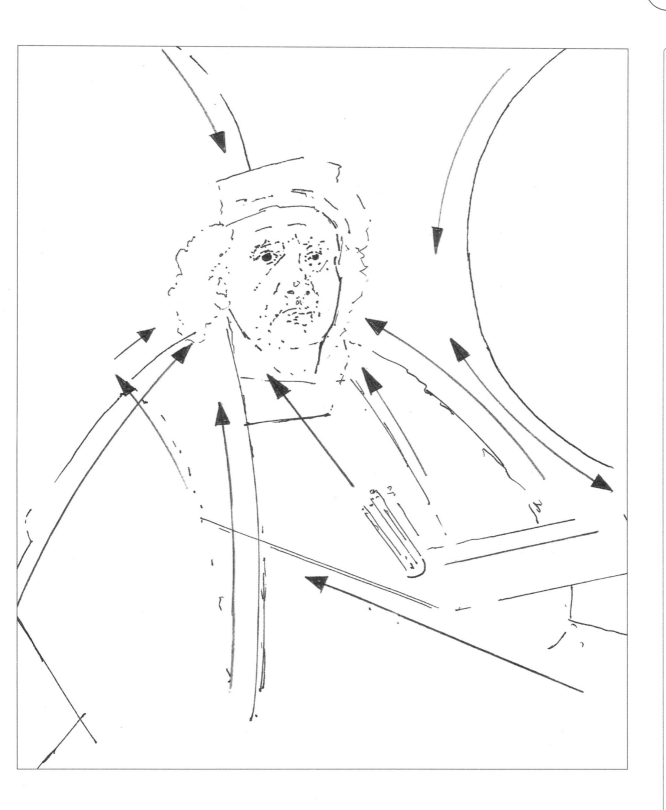

This schematic drawing taken from Rembrandt's
self–portrait shows how the eye moves around the
picture, led by the tone, colour and shapes within it.
The arrows also show how the attention keeps
returning to the head after each journey around
the picture.

SECTION 11

Using Photographs

The idea of an artist using photographs for reference is sometimes frowned upon but in the mid-19th century, artists such as Manet, Degas, Bonnard and Rodin took advantage of what was then the new technology. Provided you recognize their limitations, photographs can be useful tools.

The danger with using photographs is that they give you a very limited visual experience. The reason for this is that the process of photography has already selected the two-dimensional shapes out of a three-dimensional world and, depending upon how good the reproduction of the photograph is, much gradation of colour and tone may have been lost. Even where this is not the case, a photograph will give only an idea of what it would be like to experience the reality. This is partly because of its small size and partly because the detail is less crisp than in the three-dimensional world.

As a photograph has only reflected light on paper to work with, a landscape scene will inevitably have lost some of the intricacies that the person wielding the camera probably hoped to capture. However, in situations where there is a lot of action – people or objects moving very quickly – the camera is invaluable. You may be able to jot down something of the movement with a line or gesture but there is no chance that you will be able to record the event on paper with the measuring method.

If you decide to draw from a photograph it is better to use one that you have taken yourself, when you will also have your memory of the original view to help you flesh out the static image in the photograph.

You can transfer the image in the photograph onto paper using the same method I employ when I am copying a drawing onto a canvas and enlarging or reducing it.

SCALING UP

This drawing shows how the image in the photograph can be enlarged, keeping exactly the same proportions. Draw a diagonal line stretching from the bottom left-hand corner of the photograph to the top right-hand corner of the paper. Drawing a horizontal and vertical line at any point along this diagonal line will give you a rectangle in exactly the same proportion as the photograph.

This method is based on a horizontal, vertical and diagonal grid. One of its advantages is that, regardless of the size and proportion of your photograph, there is no more measuring required after the first horizontal and vertical lines have been drawn. The rest of the lines follow through from the earlier ones as you continue to construct the grid.

First, place the photograph on a sheet of drawing paper. If you want to make the drawing larger than the photograph, draw a diagonal line from the bottom left-hand corner of the photograph to the top right-hand corner, then extend this line on your drawing paper to the size you want the drawing of the photograph to be. A horizontal and vertical line drawn from any point on this diagonal line will create a drawing area in the same proportion as the photograph.

If you want the drawing to be the same size as the photograph, start by drawing round the edges. If you want it to be smaller, start as you would if you were doing it the same size and then, when you have drawn round the edges, take the photograph away and draw a diagonal line from the left-hand bottom corner of your rectangle to the top right-hand corner. Decide where on that line you want the top right-hand corner of your smaller drawing to be, then draw horizontal and vertical lines to mark the edges of your drawing. As the diagonal still has the same angle as the original, the drawing will be in the same proportion as the photograph.

Using a grid

Once you have established the size of your drawing, draw in the other diagonal from the top left-hand corner to the bottom right-hand corner, making a cross.

Then draw the vertical and horizontal lines going through the point where the diagonals cross. Make sure these two lines are parallel with the sides of the drawing.

Once you have done this, draw further diagonals in each of the four rectangles you have created, giving you four rectangles with crosses in them (Steps 1 and 2).

STEP 1

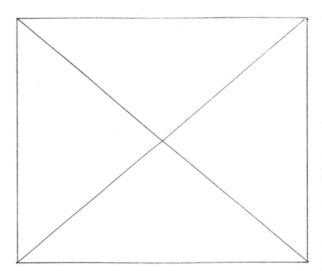

STEP 2

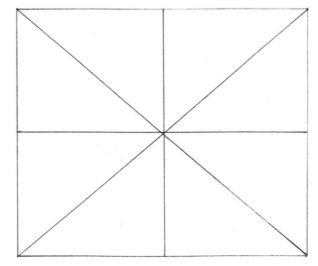

STEP 3

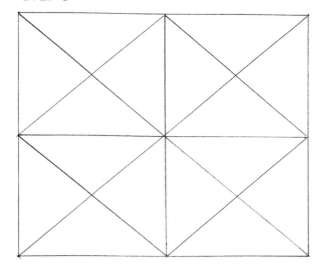

STEP 4

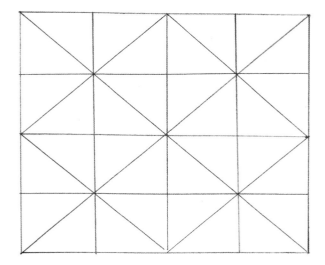

Using the points where the diagonals in the four rectangles cross, draw horizontal and vertical lines (Steps 3 and 4). You now have the basic grid. If you want a more complex grid because the shapes in the photograph are complex, continue to draw more diagonals, making more crosses in the smaller rectangles you have created and joining the intersections with more horizontal and vertical lines.

RIGHT

This drawing shows three different-sized rectangles, all with the basic grid. Because they all come from the same diagonal they all have the same proportions.

Example 1: A vase

A simple object such as a jug, vase or cup with a smooth symmetrical shape makes an easy starting point for working with a grid.

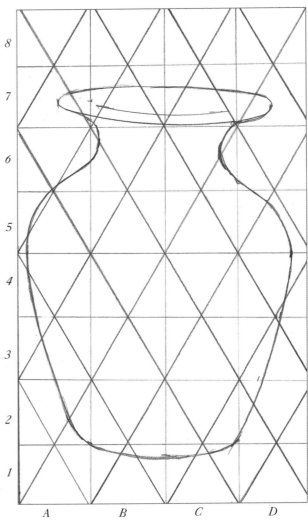

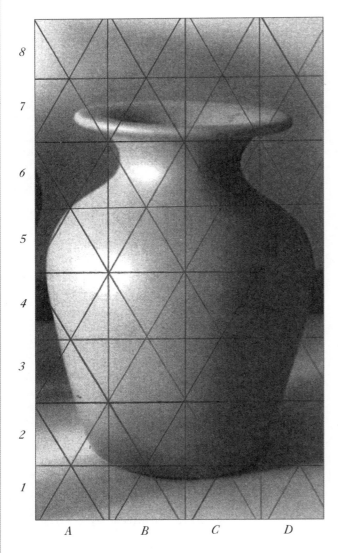

STEP 1

Draw the basic grid over the photograph by following the method already described.

STEP 2

Keeping the same proportions as those of the photograph, draw the basic grid on a sheet of drawing paper. Then draw in the vase, following exactly the lines of the object in the triangles and squares in grid on the photograph. You will need to make judgements about the exact placing of lines within a triangle and you may find it helpful to plot a few places where the gridlines intersect with the shape of the vase and then join them up.

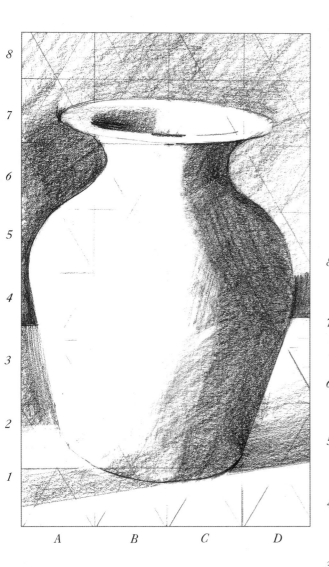

STEP 4

Continue to put in more graduation of tone, again using your eraser to create highlights and erase grid lines. By the end you will notice that the original lines in the line drawing you made at step 2 have now disappeared, because the shape of the vase is now made by the tones of both the vase and the background.

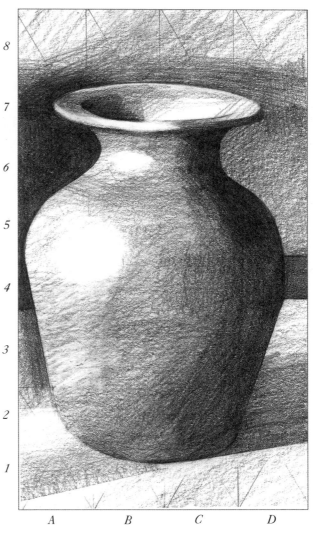

STEP 3

Once you have copied the basic structure of the shapes in the photograph, start to put in the lights and darks as you would if you were measuring and plotting from real life. At this stage, you can also use your eraser to take out some of the grid lines.

Example 2: Zoe

For this example I
have used my
granddaughter who,
at just a few
months old, has
quite a simple
facial structure.

STEP 1

*I approached her
portrait in exactly the
same way as the vase
by drawing the basic
grid over part of the
photograph. You will
notice that the grid
around the face has
been drawn with
smaller units than the
rest of the photograph.
This is because there
are more shapes in this
part of the face and
these need to be drawn
as accurately as
possible.*

STEP 2

*Transfer the main
shapes from the grid
on the photograph to
the grid on the
drawing paper. It is
important that this is
done accurately.*

STEP 3

As with the vase, start to put in the main tonal areas and continue to break the main shapes down into similar ones. For example, look at the similar shapes within the general shape of the ear. It is worth noting here how from this point of view the ears are quite different shapes.

STEP 4

In the final drawing, notice how important it is to get the shape of the whole head right.

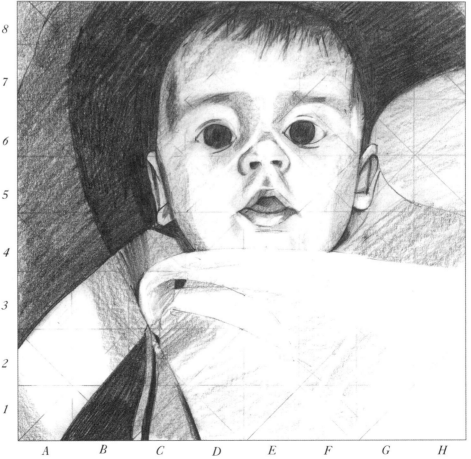

Example 2: Group portrait

This group photograph may seem complicated, but if you build up a group picture gradually you will be able to achieve a good result. Study your photograph carefully before you start work. First look at where the light is coming from, where the major light and dark areas are and what shapes they are. Note where the most detailed parts of the picture are.

As I have already described, when you draw the basic grid on the photograph put in as many triangles and squares as you need to judge where your lines should go.

If the triangles and squares of the grid are too large it is more difficult to judge where a shape belongs.

As you can see from the examples, numbering and lettering your photograph so you can read it like a road map will help you find the right place on your grid when copying.

You can see from the photograph used below that there are a number of areas that are quite complicated, such as the baby in

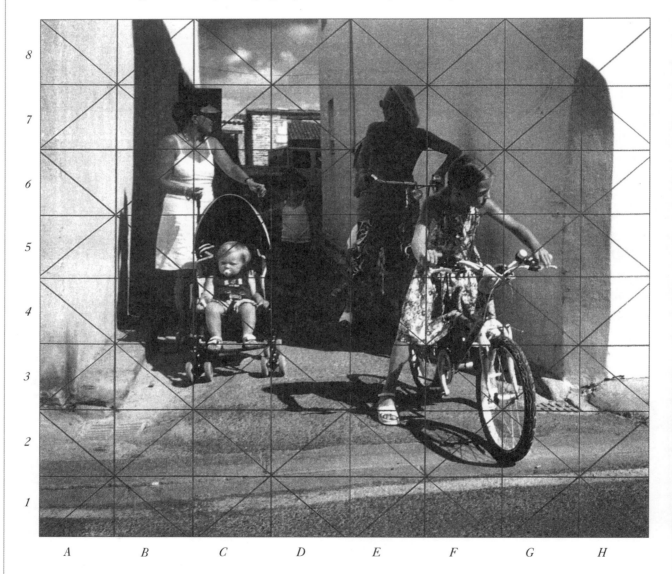

STEP 1

To begin with, draw the grid on the photograph.

the push chair and the area around the hands and handlebars of the girl on the bicycle. It is areas like these that may need more squares and triangles on the grid.

Once you have as many triangles and squares as you want on the photograph, draw the same amount on your paper.

When you start copying from your photograph, try not to go into too much detail until you have the basic shapes of the whole photograph. It is important you look at all the shapes in the photograph – the shapes of the shadows as well as the shapes of the objects. Note for instance the shapes that make up the shadow of the figure on the bicycle. It is easy to underestimate the importance of shadows and pay too much attention to the objects.

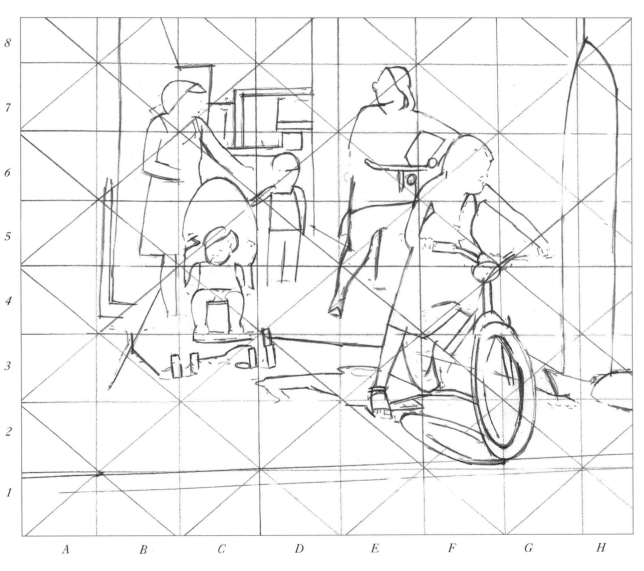

STEP 2

Draw in the basic shapes on your paper, using the grid to work out their size and position.

TIP

If you do not want to draw on the photograph itself you can take a photocopy and use this to mark out the grid.

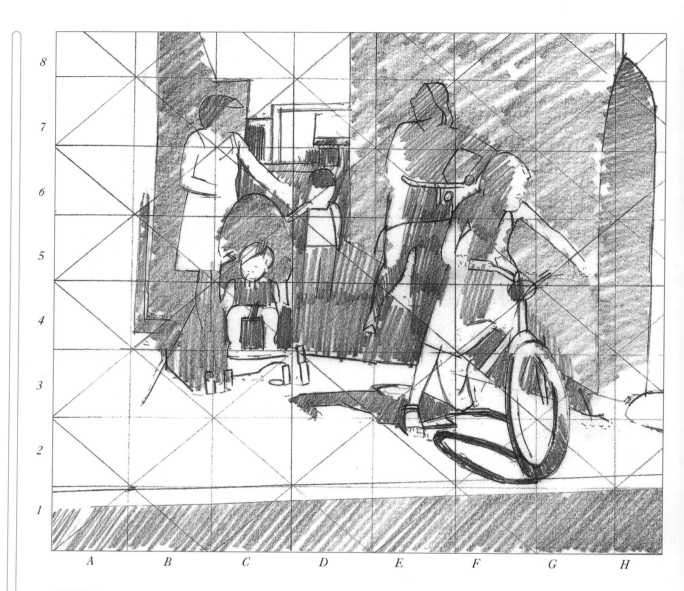

STEP 3

Begin to develop the drawing. Remember to keep the detail at the same stage all over, working from putting in the middle tones to dark and then those in between.

It is worth noting also how the strong contrast of the shadows with the light areas give the picture the feeling of sunlight.

Once the basic shapes are in and you have started to put in the tone, continue to break the shapes down into smaller shapes until you have the amount of detail you require.

Do not forget that your eraser is very useful for putting in the light tones and cleaning up the edges of shapes that might get smudged as you work on the drawing.

As the picture will probably have people in it that you know, the most difficult part of

the drawing will be stopping yourself from trying to make the faces recognisable and putting in far more detail than is necessary.

It is very important to keep your eyes and mind concentrated on the shape of the head and its relative lights and darks (tone), rather than on whether it looks like "Mary" or whoever.

In fact, you will often find that if you get the general shape of the head right as well as the shapes of the main shadows on the face this will be enough to give you the character of the people in the photograph.

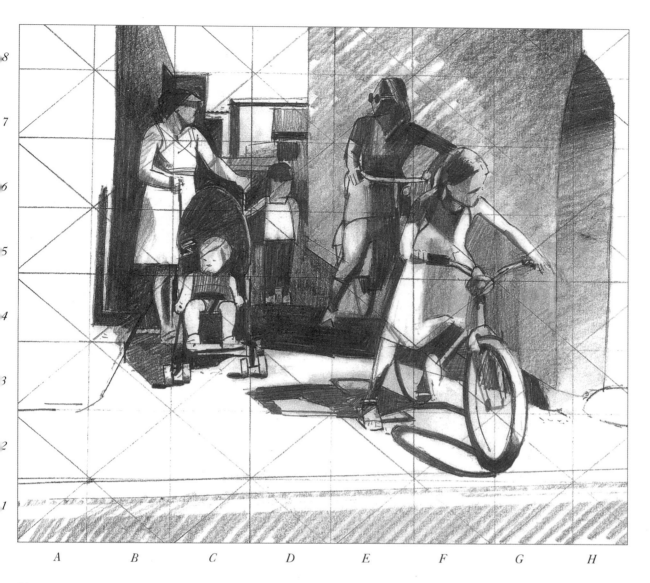

8
7
6
5
4
3
2
1

A B C D E F G H

STEP 4

In this final stage the contrast between the darkest and lightest shapes have been developed, as has more of the detail of the picture. You need to decide how much more detail, if any, you need to obtain what, for you, is the essence of the photograph. Once this has been achieved, erase any of the grid lines that remain.

Example 4: Portrait of Father

I took a photograph of my father and translated it into a more detailed drawing to show you how far this method of reproduction can be taken.

STEP 1

I decided to take only part of the portrait for the drawing, so I drew the grid only on that part of the photograph I wanted to copy and enlarge.

Example 4: Portrait of Father

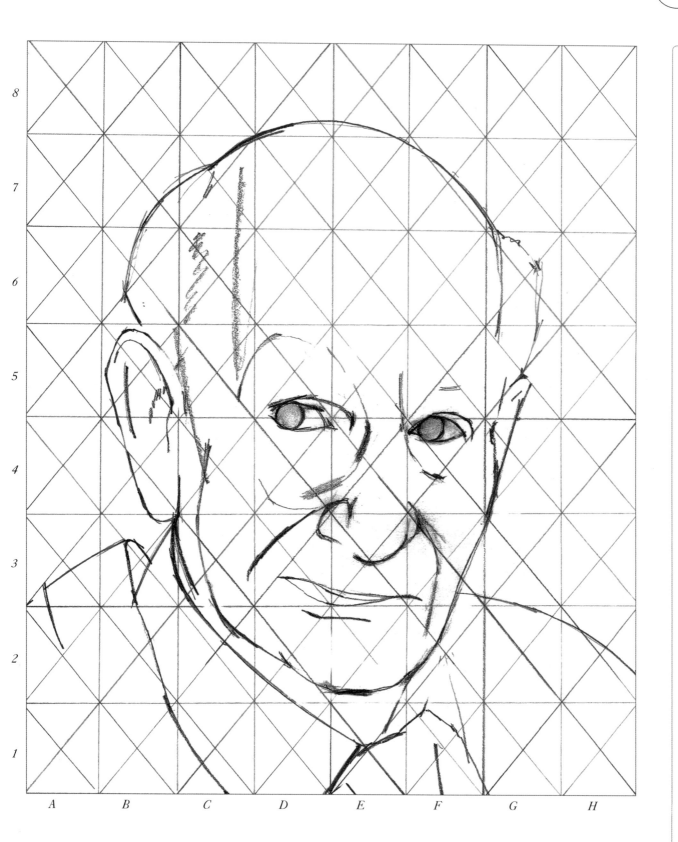

STEP 2

When putting in the major shapes it can be helpful to number the grid like a road map in order to avoid confusion as to which bit of the face is in which square or triangle.

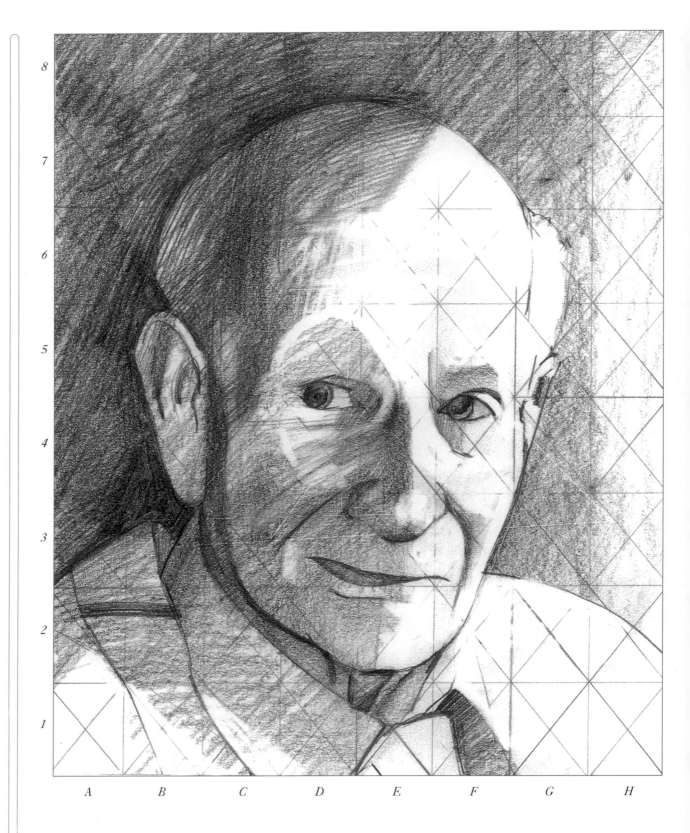

STEP 3

*This is the penultimate stage of the drawing, a time when
I tend to use my eraser to help re-create light areas that
have been smudged. This is also the stage to erase the grid
lines, though some artists choose to leave a few in.*

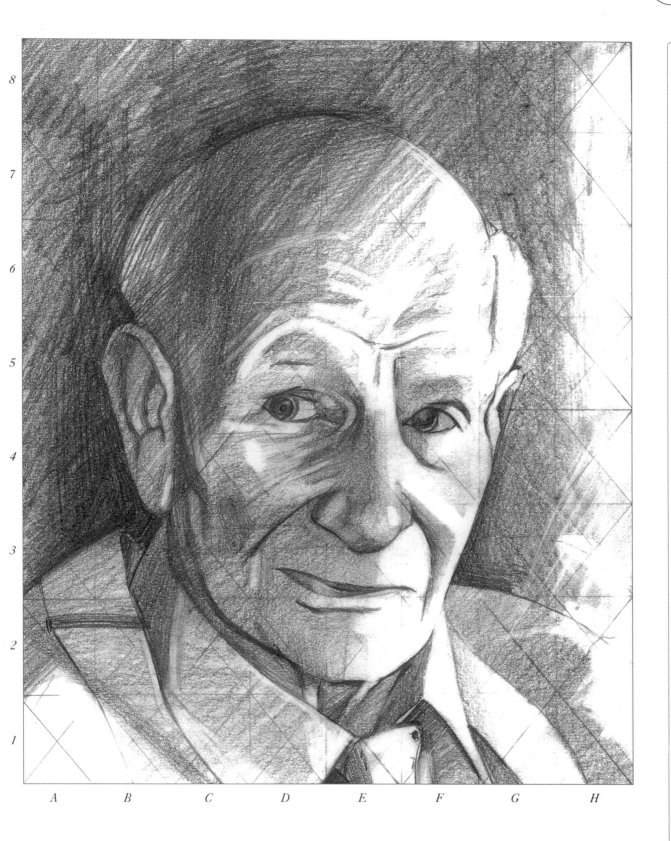

8
7
6
5
4
3
2
1

A B C D E F G H

STEP 4

*In this final drawing I have continued to break down
the tonal gradations into smaller and smaller areas. You
can see that the structure of the cheek bones and the flesh
round the eyes are becoming more descriptive.*

SECTION 12

Tools and Materials

Drawing is primarily about making marks. Marks can be made with many kinds of implements, from drawing in the sand with a stick, inscribing stone with a chisel to making marks on paper with pens made of reeds or feathers. In this book, we have so far only used B pencils. Now let's look at some alternatives.

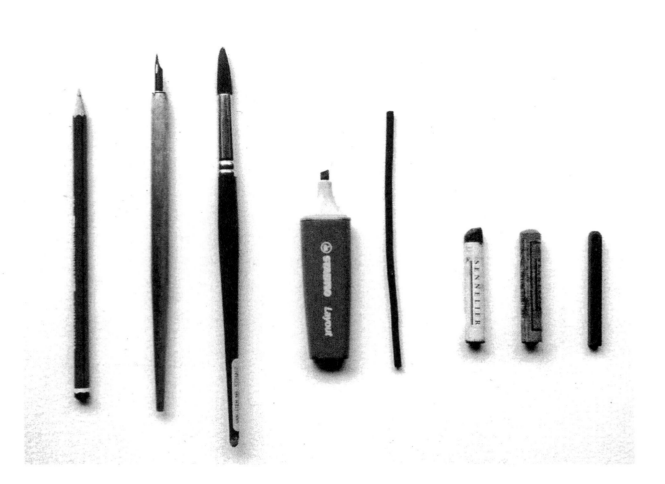

Until now I have chosen to confine us to a B pencil as I did not want you to get distracted by the variety of tools and materials that are available for making marks – drawing in one form or another.

I have spent most of this book getting you to look and see shapes and forms in certain ways. While it is this looking and seeing that is the primary aim, exploring other vehicles and instruments for making marks can not only be fun but also give you an opportunity to find out what medium you feel most comfortable with.

To give you some idea of the qualities inherent in the various implements, I have used a simple grid to show how each one has different types of thickness, density, line and ability to be erased. Try this out for yourself, as it not only makes you more familiar with the mediums but also shows you how they interact with different types of paper surface.

PENCILS

Pencils come in a range of grades from 9H (very hard) through H, then HB, B to 9B (very black and soft). It is worth trying out other grades of pencil than B just to see whether you prefer to work with a harder or softer pencil.

Harder pencils keep a more regular thickness of line but do not have much depth of tone, while an 8B or 9B pencil will give you a very dark mark but little variation of tone.

A combination of the flat side and pointed tip of the pencil

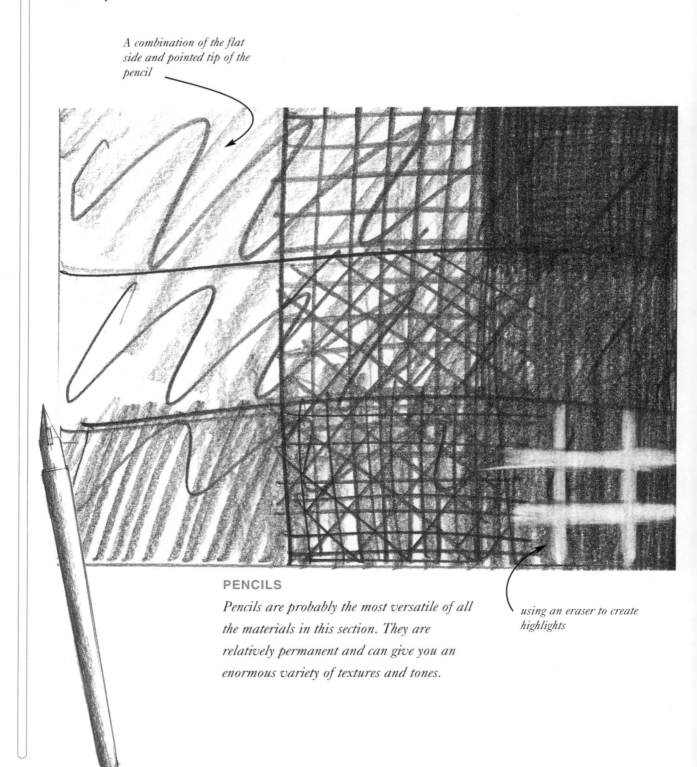

PENCILS

Pencils are probably the most versatile of all the materials in this section. They are relatively permanent and can give you an enormous variety of textures and tones.

using an eraser to create highlights

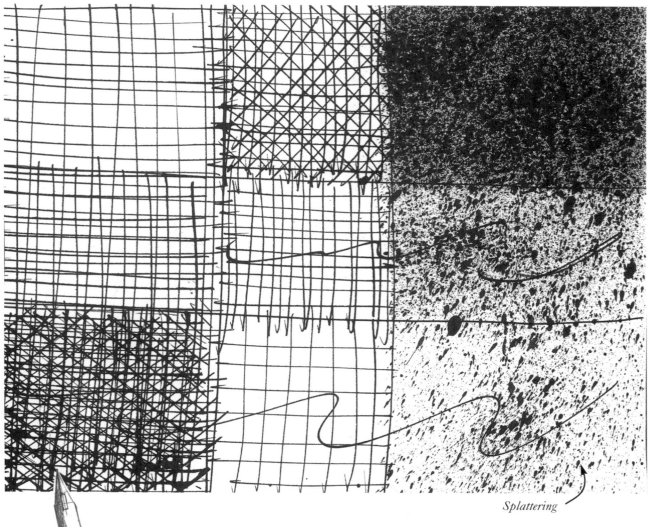

Splattering

PEN AND INK

If you look at drawings by the old masters, such as Rembrandt or Tintoretto, you will see they often used ink and wash. They did the drawing with reed pens or brushes then added water and used their brush to give a variation of tone. While this can give you nice flowing lines they are not as easy to eradicate as pencil lines. Nor is it as easy to approach the variations of tone in the same way. With pen and ink, tone is created either through cross-hatching, by a varying density of dots, or by using a wash of water and ink.

PEN AND INK

While pen and ink can give a very fine line, you need to use cross-hatching if you want darker tones. The disadvantage of this is the tendency for it to blotch.

BRUSH AND WASH

Using a black or sepia ink, you can do quick or slow tonal drawings. You can also use watercolour or gouache. The difference between watercolour and gouache is that watercolour is a translucent paint (allowing light to come through) whereas gouache is what is termed a body-based paint (it is opaque rather than translucent) and it can be over painted like the poster paint used at school. Both have a water base, unlike oil paint, which is mixed with oil, or acrylic paint, which is mixed with a polyvinyl glue.

BRUSH AND WASH

Brush and wash can often be seen in drawings from the 18th and 19th centuries, used with sepia ink and water, for landscape drawing. It is a good way of putting down the basic tonal areas of a picture. However it is more often used in conjunction with a pen to do the more detailed work.

PEN, BRUSH AND WASH

Pen, brush and wash is one of the most used mediums for drawing from the 17th century onwards. The wash is usually of black or sepia ink, sometimes of watercolour. It is an easy medium to use. Tone can be applied quickly and detailwith the pen can be rendered with precision. Like all drawing mediums that are water based, it is better if a thick paper is used.

PEN, BRUSH AND WASH

By using a combination of pen, brush and wash you can get a wide variety of tone and lines. Many artists including Leonardo and Rembrandt used this method for drawing.

MAGIC MARKERS

With the invention of the magic marker and roller ball pens it is now possible to work in a way very similar to ink and wash without having a lot of messy equipment. This can be ideal for making sketches out of doors.

Use Tippex for highlights

MAGIC MAKERS (FELT-TIP MARKERS)

While relatively new compared with pencils, felt-tipped markers offer a variety of different tones and can be very useful for doing a quick sketch without any fuss. Used in conjunction with a pen, they are very good substitutes for pen and wash.

CHARCOAL

Charcoal is made from slowly heated wood. When used as a stick for drawing it is normally made from willow twigs and has been used by artists for hundreds of years. It makes a velvety chalk-like black mark on the paper and can be rubbed off or smudged very easily. Therefore, as with chalk pastel, it needs to be fixed with a fixative spray usually sprayed on like hair lacquer. The positive aspect of charcoal is its easy flowing dark line, giving the velvety quality I have already mentioned. By using the stem of the charcoal you can get good straight lines. But you cannot get very good gradations of tone or thin precise lines as you can with a pencil. There is also the inconvenience of having to fix it. However, many artists have used it because of its spontaneity.

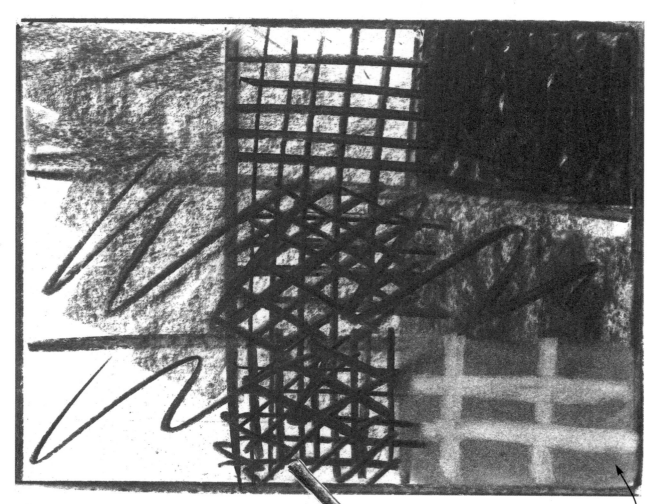

Using an eraser to create highlights

CHARCOAL

The difficulty with charcoal is the fact that you have to "fix" it, either with fixative spray or you can use cheap hair spray. As you can see from the example in the bottom right-hand square, it can be rubbed out. While it is a very flowing medium, you need to smudge it with your fingers if you require variety of tone.

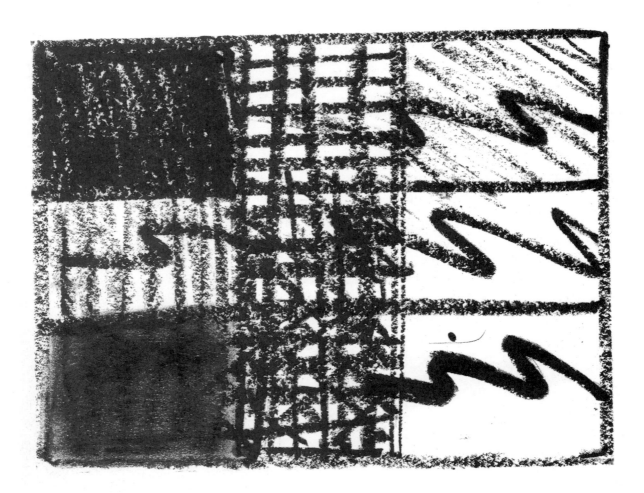

CHALK AND OIL PASTEL

The basic difference between chalk and oil pastel is the medium with which they are made. As you probably know, chalk has a powdery quality that breaks up easily when it is applied to the paper and, because of this quality, it can be easily smudged or rubbed off. If you want your chalk drawings to be more permanent you will need to fix them with a fixative spray, as with charcoal.

Oil pastel is made by mixing pigment with an oil base as in the case of oil paint, and is far more permanent than chalk pastel. It does not have to be fixed. In practical terms both types of pastel give very different visual and tactile qualities. Whereas chalk pastel has a smooth, powdered quality, oil pastel has a slightly sticky, waxy quality, as shown above. With practice, chalk pastel can be mixed easily. It is much harder to do this with oil pastel unless you use turpentine or oil to help it mix.

CHALK PASTEL

Very like charcoal, this is best used with other colours if you want to see its full potential. One colour on its own does not give you the variety or graduation of tone often needed. It also needs fixing.

OIL PASTEL

Like chalk pastels, oil pastels are most effective when three or more of them are used in combination; one or two colours will not give you the range of tone required.

CONTÉ

Conté is a hard, crayon-type, square-sectioned stick made of clay and graphite. It is usually made in black, white and earth colours. Capable of bolder marks than pencil, it can give crisp decisive lines or solid areas of dark. It was used extensively by French artists in the 19th century.

CONTÉ

Conté also needs to be fixed with a spray once you have finished the drawing. Like charcoal and chalk pastel, a range of tones can be created by smudging the marks you make with it.

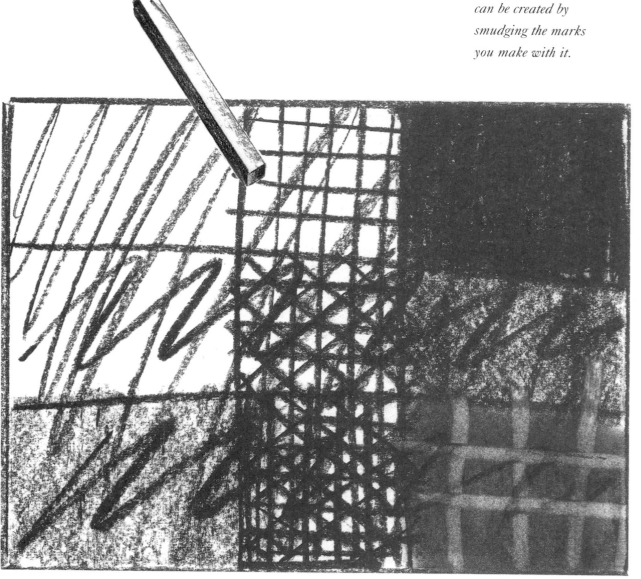

OTHER MATERIALS

Anything that can make a mark can be used to make a drawing, whether it be a lipstick, a matchstick, a twig or a stick dipped in ink or dye. Marks can also be made in sand, or you could use aerosol paint cans, as graffiti artists do. Different materials have different qualities. At a later stage it will be important for you to decide what particular qualities you need in order to say what you want to say. However, until that time arrives, do not be afraid of experimenting with anything that comes to hand to see what sort of mark you can make and whether it might be useful in the future.

THE CAMERA

Many artists, including Turner, have used anything that came to hand in order to jot down an idea or particular effect they had seen. It did not matter to them about the permanency of a sketch as long as it helped them to remember what it was that attracted or inspired them at a particular time.

Many painters since the later part of the 19th century and especially in the 20th century have used photography as an aid to capture certain fleeting visual ideas or experiences. Therefore, I think it is legitimate to think of a camera as an additional tool. But I would give a word of warning: do not to rely too heavily on photographs because, without the looking, seeing and drawing processes we have been going through in this book, using a camera can stop you penetrating the visual world and seeing something deeper than you would just walking around. A camera takes pictures of surfaces and tones – it does not get involved. Drawing gets you involved.

VIEWFINDERS AND THEIR APPLICATIONS

As I have mentioned earlier, one of the most important aids to any objective artist is a viewfinder – whether this be a simple square or rectangle made from your fingers or one made from a piece of board. Being able to isolate a view from the rest of the environment is vitally important if you want to get the composition right without going through many trial runs.

Viewfinders can also have cotton or thin string put across them in the form of a grid of squares to help get the proportions correct (page 110). This same method can be used to help you enlarge or reduce a drawing – simply drawing either larger or smaller squares than the original. This is known as "squaring up" a drawing.

Paper

Anything can be used to draw on, from the famous napkins with which Picasso is said to have paid for his meals to the back of envelopes, pieces of old card, in fact any surface that will hold the medium with which you are drawing. Never let the lack of "proper" materials stop you from drawing. There is nearly always something at hand to make a drawing with and on. But it is useful to carry a small sketchbook and pencil or pen around with you in case there is something that attracts your attention.

There are numerous different sorts of paper on the market, from high-quality rag,

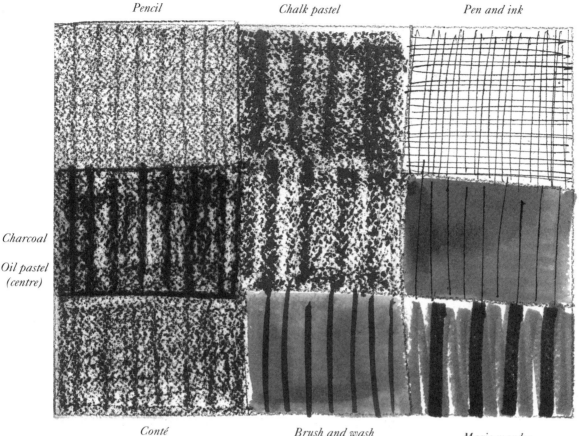

Pencil

Chalk pastel

Pen and ink

Charcoal

Oil pastel (centre)

Pen, ink and wash

Conté

Brush and wash

Magic marder

or cotton handmade paper, to cheap wood-fibre papers as used in scrap books and so on. There are also many different names of papers, such as Saunders, Arches, Bockingford. These are the brand names of paper makers or paper-mills. There are also the descriptive names showing the type of paper surface, whether it is Rough (having a rough surface), smooth (hot-pressed, HP) or cold-pressed (known as NOT, meaning not hot-pressed). Watercolour or wash often requires a rougher surface than pencil or pen.

As I mentioned in the beginning of this book, a good paper for drawing on is cartridge paper. Its surface is neither too smooth nor too rough and it is made from wood pulp not cotton rag. Expensive

ROUGH PAPER

In this example the various implements only tone the top surface of the paper and the lower parts of the rough surface are left. When the washes are used the lower parts of the surface of the paper are coloured as well.

handmade cotton papers are useful for watercolour but not in the main for drawing. However, a number of artists have drawn on Rough paper with good effect. For example, look at some of George Seurat's drawings using conté on Rough paper.

PAPER THICKNESS

The thickness of drawing paper is usually measured by its weight in lbs per ream (480 sheets). A 160lb paper is fairly thick,

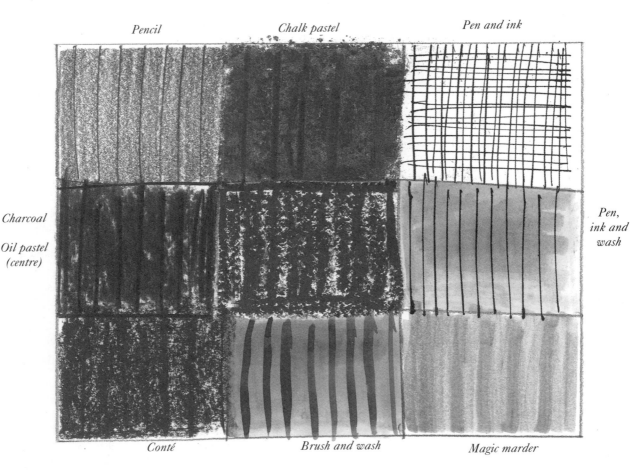

Pencil *Chalk pastel* *Pen and ink*

Charcoal

Oil pastel (centre)

Pen, ink and wash

Conté *Brush and wash* *Magic marder*

SMOOTH PAPER

With the smooth paper, the surface is more evenly coloured. This is usually the preferred paper for drawing.

whereas a 60lb paper is much thinner. Recently, paper manufacturers have started to use a new measurement known as gsm (grammes per square metre). A 340 gsm sheet of paper is similar in weight and thickness to a 160lb sheet of paper.

If you are using wash with your drawing or watercolour you will need a thick paper, at least 160lb. Most watercolour artists would use an even thicker paper, probably 200lb (430gsm). If your paper is a lot thinner, say 60–100lb (130–220gsm), and you want to use wash, you will need to stretch it; even a thicker paper should be stretched if a lot of water is to be used.

STRETCHING PAPER

Stretching a piece of paper is done by immersing it in water for a minute or two then holding it up and allowing the excess moisture to drain off.

Then lay the paper on a stout board and tape its edges down with brown gummed paper tape. Leave to dry.

You will then be able to use wash on the paper. Although it will buckle if you apply too much water, it will dry flat again. A drawing on stretched paper can be worked on again and again and will still dry flat.

Once you have finished your drawing and let it dry cut round the edges of the paper and take it off the board. It will keep its flatness and can be mounted with ease.

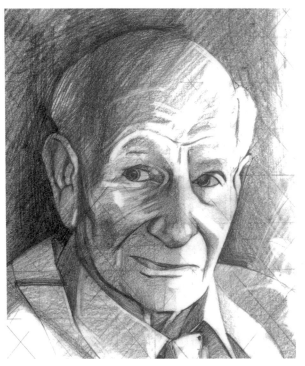

"Did", 1907– 2003

Conclusion

Now you have reached the end of this book, I hope you have enjoyed the experience as much as I did in writing it, and that your view of the world has become a little richer.

There is much to learn about drawing and seeing but it is better to take one step at a time. What I can say after many decades of drawing is that the more one look and sees the more interesting the world becomes.

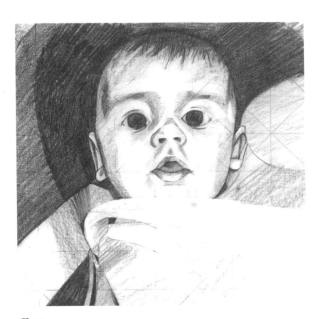

Zoë, 2003

Index

A
angles 130, 142, 156
 checking 22, 25,
 30-1, 39, 80, 82-3
 exercise 14

B
boat 94-7
brush and wash
 198
buildings 82-7, 126,
 130, 133

C
cameras 204
Caravaggio,
 Michelangelo Merisi
 89
chalk pastel 202
charcoal 201
circles 15, 38
composition 98-113,
 124-7, 156, 164-7
Conté 203
contrast 24, 117
cross-hatching 163,
 196
curves 14-15, 24

D
dark and light 55,
 62, 84, 136
Degas, Edgar 99
detail 85, 86
 simplifying 61,
 64-5, 120, 130,
 141

E
ears 153, 155, 185
ellipses 16, 23, 92
equipment 137-8
eyes 153, 155

F
figures 49-65
fleeting images
 124-7
flowers 28-33
focal point 67, 70-1,
 79, 80, 116

foreshortening 53,
 88-97, 153-4,
 155, 160
form 34-48
formats 118-19, 126
fruit 25-7, 42-5

G
Géricault, Théodore
 102-3
Golden Mean 99,
 100-1, 112
grids 180-93
groups
 objects 25-7, 28,
 42-5, 46-8
 portraits 186-9

H
heads 153-5, 156-8
highlights 183
horizon line 67,
 68-9, 70-1, 82-3,
 116, 142
human figure 57-65

I
Ingres, Jean-
 Auguste-Dominique
 106-7

J
John, Gwen 174-5

L
Landscapes 114-31
Leonardo da Vinci 67
light 38
 direction 35-6, 39,
 55, 61, 64, 84
 in landscapes 116
 in portraits 160,
 161, 164-7, 169,
 171
light and dark 55,
 62, 84, 136
lines 28, 112, 135
 exercises 11-13

M
magic markers 138,
200

mark making 202-6
materials 194-206
Michelangelo 50
mood 112, 136, 161
movement 100,
 104-5, 107
 in portraits 164,
 172-3, 175, 177
 and tone 104, 109,
 165, 172

N
negative spaces 23,
 26, 30, 33

O
objects, drawing
 17-33
oil pastel 202
orchids 30-3

P
paper 10, 204-6
pen and ink 138, 197
pen, brush and wash
 199
pencils 10, 138, 196,
 202
perspective 66-87,
 130, 133
photographs 124,
 178-9
portraits 152-77,
 184-93

R
receding objects
 74-8
reflections 63, 134
Rembrandt 176-7
rule of thirds 102-9,
 112

S
Sargent, John Singer
 166-7
self-portraits 168-77
shading 36, 41
 exercise 37
 see also tone
shadows 24, 55, 133
shapes 28, 61
 identifying 26, 46-7
 plotting 22, 30-1,
 52-3, 83, 120-1
 in portraits 153-9,
 168
sight-measured
 drawing 18, 20-6,

39, 42, 53, 83
landscapes 120-1
portraits 168
size 18-19, 54,
 60-1, 64, 143
sketchbooks 137-8
sketching 132-51,
 159-63
sky 116, 125
spheres 38
splattering 196
steps 142
stool 80-1
street scene 82-7

T
teddy bears 52-6,
 92-3
three-dimensionality
 34, 35, 36, 189
time limitations
 128-31, 141,
 148-9
tone 34-48, 162
 adding 39, 43, 52,
 55, 56, 61, 85
 in portraits 157,
 169, 193
tonal sketches
 118-19, 122-3,
 125
tools 10, 138,
 194-206
transferring images
 179-91
trees 128-31

U
Uccello, Paolo 90-1

V
Van Gogh, Vincent
 172
vanishing points
 72-3, 80, 82
vases 22-4, 39-41,
 182-3
Vermeer, Jan 108-9,
 164-5
viewfinders 28-9, 52,
 110, 116-17, 156,
 204
viewing subjects 24,
 39, 47, 139, 157
viewpoint 94-7